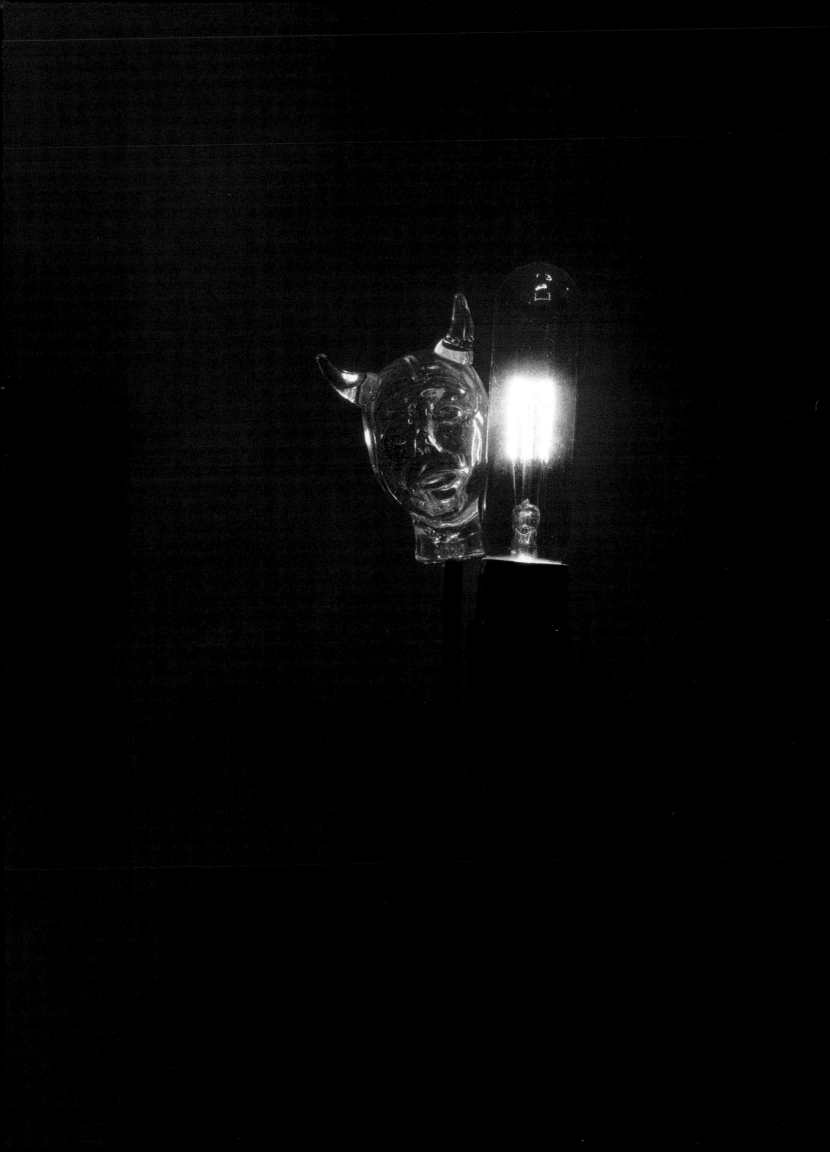

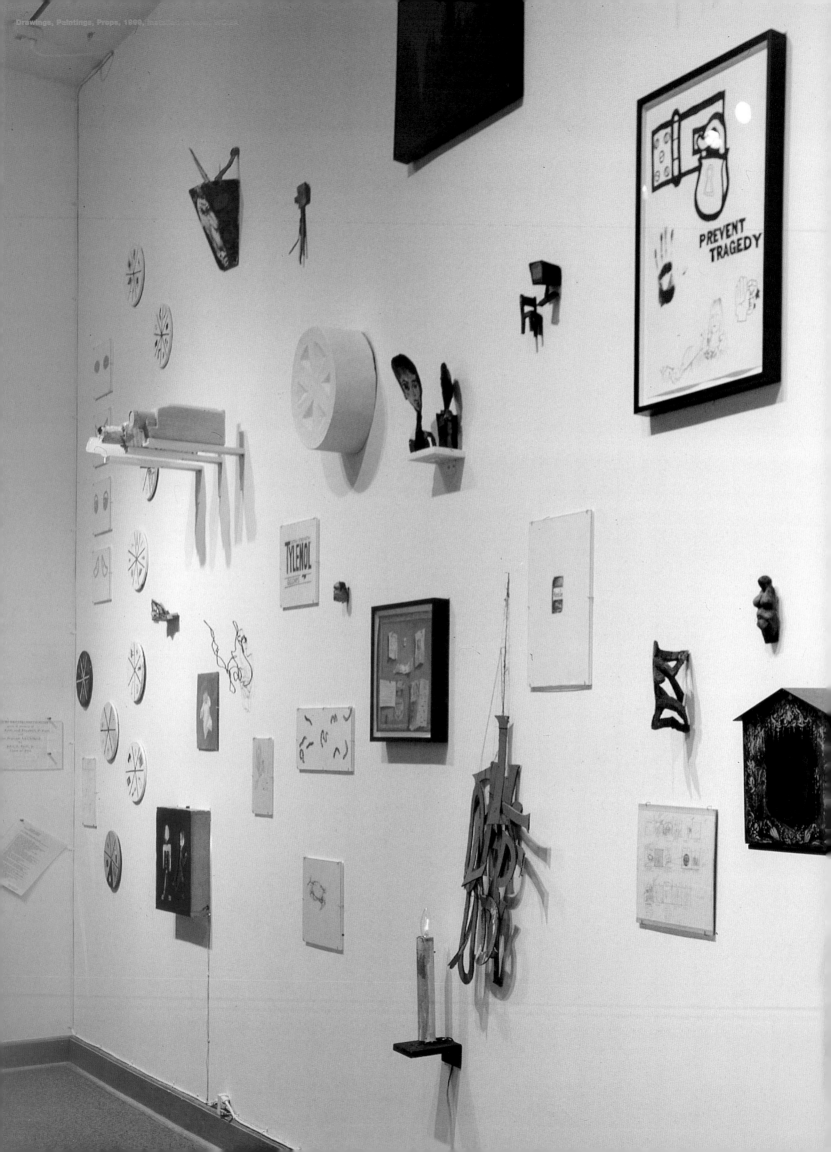

Williams College Museum of Art TONY **oursler**

Introjection: mid-career survey 1976–1999

Deborah Rothschild

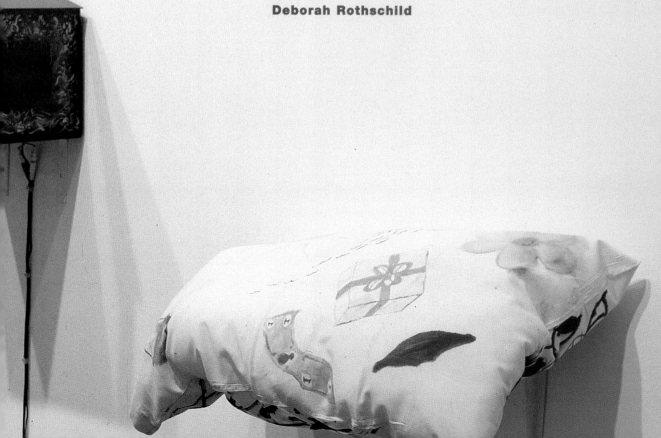

Camera Obscura, 1998

Williams College Museum of Art ISBN 34256-9876

Available through D.A.P./Distributed Art Publishers
155 Sixth Avenue, 2nd Floor, New York, NY 10013
Telephone: (212) 627-1999 Fax: (212) 627-9484

This catalogue accompanies the exhibition *Introjection: Tony Oursler mid-career survey 1976-1999*,
presented at the Williams College Museum of Art from 17 April through 24 October, 1999.
The exhibition was organized by Deborah Rothschild, curator of exhibitions at the Museum.

This exhibition has been made possible in part by grants from the National Endowment for the Arts,
the Andy Warhol Foundation, the President's Office of Williams College, the Fairleigh S. Dickinson, Jr.
Foundation, Inc., and the Michael S. Engl '66 Fund at the Williams College Museum of Art.

Exhibition Venues

Williams College Museum of Art, Williamstown, Massachusetts, 17 April–24 October 1999,
with *Optics* at Massachusetts Museum of Contemporary Art, North Adams, Massachusetts,
31 May–31 October, 1999

Contemporary Arts Museum, Houston, Texas, 11 December–13 February 2000

Los Angeles Museum of Contemporary Art, Los Angeles, California, 2 April–30 July 2000

Des Moines Art Center, Des Moines, Iowa, 11 November–21 January, 2001

Williams College Museum of Art
Main Street
Williamstown, Massachusetts 01267
Telephone: (413) 597-2429 Fax: (413) 458-9017
http://www.williams.edu/WCMA/

contents

8 linda shearer
director's foreword

12 deborah rothschild
introjection: in oursler's world, no one escapes its unbidden influences

38 mike kelley
an endless script: a conversation with tony oursler

58 constance dejong
tony oursler: L7-L5, 1984

66 ian berry
studies of a troubled world: the drawings of tony oursler

70 elizabeth janus
talking back: a conversation with tony oursler

96 laura heon
oursler's ether

102 tony oursler
i hate the dark. i love the light.

112 **exhibition checklist**

116 **exhibition history/bibliography**
compiled by ian berry and alanna gedgaudas

127 **williams college museum of art**

128 **credits/acknowledgments**

director's foreword

Over the last fifteen years many contemporary artists have revived, explored, and reframed Freud's notion of "the uncanny." Tony Oursler in particular. Anxiety realized, video as interactive presence, pain and humor of social disease come to life, impossible strangeness that becomes all too familiar – Oursler's work vividly retains the quality of the uncanny by indeed making the strange familiar, remarkably at a time when digital video technology has almost desensitized us to the magic of the strange.

Freud wrote in his 1919 essay, "It may be true that the uncanny is nothing else than a hidden, familiar thing that has undergone repression and then emerged from it, and that everything that is uncanny fulfills this condition." Freud cites the etymology of the word *heimlich*, which means, most simply, "the familiar": "*heimlich* is a word the meaning of which develops towards an ambivalence, until it finally coincides with its opposite, unheimlich." For Freud, the uncanny is complex and mutable: something we recognize easily can often become the most disquieting, and what we find most strange can suddenly draw us back to the most intimate and familiar. The uncanny appears when the familiar turns back on itself and becomes the unfamiliar and thereby can become its own opposite or double. As Oursler's personas look and talk back at us, we try to maintain our distance from them, but they seep into us and we become them, almost against our will. This breakdown of authority, of the boundaries between self and other, this undecidability, has been recognized as the source of much postmodern thinking and many artistic strategies. It is perhaps this tendency of the familiar to merge with its opposite and become effectively indistinguishable from itself that can help us to understand the power of Oursler's work.

Since the early 1980s I have watched Tony Oursler's professional evolution. After seeing his 1994 solo exhibition at Metro Pictures in New York, I was struck by the originality and appeal of his latest work and proposed doing a small show here at Williams. I knew that Oursler's innovative pieces fusing performance, video, and sculpture would win over even those most resistant to contemporary art. Through their babbling confusion, manias, and delusions, Oursler's video creatures seem so convincingly human that they evoke our empathy, and irritation, even though their parts – everyday objects such as stuffed pillows and artificial flowers combined with electronic equipment – are revealed for all to see.

Our original plans for a small show gradually mushroomed, and before we knew it, we were organizing Oursler's first American mid-career survey. The Massachusetts Museum of Contemporary Art (MASS MoCA) was planning its long-awaited opening, and eager to collaborate with our new neighbor in North Adams, Massachusetts, we broached the idea of commissioning a new work by Oursler as part of its inaugural exhibitions. Joseph Thompson, MASS MoCA's director, was immediately enthusiastic and ready to participate. Kleiser-Walczak Construction Company, the digital animation firm whose offices are located at MASS MoCA, was also brought into the project. Jeff Kleiser and Diana Walczak gave generously of their time and resources to realize the complex new installation. Major funding from the National Endowment for the Arts, the Andy Warhol Foundation, the President's Office of Williams College, the Fairleigh S. Dickinson, Jr. Foundation, Inc., and the Michael S. Engl '66 Fund at the Williams College Museum of Art made it possible for us to go forward with a more ambitious exhibition than originally envisioned. The result is an overview that provides an opportunity to see not only the development but also the continuity and cohesiveness of Oursler's body of work from its very beginnings. I wish to thank Jennifer Dowley, formerly of the National Endowment for the Arts; Pamela Clapp at the Warhol Foundation; and former president of Williams College, Hank Payne, for recognizing the importance of the project and providing key resources to make it happen.

A project as complex as this one involves the talents and support of many individuals. At the museum, Deborah Rothschild, curator of exhibitions, has been the guiding force, and I owe her my deepest gratitude for ensuring that this exhi-

bition was realized so beautifully and professionally. Marion
Goethals, associate director, expertly oversaw the administra-
tion of the exhibition, and its tour and budgetary matters in par-
ticular. Diane Agee, museum registrar, has handled with her
usual equanimity the many complications of traveling an exhi-
bition that includes more than 75 television monitors, VCR play-
ers, and video projectors. Kay Kamiyama, public relations coor-
dinator; Ted Wrona, security supervisor; Judy Raab, director of
membership and events; Ann Greenwood, members program
coordinator; Barbara Robertson, director of education; Stefanie
Spray Jandl, Mellon curatorial associate; Sheila Mason, secre-
tary; and Amy Tatro, assistant to the director, contributed their
individual skills and talents to a project that reached every
office at the museum.

We owe a tremendous debt of gratitude to Hideyo Okamura,
chief preparator, and his staff including Greg Smith, intern Dana
Steinberg, and especially J. Patrick Holden, preparator, who all
worked long hours and gave up many evenings to realize this
complex exhibition. We are appreciative to Hideyo for his
resourcefulness and calm in the face of a unique and intensive
installation. Bruce Wheat, Richard Lescarbeau, David Dabrow-
ski, and Timothy Downey all helped with the many technical and
equipment-related details of the installation. Graduate interns
Annie Elliott, Sonia Bekkerman, Amy Hamlin, and Alanna
Gedgaudas devoted many hours to the exhibition, undertaking
everything from canvassing second-hand stores for old furni-
ture to aiding Tony's research.

Above all, both Deborah and I would like to thank Ian Berry,
assistant curator, who has been involved in every aspect of the
exhibition, including managing its mammoth electronic needs.
His professionalism, art savvy, and willingness to do everything
and anything have raised the bar for all of us at the museum.

Tony Oursler's studio assistants, Lilah Freedland, Tom
Hines, and James Oursler, have been indispensable not only to
the smooth realization of this exhibition but also to the high
spirits and good humor that pervaded its implementation. The
staff of Metro Pictures, Tony Oursler's gallery in New York, was
critical in shaping the exhibition. We are grateful to Helene
Winer and Janelle Reiring as well as Tom Heman, gallery direc-
tor, for their helpfulness and continued support throughout the
project. Jeff Gauntt, Todd Hutcheson and Tony Huang were also
attentive to our many queries and needs. Sidney Lawrence at the
Hirshhorn Museum and Sculpture Garden in Washington, D.C.,
was extremely helpful and supportive throughout the initial
phases of preparation, having recently organized an exhibition
of Oursler's collaborative pieces with Tracy Leipold that was a

I'll Get You, 1970

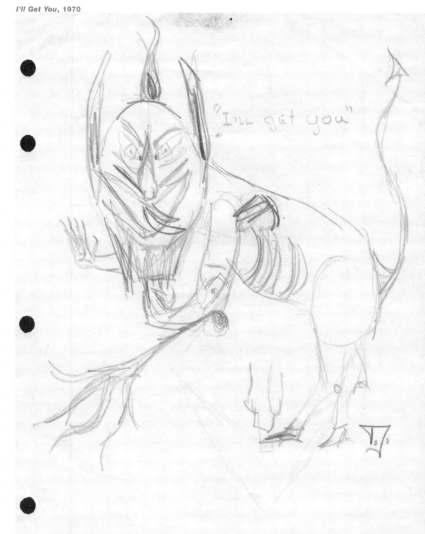

model of focused connoisseurship. Stephen Vitiello, artist, collaborator, and director at Electronic Arts Intermix, went out of his way to help with our many video requests. The artist would like to thank Tracy Leipold, Zoe Pettijohn, and Constance DeJong for their support.

Ed Merritt, of Berkshire Contemporary Glass, and Martin Stefanchik contributed their expert problem solving and creative design to help fabricate components of several pieces in the exhibition. Masako Takagi came to the rescue to help create the text panels and other graphic design elements for the exhibition and its accompanying materials.

For this catalogue we had the privilege of working once again with our former public relations director, Brenda Niemand. Since leaving the Berkshires she has been sorely missed, and we are grateful for her expert editing. We are also thankful to Pascale Willi of xheight, inc., for producing a catalogue design remarkably in tune with Oursler's sensibility. Thanks to Suzanne Salinetti at Studley Press for her attention to the many details of the publication and to Arthur Evans, who spent many evenings at the challenging task of photographing video pieces that simultaneously need light and darkness. Thanks to the contributors to the catalogue, Deborah Rothschild, Tony Oursler, Mike Kelley, Constance DeJong, Ian Berry, Laura Heon, and Elizabeth Janus. Their combined writings provide an overview that will become a key resource for information on this important artist.

It is our hope that this exhibition will be the first of many collaborations with MASS MoCA. We are grateful to Joseph Thompson, director, for his readiness and early interest in this project. Laura Heon, associate curator, ably and intelligently oversaw the installation of the new piece; Jennifer Trainer Thompson, director of external affairs, diplomatically addressed countless issues associated with the opening of MASS MoCA and with the Oursler installation in particular, and Richard Criddle, preparator, spent many hours assisting with fabrication and installation. Kent Mikalsen, Chris Swing, and Phearuth Tuy of Kleiser-Walczak Construction Company combined forces with Tony to take his work into a new medium of computer-animated video.

We are pleased to share *Introjection: Tony Oursler mid-career survey 1976–1999* with the Contemporary Arts Museum in Houston, the Los Angeles Museum of Contemporary Art, and the Des Moines Art Center. Our thanks are extended to Marti Mayo, Dana Friis-Hansen, and Paola Morsiani in Houston, Jeremy Strick and Ann Goldstein in Los Angeles, and Susan Talbott and Jeffrey Fleming in Des Moines. On behalf of all three museums I express profound appreciation to the lenders to the exhibition, including Laura Lee W. Woods, the Broad Art Foundation, Mr. and Mrs. Frederick Rudolph, the Robert J. Shiffler Foundation, the Museum of Modern Art in New York, the Whitney Museum of American Art, and Metro Pictures. To part with their works for a long period is an act of generosity for which the exhibition is immeasurably richer. We are also grateful to Michael Govan, director of the Dia Center for the Arts, for facilitating the exhibition of *Fantastic Prayers*, an interactive CD-ROM by Tony Oursler, Constance DeJong, and Stephen Vitiello originally commissioned by Dia. Karen Kelly, director of publications, and Tim Gardner made several trips to Williamstown to install *Fantastic Prayers*.

Finally, we would like to extend our heartfelt thanks to the artist himself. Tony has been deeply involved in every aspect of this project, from the smallest detail to its overarching themes and content. He set the tone for simultaneously working hard and having fun, and all who had the privilege of assisting him through the actualization of this exhibition have been impressed by his kind, funny yet serious, intensely intelligent but totally unpretentious persona.

Linda Shearer
Director

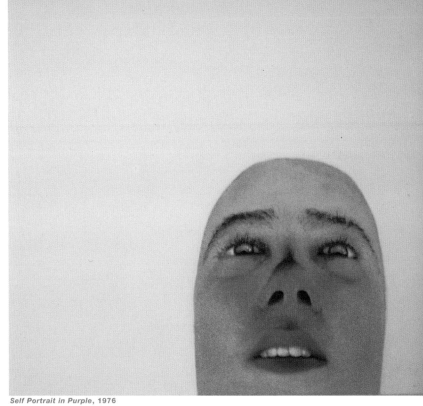

Self Portrait in Purple, 1976

Figures, 1977

Order Obsession, 1976

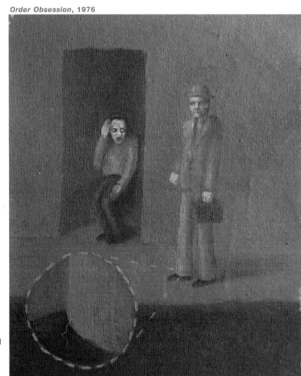

introjection: in oursler's world, no one escapes its unbidden influences

by deborah rothschild

Part I

If you've ever noticed how people can start to look like their dogs, or how friends who have known one another a long time begin to act alike, you've seen introjection. Meaning literally "to throw within," it is a psychological term for the unconscious absorption of one person's qualities by another. We all pick up mannerisms, speech patterns, and quirks of personality from others and incorporate them into ourselves. Tony Oursler is engaged in exploring various aspects of introjection, from the basic psychological "copy function" we all share to the absorption of toxins in our environment through chemical osmosis and ingestion. He sees that our bodies, our minds, our very souls, have been infiltrated by technology and its by-products. Oursler is particularly interested in a subtle form of the phenomenon that might be called media introjection, i.e., our assimilation of thoughts and behaviors from television and film.

It's not that he shares in the simplistic assumption that television is bad, but rather that he sees the profound power it has to insinuate itself into our lives and even into our subconscious. So much information is filtered through it, so much experience formed by it, that television has become as real as anything outside itself. Through introjection, the power of the screen extends from linking us to international events to telegraphing shifts in social conventions. Oursler believes that the "Disneyfication" of our culture, which contributes to a simplified, prettified, and commodified view of life, is due largely to TV.

The fact that "so many of us perceive the world through television" has been a major catalyst for Oursler's work. "My main focus is the position of the individual in relation to the mass of information we are fed and the manipulation we undergo by the powers that be, such as large conglomerates. That is one reason I want to understand the language of movies and TV, in order to see what causes – and then how to break – the hypnotic thrall media systems have over us. Introjection, this 'copy function' we have, can be applied to televised images, and we have to have some awareness of their power."[1]

Admittedly, in a country where each home averages three TV sets, the idea that life imitates and blurs into television is not exactly startling. It has inspired such movies as *The Truman Show*, *EdTV*, and *The Matrix*, as well as studies such as Neal Gabler's recent book, *Life the Movie: How Entertainment Conquered Reality*. David Cronenberg's paranoid science fiction films *Videodrome* and *eXistenZ*, where video mechanisms are inserted into the human body, illustrate literally the idea of media introjection in the extreme. What differentiates Oursler's work from more preachy variations on this familiar theme is his nonjudgmental stance and playful approach. He does not sneer at television but instead uses droll amalgams of research, humor, and art to make us see and think about its immense effect on our lives.

Oursler explores another definition of introjection – the assigning of living characteristics to inanimate objects – through his video-projection sculptures. We see in Oursler's evolution how he gradually squeezes the TV out of the tube by using first reflection and later effigies to do away with the TV monitor. In this way media entities become tangible as they occupy physical space. By relinquishing the monitor and "the immaterial transmission of the screen with a projection in real space,"[2] he eerily gives life to the technically inanimate.

Empathy – an ability to feel for others – can be seen as a precondition to some kinds of introjection, and Oursler's work has always been noteworthy for the empathy it is able to arouse. His repertoire of characters, including those of his single-channel works and his video-animated sculptures, engage us through their very human neuroses and confusion. The marginalized and forlorn, those rejected examples of humanity who don't belong or are looked down upon, are Oursler's usual protagonists.

This exhibition provides an overview of Oursler's career that allows viewers to trace his evolution, but it also points up recurring themes in his work – paranoia, superstition, and an awareness of introjection by devices that convincingly represent reality and influence human behavior. Issues of identity crop up

Life of Phillis: Phillis, 1977, production still

frequently: Oursler often asks, What makes us human in a mechanized world where androids are no longer entirely in the realm of science fiction? He finds the answer in our capacity for empathy and in our individuality, expressed through quirkiness, unpredictability, fallibility, and refusal to fit the mold. In Oursler's universe, a creature that resembles a bouquet of flowers or a lump of clay may qualify as human even when something that looks and talks like a man does not. He says, "What concerns me most deeply is individuality and creativity surviving in the culture, and I think artists are and should be catalysts for that."[3]

The exhibition begins with a survey of Oursler's single-channel videos that span 1976 to 1999. It also recreates three large installations from the early eighties – *Son of Oil*; *Diamond: The Eight Lights*; and *L7-L5* – and includes later experiments with mixed media and monitorless video. Oursler's signature sculptures using video projection onto effigies are represented by such pivotal works as *The Watching*, *Judy*, and *Getaway #2*. The largest gallery has been loosely divided between those works that deal with psychological introjection, as in "media-induced" dissociative identity disorders, and those that treat chemical introjection via mutation and environmental poisoning.

Represented too are early paintings, drawings, and props, some dating back to Oursler's youth, that foretell later preoccupations. A devil (p. 9) drawn when he was thirteen is a surprising precursor of the glass demons that punctuate *Optics* (pp. 97–101), the newest work on view. A fly described as "sent from the devil" in a sketch from 1978 crops up again in the video still life *Aperture* (1998). An ink sketch depicting a dagger-wielding hand emerging from a television set and threatening to slit the viewer's throat provides hints of the media paranoia to follow. *Order Obsession* (1976) (p. 11), a small painting by the nineteen-year-old Oursler, is prophetic of the cast of projected-video neurotics and psychotics that appear in the 1990s. In it, Oursler's trademark recipe of humor mixed with pathos is evident as a man crouches in horror inside a doorway; his frightened eyes focus on the bottom of a businessman's suit. Through an enlarged detail we see the cause of distress: a tiny loose thread on the man's pant leg.

A persistent hallmark of Oursler's work – that is also characteristic of much contemporary postmodern art – is his method of moving his audience from passive viewers to participants in the work he creates. Through his confrontational video-animated dummies of the nineties that verbally attack, ask questions, and give orders, we are amusedly and bemusedly drawn into an active dialogue with TV. The dummies stir empathetic reaction as we project ourselves into them, and vice versa. In other earlier works Oursler combats passive viewing by rousing our imagination to fill in the blanks – fleshing out stick-figure protagonists and imagining scenarios that are verbally described rather than shown. In *Optics* he takes us through a personalized history of media technologies, beginning with the camera obscura, that explores its own process while telling its story.

The irony of using video to critique other media is not lost on Oursler, who is acutely aware of the mesmerizing powers of moving pictures as well as viewers' disposition to be seduced by them. Exploiting the medium he knows is undeniably effective, he packages serious content in video designed to amuse and engross. Throughout his development he has acted as a persistent gadfly, entertaining us while pointing out how pathetically addicted we are to being entertained.

Single-Channel Videos

As a child growing up in Nyack, New York, in the 1960s, Oursler watched a lot of television. At some point in his teens he became aware of TV's ability to induce emotional identification with its broadcast images. As Oursler says, "We bond with these electronic entities. As soon as we sit down before a movie or TV screen, we are willing to suspend disbelief and empathize with images we know are not real."[4]

While a student at the California Institute of the Arts, Oursler began experimenting with single-channel video in order to see just how far a character could be reduced and still induce empathy in the viewer. He wondered, "What constitutes a media entity? Would a moving dot with a voice attached be accepted as a real actor? What makes something animate?"[5] The results of these experiments can be seen on several single-channel videos in which anything from a square of toilet paper to a spoon can function as the lead character. In *Diamond (Head)* (1979) (p. 15), for example, the heroine is a crudely painted triangle of cardboard that a voice-over tells us "was beautiful as a young girl. Many men came calling on her." We watch this "woman" find a mate and give birth to a "good son" – a small fetus-shaped balloon. Enacted largely by characters of string and cardboard, *Diamond (Head)*, in Oursler's funny/serious way, does cause us to suspend disbelief, engaging our emotions as it tells a tale of suburban malaise and its source in greed and lust. As the narrative takes us in, we involuntarily agree to imagine the triangle of cardboard as a beautiful woman.

Embracing an anti-aesthetic that was part of the late seventies and early eighties California all-media, "post-studio" movement and intended as a critique of Hollywood's slick production values, Oursler's early single-channel videos have a deliberately adolescent *Wayne's World*, made-in-the-basement look. Like his California "funk art" contemporaries such as Mike Kelley, Raymond Pettibon, Jim Shaw, Paul McCarthy, Kim Dingle, and Charles Ray, Oursler early on made work that seemed anti-intellectual and sophomoric but that was theoretically and philosophically informed – usually by postmodern thinkers (Georges Bataille, Jacques Lacan, Jean Baudrillard) and by the teachings of John Baldessari. By combining cool theory with material excess, these artists developed a counter-canon characterized by an aggressive search for taboo subject matter that was designed to disturb, baffle, and amuse. Recalling their dada precursors earlier in the century, they thrived on "defamiliarizing" the familiar and refuting commonly held assumptions regarding human nature and culture through shock and humor. For example, Paul McCarthy's satire on abstract expressionism, in which the artist impersonating a tube of paint makes a disgusting mess, deflates illusions of the fifties and sixties by lampooning the so-called "heroism" of action painting. Along the same lines, Mike Kelley's thrift-store crocheted stuffed animals in porno-

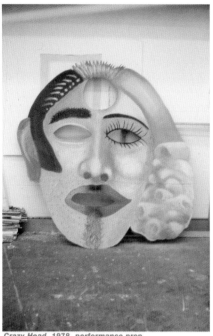

graphic positions call into question cultural assumptions about both childhood and grandmotherly innocence. In a like manner, Oursler's single-channel playlets, with their kitsch, pop, and folk references and funhouse sensibility wed to high art concepts, yield an anti-intellectual yet college-educated style analogous to the derisive humor of media icons such as David Letterman or Dennis Miller.

Oursler's videos with their miniaturized, hand-constructed sets colored with poster paint, their somnambulant voice-overs, and their disorienting sound evoke post-punk spectacles via German expressionism – *The Cabinet of Dr. Caligari* by way of *Eraserhead*, as one critic has noted.[6] They celebrate the personal touch of the hand and are free of the hyperrealism that characterizes much tech-media. Clay and cardboard props as well as Oursler's fingers, hands, and other body parts, painted and dressed, serve as characters and sets along with whatever objects he finds at hand.

Oursler's low-budget fakery is ingenious. For instance, water dripping from a plastic bag simulates the protagonist's tears in *The Loner* (1980) (p. 17), thereby stimulating our compassion; and a canister being sprayed serves as a sick man's sneeze and enables us to feel his germs spreading. Two rolls of toilet paper, representing breasts, illustrate the toll time takes on beauty; as they unwind, the breasts fast-forward from firm to saggy. As artist Tony Conrad has noted, "The most startling thing that hangs in his work as a through theme [is] the way almost any tawdry bit of fluff can become the protagonist. . . ."[7] One striking prop from *EVOL* (1984) (p. 23) is the intertwined wire couple (*evol* is *love* backwards) that inadvertently reprises Max Ernst's 1927 painting *One Night of Love* (private collection, France). In both, the idea of two lovers' bodies merging and mirroring each other is given visual form as a single line.

The Life of Phillis/Part II: Revenge (1977) taps into modern tabloid sensationalism. In it Phillis, a mass-murderer played by a pair of fingers dressed in white go-go boots and short shorts, walks along a small-scale city block. She then waits in an alley for an unsuspecting victim to round the corner. There is a splat of dark paint on the wall, and we understand that Phillis has killed again.

The single-channel videos (see Oursler interviews by Mike Kelley, p. 38, and Elizabeth Janus, p. 70) present layered and disconnected images and stream-of-consciousness voice-overs that create an interrupted and fragmented effect, echoing the modern person's experience of fracture and dissonance. These multivalent sensations – largely an urban phenomenon earlier in the century – are now part of our channel-surfing culture. They mirror the contemporary electronically bombarded mind as private thoughts flit from one subject to another, overlap, and mingle with snippets of overheard conversation, newspaper headlines, and broadcast phrases. While maintaining a narrative structure (which he would later discard), Oursler in his early videos rejects linear logic in favor of this more experiential mode. He notes, "In the early tapes I was working to try to make something I knew people would understand. More of a voice inside your head, the way the brain sees pictures and arranges them. The mixture of memories, sounds, images, collaged together, which

Get out of That Tree, 1977–79, video still

Crazy Head, 1978, video still

Crazy Head, 1978, performance prop

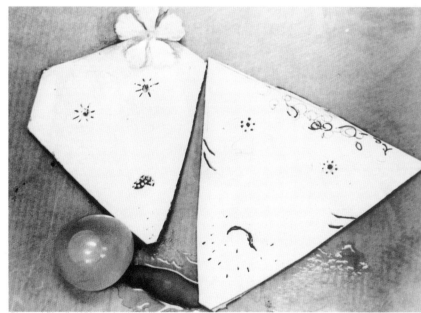

Diamond (Head), 1979, production still

Study for Nuclear Blast, 1979

How Bad Crime Is, 1979

is really the way that I felt I thought – I'm looking at one thing and I hear a voice in my head say something else. I felt that those people [TV and movie producers] really underestimate how the brain works in terms of associations and understanding the world in simultaneous ways. I wanted to create anti-Hollywood work, in which the editing and the narrative worked in opposition to preconceptions of how films should operate. So I ignored the accepted structure of a beginning, middle and end with long shot, mid-shot and close up."[8] The resulting density may be one reason why, even though story lines are roughly followed, the single-channel tapes are often best viewed in five- to ten-minute stretches.

Among the themes tackled in the single-channel videos are teenage loneliness, paranoia, sexual alienation and a confused sense of self; corporate/political control of the environment and society through chemical and media tampering; and an overall sense of the individual's helplessness. Oursler notes, "I was trying during the seventies and early eighties to make things that were edgy or irritating or infantile. I was reacting against the concept of beauty and instead was interested in the juxtaposition and balancing of ideas and what might take hold in the mind of the viewer, so that he or she might have new thoughts or look at things differently."[9] These substantial and often dark intentions are masked and made palatable in the early tapes by Oursler's off-the-wall humor and playfulness. A mix of black comedy, lurid cartoon, and paranoid theological melodrama – the latter a remnant of his Catholic schooling – characterizes his work from the late seventies and early eighties.

Son of Oil

In 1982 the props used in the single-channel videos began to spill over onto real space, and Oursler's first public installation, *Son of Oil* (pp. 19, 21), was born. First shown at P.S.1, the contemporary art center in Queens, New York, and re-created for this exhibition, the work includes a thirty–foot canvas, painted to look like a blazing orange/yellow sunset or an oil field on fire, that serves as the background for cardboard gravestones and gas station pumps festooned with strings of mini-mart flags. This set also appears in the video, which features human actors in addition to the usual puppets and props. The video is projected on a monitor embedded in one of the grave markers. In part as a reaction to the previous generation of artists like Nam June Paik, Dara Birnbaum, and others who tried to convert the TV set itself into an art object, Oursler began manipulating "the video image to remove it one step from its physical origin into another space or dimension"[10] – usually by reflection.

In free-associative fashion, *Son of Oil* links America's romance with machines that drill or drive to sex, violence, money, power, corruption, and insanity: "Go faster, go deeper, joy ride, a dummy ride, a nightmare, just having too much fun. Oil, oil, oil, sex. It's under pressure, and drugs – a hole is needed – are depressing – to relieve this vile, smelling fluid. . . ." There is a mix of references to early 1980s American celebrities such as the Son of Sam killer, David Berkowitz; John Hinckley Jr.; and Howard Hughes ("the old driller himself"). Allusions to the La Brea tar

pits and the prehistoric animals trapped there intersect with references to cows killed from drinking water polluted by oil refineries. When Oursler narrates, "Small as it may seem, a little nut is born into an important position, and without it everything grinds to a halt. . . . First generation was crude. Second generation was refined . . . ," he is ambiguous about whether he means the heir to an oil fortune or the machinery of drilling itself.

Son of Oil continues poetically to address abiding Ourslerian themes – the violation of the earth, the corrupting power of money, and the impotence of the individual against mega-corporations and conglomerates. It also hones his essentially unpretentious cinematic technique, with its background noise, cartoonish sets, and virtual absence of post-production editing. A Pirandellian shattering of narrative illusion – where we see the actors breaking "character" or hands popping in and out of the camera's sight line to adjust props – enhances Oursler's desire to implicate and involve the viewer. He continues to use this device today. In his recent work *Optics*, a segment of the installation is a silent-film-type battle between an angel and a devil. In addition to the "narrative" – studio assistants Lilah Freedland and Tom Hines dressed as angel and devil wrestling like a good and bad conscience – the video includes footage of them putting on makeup, standing around waiting for direction, receiving a "high five" from Oursler, and other off-stage moments.

Oursler regards *Son of Oil* and his other video installations from the early eighties as a hybrid form hovering between conceptual and object-based artwork. Usually constructed from ephemeral materials like cardboard and poster paint, they "went right in the garbage after an exhibition was over."[11] Thus they would be reconfigured and changed in subsequent incarnations. For example, *Son of Oil*, while remaining essentially the same in theme and concept, was modified in later showings in Toronto, California, and now here.

L7-L5

When Steven Spielberg's film *E.T.: The Extraterrestrial* was released in 1982, the story of the lost little alien who befriends a ten-year-old boy touched millions, but it only irritated Oursler. It struck him as "a trite simplification" of more complex ideas circulating in the culture as expressed by science fiction writers such as Philip K. Dick, Ursula Le Guin, and Robert Heinlein. "I felt Hollywood was taking the public's real interest in extraterrestrials and Disneyfying it. I had looked on science fiction as a new frontier where larger philosophic and metaphysical questions mingled with pop culture, a place where the imagination ran free, and so I was dismayed to see these notions codified, sentimentalized, and simplified in *E.T.* and the *Star Wars* films [1977, 1980, 1983]. With movies like *Star Wars*, the media was replacing fantasy with stereotypes. A lot of my interest in fringe- and subcultures comes out of wanting to give voice to people who function outside the mainstream, who break away from the pressure to conform to social norms. These people take culture into their own hands instead of having it spoon fed to them by whatever streamlined cultural manufacturers are out there."[12]

In part as a response to Hollywood's treatment of the sci-fi genre, Oursler set about finding someone who had personal experience with outer space phenomena. He placed an ad in *The Village Voice* that read, "Looking for firsthand accounts of sightings of UFOs or meetings with aliens, $15/hour paid for your story." As a result he met Gloria, a secretary who refused to be photographed, except for her hands, who told of her experiences with aliens. Oursler's videotape documenting Gloria telling and drawing what she saw is the centerpiece of *L7-L5*, a room-size installation with four components, first exhibited at The Kitchen in New York in 1984 (pp. 25, 58). L7 is 1950s hipster slang for someone who's "a square," and L5 is the location between the earth and the moon where an object can be placed in perpetual orbit. The reference is that as our culture, like science fiction, is increasingly simplified and commodified, independent souls will more and more be like square pegs that cannot fit into round holes. "The piece is basically subversive," Oursler notes. "It's about people trying to be heard, understood, and respected who don't fit the conventions of society."[13]

In a rudimentary model of a house, shards of glass reflect a TV monitor's video image: Gloria's hand drawing her bedroom as she describes waking up to two glowing figures, one very large, one gray (or dressed in gray), standing totally still. She gets out of bed and they dissolve into little squares of light before her eyes. She does not remember anything after that but wakes up in the morning and notices she has marks on her feet and a one-inch cut on the back of her leg. She goes on to describe other inexplicable puncture wounds and midnight apparitions of tall, broad-shouldered beings and hairy animal-like creatures in the weeks that follow, ending her account with the sighting from her bedroom window of a spaceship parked in the middle of her New York City street. Some weeks after these experiences, she sees the faces of two of the aliens in the newspaper; they turn out to be Houston serial killers who have tortured and murdered twenty-seven young boys. Gloria is convinced that these men are really aliens, but she knows her ideas sound crazy.

What to make of this testimony? Oursler reserves judgment and leaves the decision to the viewer, who probably alternates between thinking Gloria is mentally ill (or at least delusional) and giving some credence to her story. This is in part because her matter-of-fact delivery, tinged with a Brooklyn accent, and her admission that her story sounds nuts, make her seem "normal."

In addition to the shattered glass house and Gloria, who represents the true believer – someone who has actually experienced aliens – *L7-L5* has three other parts. Through a peephole in a cardboard casing resembling a video arcade game, the viewer can watch another reflected video of children playing with spin-off toys from movies like *Star Wars* or *The Return of the Jedi*. Oursler was interested in tracking introjection by observing the ways children – signifying the unwitting consumers and interpreters of Hollywood's science fiction – incorporate movie characters into their play. He found that they filter the films through their own sensibilities, personalizing the stories and imagining their own plots. Oursler notes, "Even though these movies are packaged in a conglomerate setting by studios, it's fascinating to me how they are changed by the individual, rein-

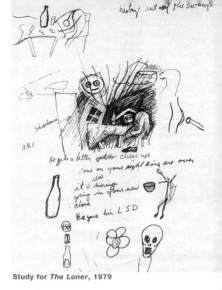

Study for *The Loner*, 1979

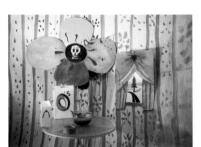

The Loner, 1980, production still

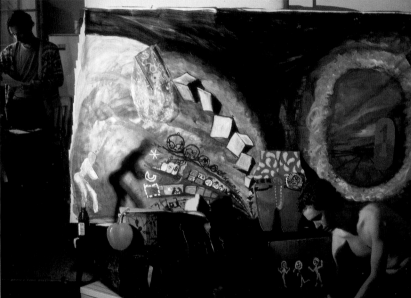

The Loner, 1980, production still

Grand Mal, 1981, production still

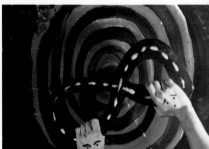

The Weak Bullet, 1980, production still

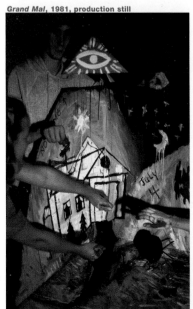

terpreted by memory and re-formed into something singular and idiosyncratic. This experiment showed a positive kind of absorption or introjection of media roles."[14]

The other elements of *L7-L5* include a TV image reflected onto a starry night sky, and an uprooted, upside-down flagpole flying a red and green American flag in which a TV monitor replaces the field of stars. The monitor's video contains a poetic parable – a battle between two colors enacted by Claymation figures: flesh, standing for humans; and green, standing for aliens. Formally, in *L7-L5* Oursler frees the moving image from the monitor by reflecting it onto glass or water. In this way he seeks to take the image off the screen to create a sculpture of disembodied television.

Diamond: The Eight Lights

The third early installation in this exhibition, *Diamond: The Eight Lights* (pp. 26–27), was part of a larger piece entitled *Spheres of Influence*, which was commissioned in 1985 by the Centre Georges Pompidou Musée National d'Art Moderne in Paris. The city of Paris is the setting for this multi-channel work, which centers on a soap opera/crime story about the trials and revenge tactics of the rejected and lovelorn. "A lot of the work that I have been doing throughout my whole career," notes Oursler, "has to do with media critique in one way or another. Traditional narratives are more about brainwashing than developing the brain or collaborating with the brain. *In Diamond: The Eight Lights* I looked at some of the clichés television uses – the soap opera, the sitcom, the cop show, the game show – these are all formulas that are repeated and which easily lead to a type of addiction. In other words, I believe media clichés have addictive qualities."[15]

In a critique within a critique, Oursler's anti-narrative video for *Diamond*, with music by Edward Primrose, is reflected from two monitors onto some forty small mirrors set at different angles into a template in the shape of a diamond solitaire. From a distance these reflected video images look like the glinting facets of a brilliant gemstone. As we draw closer, a fractured drama is revealed. The video begins with an off-screen narration that parodies the pseudo-philosophical baritone introductions to soaps such as *The Guiding Light* or *As the World Turns*: "When a heart is broken, a mind snaps, and a shattered world comes tumbling down around it. Reckless, reckless, caprice – right up to the end you can't hurt someone who no longer cares, but you can try.... If only there were a little guiding light." From there we are taken on a psychedelic ride through the aftermath of the breakup of a romance.

The rejected hero, who is gifted with paranormal/telekinetic powers, is able to visit his ex-lovers and experience their troubles. A series of mishaps ensue – he is falsely accused of murder and has no luck with a video dating service. In one scene a woman's disembodied mouth (p. 26) announces in breathy French, "I have returned... I have waited to take my revenge with your death." As others have noted, this isolated mouth recalls the character The Mouth in Samuel Beckett's 1973 play, *Not I*.[16] It is a motif that looks back to Oursler's interest in reducing a character to its most expressive minimum, and it appears again in

later works such as *Joy Ride* and *Organ Play* (p. 59), where a detached mouth struggles, as Beckett's does, to make sense of her experience.

Several other scenarios follow – including a "hate triangle" of three forlorn men walking backward in a circle – that relate to jealousy, gossip, and scandal. From this theme Oursler segues into a scene of a diamond mine, with a voice-over describing the unbearable working conditions, followed by an above-ground scene when we are told, "A symbol is needed, something rare and wonderful. And what better ambassador between now and the future than the versatile diamond. It is one of the strongest materials on earth, and when hewn by man it possesses extraordinary properties. The diamond's ability to refract light into a spectral array of colors is highly aesthetic.[17] Millions of people need these stones; they have attached a deep significance to them. But there is a conspiracy adrift on the winds of romance and finance." This portion of the narrative is accompanied by the image of a woman's hand sporting a giant cardboard "diamond" ring. In his typically splintered and imaginative way, Oursler points up the symbiotic relationship between the diamond industry and advertising – how together they manufacture desirability by promoting gems as status symbols and romantic collateral.

Meanwhile, those unlucky in love, who live in "cold and dismal apartments" nursing "broken dreams," turn to "the congregation at the TV show," where orgasmic dreams are rated and rewarded for their entertainment value. Here Oursler sends up "confession television" and the phenomenon of people revealing on shows like *Jerry Springer* or *Sally Jesse Raphael* intimacies that would normally be kept private. A machine that projects the thoughts of contestants at the moment of orgasm illustrates in the extreme the notion that pornography is not the exhibition of sex but the exposure of our most personal thoughts.[18] The philosopher Jean Baudrillard observes that obscenity occurs when everything is on display and nothing is private: "This opposition [between public and private space] is effaced in a sort of obscenity where the most intimate processes of our life become the virtual feeding ground of the media. . . . Obscenity begins precisely when there is no more spectacle [public space], no more scene, when all becomes transparence and immediate visibility, when everything is exposed to the harsh and inexorable light of information and communication. . . . Unlike the organic, visceral, carnal promiscuity, the promiscuity that reigns over the communication networks is one of superficial saturation, of an incessant solicitation, of an extermination of interstitial and protective spaces."[19]

In *Diamond: The Eight Lights* Oursler examines the phenomenon of television as surrogate family, friend, therapist, and confessor, a theme revisited later in the single channel videos *ONOUROWN*, *Toxic Detox*, and *The Watching*.[20] In *Diamond* he also probes just how impressionable or pregnable our consciousness and our most intimate zones are – how fragile our privacy – and he dissects identity as something we adopt by mimicking what we see on our screens. As Oursler continues to explore the nature of our relationship to a synthetically created society, media introjection remains a central theme.

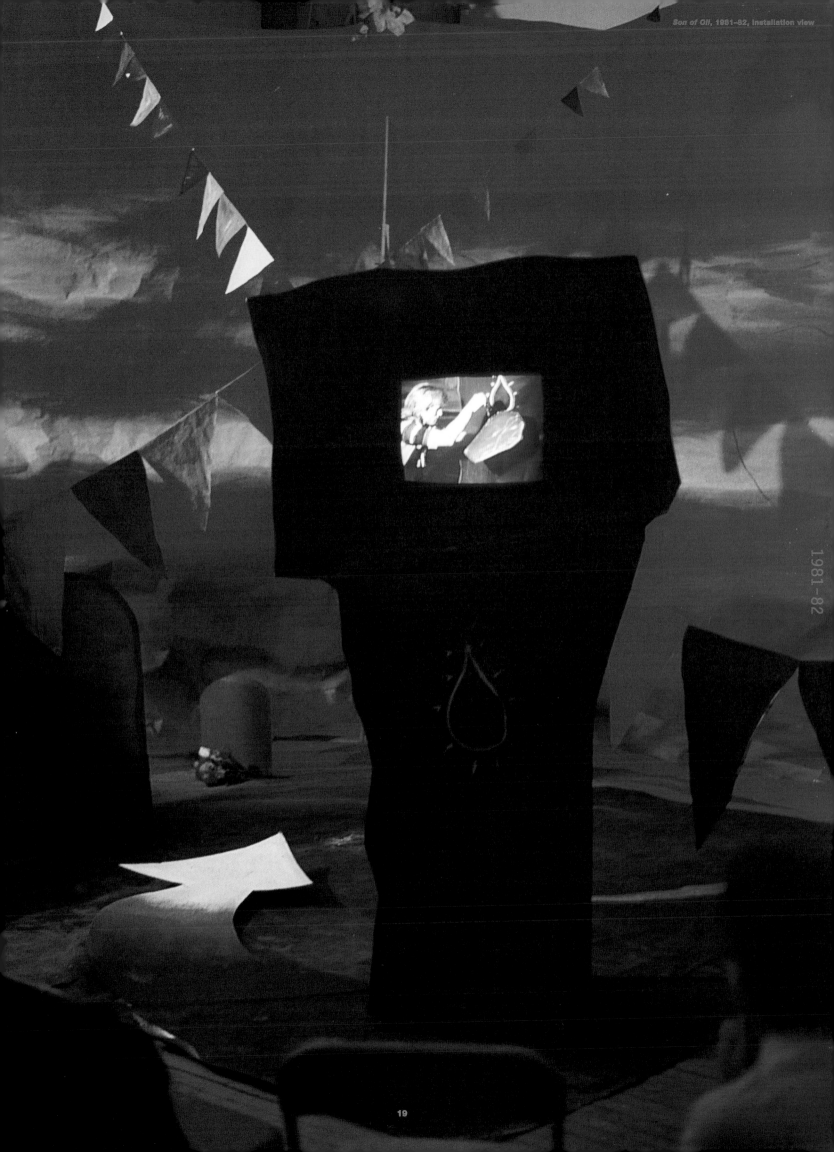

Chemical Introjection:
Kepone Drum and Molecular Mutation

In addition to exploring the idea of television as a drug to which we may became addicted, Oursler in the eighties became interested in other ways our minds and bodies are altered, invaded, or colonized. Acknowledging the benefits as well as the liabilities of chemical advances, he noted, "There is a fine line between a compound that can end up being good or end up killing you."[21] One area that absorbed him was environmental pollution and, by extension, the toxic effects of a number of man-made chemicals. Here he introduced another kind of introjection – that of one substance permeating and altering another. In the course of researching, Oursler was inspired by Rachel Carson's *Silent Spring* (1962), one of the earliest calls for public awareness and environmental action against the use of insecticides.

In *Kepone Drum* (1989) (p. 35), a fifty-five-gallon oil drum deceptively decorated with homey colonial American stencils of fruits and nuts leaks the deadly chemical kepone onto a simulated spill on the floor. This glass puddle serves as the screen for a video, projected from within the drum, that details the destruction of the town of Hopewell, Virginia, by kepone, a highly toxic chemical used as an insecticide that was produced there from 1966 until 1992. Noting that petrochemicals were redirected toward agricultural usage after being developed for the military during World War II, Oursler chronicles the breakdown of responsibility that resulted in the illness of thousands of Hopewell's citizens, as well as in the ruin of the town's fishing industry, the lifeblood of its economy. He reports as well how many townspeople resisted attempts to shut down the chemical factory in an effort to save their jobs and sustain the financial boom that kepone's production had created for the local economy.

Oursler's proclivity for research results here in a mini-documentary grounded in primary source material. Against an Ourslerized video backdrop of crude props and screaming heads, a printed text scrolls the information that in 1961 "kepone was demonstrated to be carcinogenic in male and female rats." In 1964 "experiments with quail show 'heavy' death rate, tremors" and other symptoms of poisoning. Yet despite knowing it was highly dangerous, Allied Chemical Corporation began manufacturing kepone at its Hopewell plant in 1966. In 1974 researchers concluded that kepone "interferes with the reproduction of birds and mammals." That same year Life Science Products, a subcontractor of Allied Chemical, produced 3,000 pounds of kepone per day in Hopewell.

In general, residents relied on the government and Allied Chemical to protect them, but like the sick and devastated townspeople of Woburn, Massachusetts, chronicled in Jonathan Haar's *A Civil Action*, their faith was misplaced. It did not take into account corporate greed or the arrogance and irresponsibility of regulating agencies and individual specialists who lacked the knowledge to anticipate and contain kepone's toxicity. As one kepone victim told his doctor, "I never believed that the government and state would allow something like this to occur. I believed them when Life Science told us it would not hurt us. . . . I went back to work." Such workers later suffered severe chest pains, abnormal eye movements, disorientation, and severe tremors known as the kepone shakes. In references to colonial America – the tape shows a demented fife and drum corps, an allusion to Archibald Willard's famous 1876 painting, *The Spirit of 1776* (p. 35) – the artist seems to draw a line between the drive for economic independence that galvanized colonists and the drive for short-term profits that motivates practitioners of the free enterprise system today; it's as though he asks, When did America move from a country of idealists to one of self-interested cynics?[22]

Molecular Mutation (1987–89) (p. 32) can be viewed as the other side of the "individual versus corporation" coin. Like the tale of David and Goliath run amok, the narratives relayed within this piece tell of individuals terrorizing corporate monoliths. Three video interviews are set into glass globes that are part of a diagram of a molecule mutating after being struck by ultraviolet rays. Two of the interviewees recount, in English and Japanese, incidents in which multimillion-dollar corporations were damaged by rumors of product tampering. One woman describes the Tylenol scandal that forced Johnson & Johnson to spend vast sums on repackaging after their painkillers were repeatedly tainted. Another person tells of the Gulico scare, when candy was contaminated as part of a plot to bring down the stock price of the Japanese candy giant. The third account looks into drug introjection and the way media can be personalized. A narrator tells of a friend who viewed *The Exorcist* while on LSD and believed that Satan moved off the screen to sit beside him in the movie theater. This person remained tormented by the devil until he was given another dose of LSD and taken to see *2001: A Space Odyssey*, which returned him to "normal."

Originally part of a larger installation entitled *Spillchamber* (p.33), *Molecular Mutation* merges Oursler's interests in toxicity, the individual pitted against corporate might, and the potentially destructive nature of rumor and legend. An insidious type of introjection takes place when trusted mass-marketed products are infiltrated and tainted. Similarly, rumor itself is viewed as a poisoning agent, and language as a potential means for destruction and mutation. As Philip K. Dick, one of Oursler's favorite science fiction authors wrote, "The basic tool for the manipulation of reality is the manipulation of words."[23]

As the progeny of literary forbears, Oursler has a healthy respect for the power of words. His grandfather Fulton Oursler Sr. wrote *The Greatest Story Ever Told*, and both paternal grandparents (his grandmother was Grace Perkins) authored books and screenplays. His father, Fulton Oursler Jr., was an editor at *Reader's Digest* for thirty-four years and now edits a magazine on angels. Tony writes most of the scripts for his single-channel and projected videos. In addition to writing essays, poetry, and dialogue, he often composes, surrealist-style, from found material such as phrases from a television show, questions from a psychological test, or a book's index. An example of his part scholarly/part whimsical style is presented in his optical timeline (p. 102).

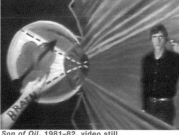
Son of Oil, 1981–82, video still

Blowout, 1981

Part II
Ground Zero

As Oursler's video techniques became more elaborate, he began to introduce human actors into increasingly complicated sets. This development is illustrated by *EVOL* (1984), which Oursler calls his Busby Berkeley video for its relatively slick production values, and *Joy Ride*, a 1988 collaboration with Constance De Jong. But he felt he had taken creating sets and props for his videos as far as he could and was ready to move in a new direction.

The single-channel video *ONOUROWN* (1990) (p. 37), made in collaboration with the artist Joe Gibbons, is without fabricated backgrounds or painted props and is basically an acted film. In it and its sequel, *Toxic Detox* (1992) (p. 47), Oursler and Gibbons play two delusional paranoids who are prematurely released from a mental institution due to budget cutbacks. Forced to live on their own for the first time, they make a video diary "about our struggle to exist in a crazy society." This footage, shot in an auto-documentary style, describes their encounter with real and imagined threats such as toxic Halloween candy, simultaneous castration fantasies, and murder plots. Oursler's fear of chemical contaminants plays out in a supermarket scene in which Joe injects poison into a carton of yogurt and then reads aloud the frightening ingredients on a package of candy.[24]

Later, in a scene that brings to mind William Wegman's 1974 video *Spelling Lesson*, Gibbons lectures his dog Woody (Oursler's dog in real life) about wasting time. Woody listens intently as Joe asks, "Did I ever talk to you about death? How old are you, four or five? You're getting on in years. You're feeling good now and you think it's always going to be like this. But you've got to make the most of it. You sleep too much. You need a project."

While Joe scolds Woody, Oursler is shown making phone calls trying to get a job. When asked if he could hold the line, he answers desperately, "No, I can't wait. I need a job and I need it right away!" Thoroughly unqualified and clueless, he tries for a position advertised as "a chance to meet and greet the elite." But when told it's a receptionist position, he balks, saying, "I was looking more for a business position."

Other delusions follow. The two begin to suspect each other – Tony sees the Underwood Devil in Joe's face, and Joe asks his television shrink, "Should I kill Tony? Should I put him back in the hospital?" In the end, what they believe to be personal counseling is actually a videotaped, platitude-laden pep talk from their doctor, played by artist/composer Tony Conrad.

ONOUROWN revisits familiar Ourslerian themes such as psychological malfunction, fear of chemical contaminants, and the phenomenon of television as surrogate family, friend, and therapist. In it and in *Toxic Detox* Oursler uses a standard narrative structure to film mental psychosis and neurosis. Instead of the fragmentation of his earlier videos, he uses a straight narrative to present fractured characters.

After *ONOUROWN* and *Toxic Detox*, Oursler felt he had gone as far as he could with single-channel video. He found himself at an artistic impasse, which he calls his personal "ground zero" in terms of image making. "I had a meltdown. The natural next step after almost feature-length videos like *EVOL* and *ONOUROWN* was to make movies. But by 1991 I decided that I

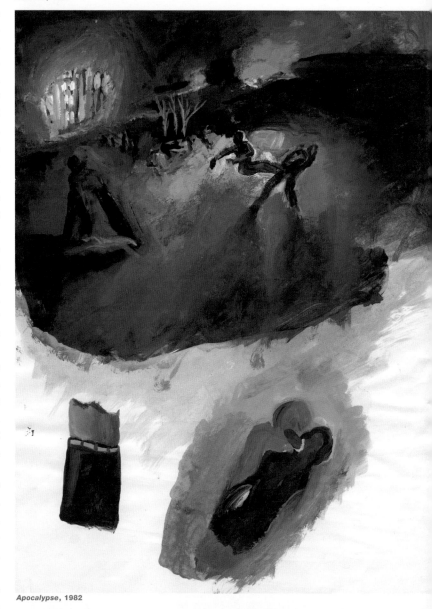
Apocalypse, 1982

Spinout, 1982, video still

didn't want to do that. Instead, I turned to sculpture and asked myself the biggest cliché in the art world – How am I going to make a figure? It was a bit overwhelming, but I had been prepared for this challenge by the whole learning process and experimentation that went into the previous ten to fifteen years of making videotapes, where I dealt with the issue of what constituted a figure or really the spirit of a figure."[25]

Instead of looking to classical art history, Oursler turned to folk and outsider art. "I had found this beautiful book of photographs of New England scarecrows, and that did it. . . . So I went to thrift stores and bought suits and tried a hundred different ways of manipulating them. . . . They were very Frankensteinian. I was stuffing and sewing figures, but the problem was that the elegance and movement inherent in the suits was convincing, but when I put faces to them, they became too static. So the first figures had no heads. (pp. 37, 41) I made them as surveillance pieces. There were these headless figures in the gallery and one had a lens coming out of its fly like a penis, another was draped over a monitor that was a closed-circuit system with camera. They were about power situations; one figure was watching and had the power of the camera. Another was seeing itself on the monitor. I did things like that until I discovered the miniature liquid crystal diode (LCD) projectors."[26]

The advent of the small video projectors led to a breakthrough for Oursler that enabled him to animate his scarecrow effigies and finally free the TV image from the monitor. The projection figures were uncannily convincing as living beings and entered viewers' minds much as TV characters do, but more effectively, because instead of being confined to a box, they inhabited real space. The effigies consist of a stuffed doll anywhere from ten inches tall to life size, suspended from a tripod or laid out on the floor, with a little projector a couple of feet away that throws a videotaped image onto the effigy's face. Oursler soon realized that his video creatures had enormous potential for arousing empathy – a goal that had engaged him from the beginning.

Crying Doll (1993, Metro Pictures) (p. 51) is Oursler's first experiment with this hybrid form that is both a physical object and a media object. He began by searching for someone who could cry indefinitely on command, and his friend the composer Stephen Vitiello suggested the actress Tracy Leipold, who had studied at the Actors Institute in New York and worked with the Wooster Group, a Fluxus-style free-form theater collective. She and Oursler developed an immediate rapport, and over time she has become his most frequent "lead."[27]

The first experiments were what Oursler terms "sublingual": they projected Leipold's face in a continuous, never-ending loop of crying, sighing, growling, laughing – i.e., emotions expressed without words. Oursler says, "I wanted to just take the most potent, most manipulative moment out of a narrative and put it in video to see if an audience would be affected by it out of context. I was trying to create an experience that bypasses language and directly penetrates the subconscious."[28] He also notes, "The emotive works came first. For me these works became the embodiment of the link between media and the psychological states it is capable of provoking – empathy, fear, arousal, anger."[29]

Earlier, in his single-channel videos, Oursler had dropped the use of narrative, replacing it with a more fragmented and nonlinear structure in order to pursue the cataloguing of emotional states.[30] Now, for his first projected videos, he further mined this vein, testing how we react to someone (on videotape) in distress – especially a tiny, helpless, and suffering figure. How long can we watch? How do we move into feelings of empathy and then out of them? How do we react when we come upon extreme emotional states but have no context or story with which to make sense of them? Oursler notes, "What makes the *Crying Doll* effective is its superhuman ability to never stop weeping, which in turn becomes horrifying for the viewer, who eventually must turn away. It is that moment of turning away which tests empathy."[31]

While the single-channel videos combine visual inventiveness with pop cultural and sociopolitical content, their convoluted structures and hermetic narratives can try the viewer's attention span. Oursler had come to realize that most people are not willing to stand or sit before experimental video installations in the same way they do for the mesmerizing images presented by commercial television and film. The non-narrative video-animated sculptures, which are without beginning, middle, or end, allow visitors to engage and disconnect from a piece at will.

The projected dummies were an immediate popular as well as critical success, making Oursler's work familiar to a much larger audience. Requiring less viewing stamina and patience than the earlier videos, they tapped into the fascination we innately feel for puppets, dolls, ventriloquist's dummies, and automata. Such mannequins provoke doubts about "whether an apparently animate being is really alive; or conversely, whether a lifeless object might not in fact be animate."[32] Through the uncanny simulation of life they surprise, captivate, and frighten. The *uncanny*, usually defined as "fear caused by intellectual uncertainty," is what most viewers of Oursler's "dysfunctional peanut gallery"[33] experience as the mental rug is pulled out from them; first they are unsure whether his creatures are living or not, then they subliminally question what it means to be alive in the first place.

Oursler's video personae are part of a long tradition of automatons, dolls, and dummies from both the high art and popular sectors.[34] Medieval polychrome statues of saints that could weep, and eighteenth-century automatons that could write are but two examples. Dada and surrealist practitioners such as Marcel Duchamp and Hans Bellmer capitalized on the fetishistic potential of dolls, while waxworks and store mannequins aimed at verisimilitude. The explosion of artists today who use human surrogates – as opposed to classical representations of the human figure – is in part a response to hyperreal technologies such as virtual reality, cyber sex, cryonics, and even plastic surgery. Artists such as Charles Ray, Robert Gober, Kiki Smith, and Cindy Sherman, as well as Oursler, seem to be inquiring into society's desire for artificial transformation and its influence on our culture as we approach the twenty-first century.

The Watching

The Watching (pp. 48–49) was originally shown in 1992/93 on five landings of the stairwell at the Fridericianum, as part of the international art exposition Documenta 9, in Kassel, Germany. An enigmatic and complex work, it uses both the earlier headless surveillance effigies and the new LCD projection technology. It takes as its theme the movie industry's preoccupation with sex and violence. Oursler has noted, "Our culture is obsessed with the whole horror-sex-violence thing. It's a weird form of refinement, like bonsai; it has a ritual dimension. Whether the media is performing a positive service for the public or whether we are involved in some kind of sick cycle, I don't know. But we love to watch it, and I'm obsessed by the fact that we love to watch it."[35] *The Watching* not only is about film – it actually unfolds cinematically. As the viewer walks up or down the staircase, the point of view changes, and each element of the piece is gradually revealed.

The two main protagonists in *The Watching* are movie insiders. *F/X Plotter*, the main male character – suspended close to the ceiling (pp. 45, 48) – is a special effects expert who describes the plot of a high-tech sci-fi thriller, pausing to relate the way each gruesome effect is achieved. *Sex Plotter* (p. 49), the main female character, is a set decorator/art director for a different film – a generic lover-comes-back-from-the-grave romance. Her "shrunken head" contrasts with *F/X Plotter's* overblown one, and as Oursler has noted, she "appears to be melting like the wicked witch in *The Wizard of Oz*."[36] She also owes something to the distorted figures of Picasso's drawings from the teens and twenties, in which a figure's large legs seem to be a city block away from its pin-size head. As these characters describe in uninflected tones fictional movies and how certain effects are achieved, the viewer imagines each scene and fills in the blanks of the sketchy plot lines. This conceit for *The Watching* grew out of Oursler's feeling that it is often more interesting to hear someone tell about a movie than actually to see it. Again the idea funnels into his desire for our relation to media to be interactive instead of passive. He says of the project, "When a viewer visualizes scenes in his/her head, a real collaboration takes place. I felt my job is not spoon-feeding images but having the viewer do some of the work."[37] A reaction to the industrial monolith of the film industry is also implied in the personalized, idiosyncratic description of the films.

Other elements of this complicated piece conjure a variety of movie tropes: science fiction aliens in *Instant Dummies* (add water, and these foot-long glass capsules stuffed with scrunched-up clothes, a wig, and a dildo look as if they might expand into synthetic humans); mob or horror movie murders in *Bucket of Blood*; and high tech robotics in the mechanical *Effigy Eye* that "watches" a movie of a burning figure projected onto the wall in the shape of a cross. Additional components include *Model Release Forms*, painted on fabric, similar to those on pages 51 and 53. Using the language of standard legal documents, Oursler indicates that in signing away the rights to their images, models and actors may be signing away more of their identity than they bargain for. *Chain of Figures* consists of swaths of red thrift-store clothing hanging twenty feet from the atrium cross-

The Lovers, 1984, prop for the video *EVOL*

EVOL, 1984, video still

Animal Circle, 1984

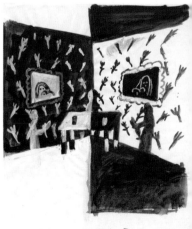

what's wrong with Picture?
Madonna and Child – Mirror, 1984

walk. Like the pile of shoes, clothes, and bric-a-brac in "The Place Where Lost Things Go" in *Fantastic Prayers*, the 1999 CD-ROM by Oursler, DeJong, and Vitiello, these used garments bring to mind specific eras and memories. In this case, their redness evokes blood and lust in keeping with *The Watching*'s sex/violence theme, while their 1940s and 1950s provenance evokes the *Black Mask*–era detective fiction of Raymond Chandler and Dashiell Hammett. *Reflecting Faces*, two TVs painted silver, provide reverse images of three circles that read as a rudimentary face, indicating "an empathetic feedback bond." In Kassel a television monitor on the top floor was wired to a surveillance device on a lower level that allowed users to watch, listen, and talk to visitors without their knowledge. A similar surveillance system, part of another piece entitled *Judy*, serves the same function in this installation.

Watching and being watched are dominant themes in Oursler's work. The hypnotic viewing of TV or cinema, when we passively absorb what is on a screen, contrasts with active viewing through surveillance devices, when we observe or are observed by someone screened from sight. In Oursler's paranoid world view, both states may threaten individuality through fostering conformity. He not only questions what is being programmed into our brains while we sit mesmerized by moving images but, conversely, asks questions about who is monitoring our lives – finding out how we spend our money, what our political views are, the kind of medical care we seek, and so forth. Thus, both watching and being watched constitute potential intrusions into our collective psyche and individual identity. Through the panoptic technologies created in the last half century, we may have unwittingly sacrificed a critical human need – privacy.

The Watching, however, is not a dreary discourse about the evils of the media. Instead it possesses a Halloween mock-goulishness that mixes fun with creepiness. Typically for Oursler, elements of play and creative childlike activity are used to produce a cinematic tableau that poses open-ended questions as it involves participants in media issues. As Regina Cornwell has written, *The Watching* "allows for the play of the imagination, puzzling together the props, sometimes under the watching eye of a camera. . . . What unfolds in its space does so over the course of our own time and in whichever order we choose to attack it. Oursler gives us no answers and allows us to construct our own scripts from the props and fragments, as well as the space in between, which he makes available to us."[38]

Keep Going

In the life-size effigy *Keep Going* (1995) (p. 62), Oursler continues to explore the idea of suggestibility in the form of a character describing situations that the viewer then recreates in his/her mind. A mismatched plaid suit hanging limply on a tripod provides the armature for a pillow head onto which is projected an unscripted videotaped performance by Tony Conrad. Using facial expression and lens distortion to great effect, he takes on the role of a megalomaniacal Hollywood-style movie director who constantly changes his mind while barking out impossible commands. In the space of twenty minutes he calls for an erupting

volcano, a wheat field on fire, electronic hail, an alien landing, a train/bus crash, alpine horn music emanating from trees, and the script line "rhubarb, rhubarb, rhubarb." In quick succession our brains conjure this series of incongruous and ridiculous scenarios. For example, Conrad – his eyebrows shooting upward in perpetual alarm or consternation – orders the romantic leads to kiss. As we begin to visualize this, he screams, "No, not each other! Kiss the thing!" What are we to visualize now?

Conrad is brilliant at lampooning American filmmakers' addiction to pyrotechnic special effects; after the volcanic eruption is not sufficiently stupendous, he tries a train/bus crash and an alien landing. Nothing seems to meet his grandiose expectations, and he maniacally alternates between poking and stroking his crew – "We have to get some energy going today, people! There's nothing happening here. . . . You incompetent boobs, I'm going to fire you all. . . . No, I take it back. You people are good. You stick with me, and I know I change my mind. I love you. . . ."

With *Keep Going*, Oursler moves further toward his goal of active audience involvement. At times viewers have been seen attempting to carry out Conrad's directives. Children in particular have responded to his commands to "Be quiet!" "Don't look at me," and "You, yes, I'm talking to you, move to the left." Humor, a constant in Oursler's work, dominates this piece, which holds audiences captive through its playful hilarity.

Six

Sustaining the watched/watching theme are six oversized eyeballs projected onto white spheres about fifteen inches in diameter; these eyes hang on wire at varying heights from the ceiling or rest in a pile on the floor (p. 71). They dart and stare, disconcertingly blank and without emotion. At first people generally feel discomfited, even violated, by the giant eyeballs gazing at them. It takes closer inspection to realize they are watching not us but TV. The reflection of a televised image can be seen in each of the eyes, further convoluting the watched/watching theme and creating "a self-referencing cyclical loop."[39] As often happens with his trial and error method of creating, *Six* (1996) turned out differently than Oursler expected. "Eyes are always talked about as being the mirror of the soul, and I expected them to be expressive. But when you tape just the eye, disembodied from other facial features, it is totally blank. It looks cold and reptilian. Seen alone, the eye comes across as a light-measuring organ devoid of emotion, like a camera."[40]

Each of the six eyes is watching a movie having to do with dissociative identity disorder (DID) – formerly known as multiple personality disorder (MPD) – which some experts believe may be media-influenced. *The Three Faces of Eve*, released in 1957, is reflected in one eye, the made-for-television movie *Sybil* in another, and *Doppelgänger* in a third. Oursler has always been interested in mental illness. Multiple personality disorder struck him as the perfect mirror of our channel-surfing culture, in which morphing via clothing, hairstyle, and plastic surgery is a commonplace of modern life. As Oursler has said, "MPD was a metaphor for a postmodern persona. . . . If you look at the works of Cindy Sherman or the career of David Bowie, or pick up a

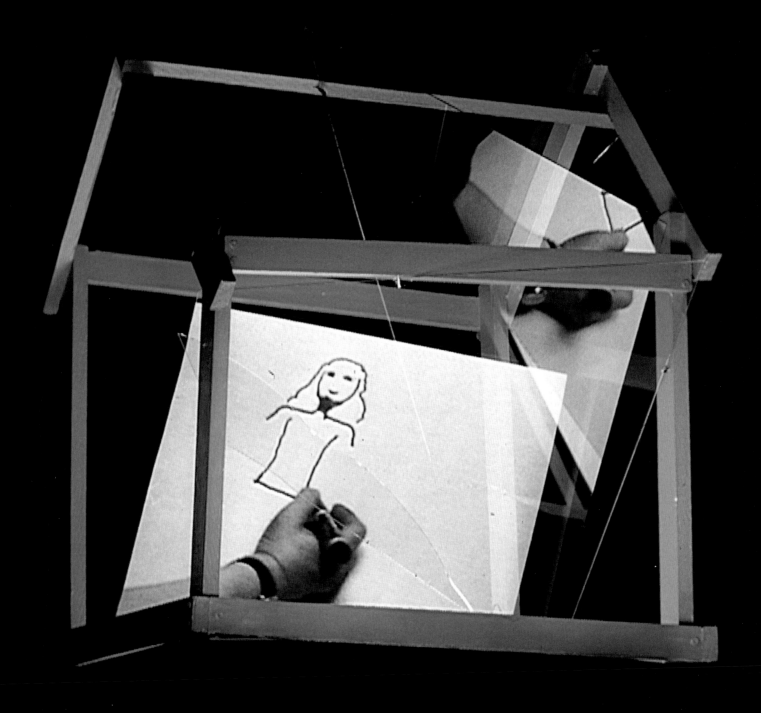

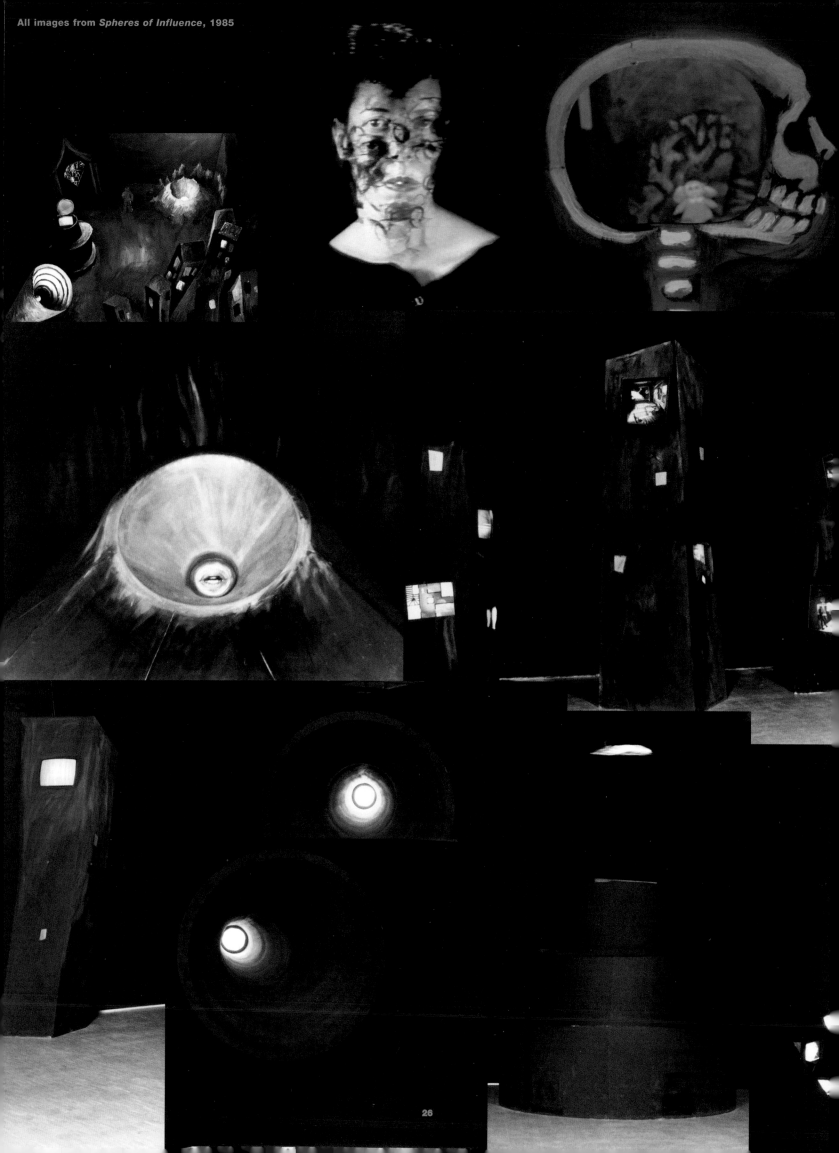

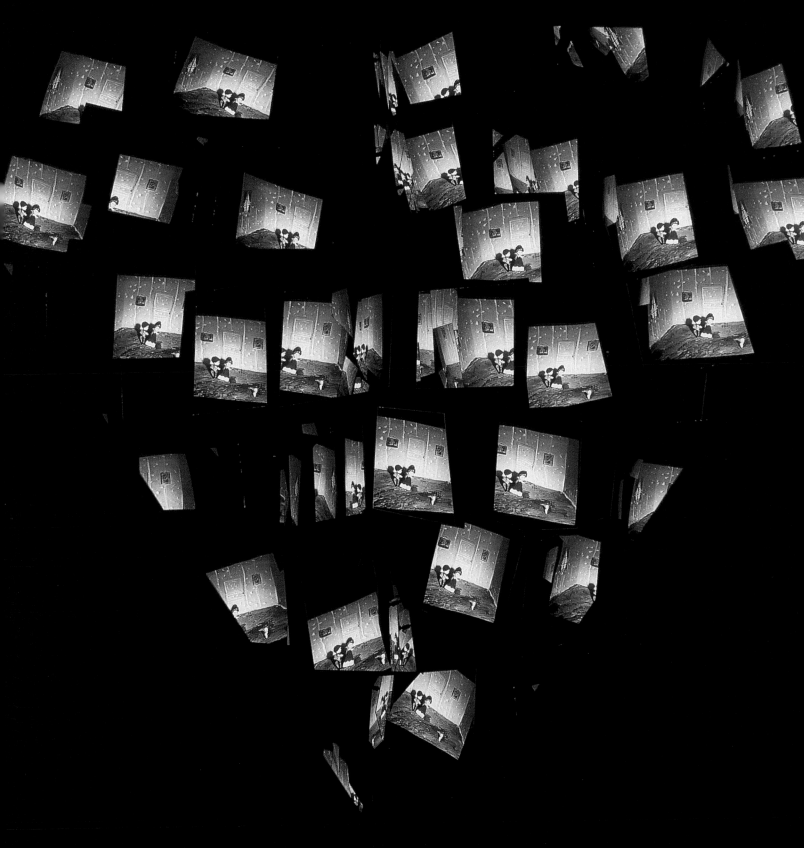

1985

tabloid newspaper featuring stories of repressed memory and ritual abuse, or pick up the remote control . . . and switch from station to station, you begin to understand the ubiquity of MPD."[41]

Six, which examines the feedback system of seeing and processing imagery, prompted Oursler to further research optics and the history of media structures, beginning with the camera obscura. This investigation into the mechanics of reproducing reality continues in *Optics*, the most recent piece on view in this exhibition.

Judy

After interviewing Gloria for *L7-L5* in 1983, Oursler gradually became interested in studying mental disorders. *Judy* (pp. 55–57), initially shown at the Kunstverein in Salzburg, Germany, in 1994, was Oursler's first work to grow out of his research into dissociative identity disorder, and it remains among his most powerful works to date. DID or MPD is a psychosis (some say pseudo-psychosis) diagnosed in victims who claim to have experienced extreme violent, sexual, or psychological trauma, usually in childhood. These people develop other personalities or alter egos to protect their "core self." Although the installation is a composite of many cases Oursler studied, *Judy* is the name of an actual MPD sufferer who reported, "I only experienced isolation as I flew above the room, watching below me as the invaders tortured the bodies of the other children I had created so that I could survive."[42]

Arranged on a diagonal in the gallery, a feminine but trashy-looking flowered décor contains a number of characters or "alters" (short for *alternative personalities*) that express and recount the trauma that caused Judy's personality to split. The benign flowered fabrics belie the violence and terror that takes place in the domestic setting. The trail of gaudy floral fabrics, including a pile of clothes, a curtain, a couch, and an armchair, works both as a transition between the personalities and as a passageway into Judy's world.

First encountered, hung from a tripod, is the victimized *Horrerotic Doll*, a fifteen-inch-high stuffed effigy which, terrified, screams endlessly. Similar to *Crying Doll* but a step up in development, the *Horrerotic Doll* differs in that she is not totally "sublingual," or nonverbal. Using the expressive face of Tracy Leipold, the doll-sized figure looks around in abject fear of unseen dangers, sometimes contorting her face in utter torment while she screams and wails laments such as "Oh no! No, not that! Oh God! Noooo! Stop!" It does not matter that the means of animation, the projector, is in full view; she is still convincing as a suffering being, and serves as an empathy test in her own right. Below her lies a tiny doll's dress that seems to stand for Judy's diminished self. Next along the diagonal line is a large pile of shapeless clothing, perhaps suggesting an amorphous identity.

A flowered yellow curtain separates this group of three from the next section. Here a bouquet of artificial flowers is attached to a tripod onto which is projected the contemptuous face of *The Boss*, also enacted by Leipold. With her mouth projected over the stamen of a lily, this alter takes on the persona of an abuser who shames and defiles while yelling orders and threats such as: "Eat this! Eat this now!. . . I got you, you little bitch. I said take it

off. . . . You disgust me. God, you are stupid, you're an idiot. You're a worthless piece of shit." After moaning and groaning as if experiencing an orgasm, *The Boss* threatens: "Don't tell anyone. Remember what I said would happen. I'll just do it again and no one will believe you. You can't tell anybody. I'm going to stick your head in the toilet again. I'm going to get the hairbrush again. I'm going to stick the hairbrush up your ass – you know I will." After about twenty minutes of such chilling vilification, the tape loops so that the torrent of abuse is relentless and unending.

Next to *The Boss* under a raised couch lies *Fuck You*, a deflated figure that emits a constant stream of obscenities. Its large "pillow" head, attached to a limp pile of flowered clothing, mutters angrily but powerlessly, trapped by the couch, the lack of a body, the inability to move, and the projector that is its existence. The incongruity of being accosted by a figure that is at once aggressive and impotent makes the encounter both amusing and disquieting. It is analogous to the urban experience of coming upon a ranting homeless person. As in that situation we must decide, should we be afraid? should we try to help? or should we just walk on – the usual choice.

Next to the couched *Fuck You* stands *Fetal Figure*, a headless scarecrow effigy wearing a garish, hot pink muumuu onto whose belly is projected the nude figure of a writhing woman in a fetal position, turning and twisting as if in a pool of amniotic fluid. She suggests that even in utero Judy was distressed and traumatized. Oursler's use of an adult figure is especially poignant, poetically suggesting that Judy's unfortunate fate or future was determined before her birth. Hanging from the ceiling above *Fetal Figure*, a pair of little girl's flowered leggings is suspended upside down. They bring to mind one of the tortures Hattie Dorsett inflicted on her daughter, recounted in Flora Rheta Schreiber's book *Sybil*. According to the book, which some believe is apocryphal, Mrs. Dorsett would fill Sybil's bladder with water and then string her up by her feet.

The final element in *Judy* is a remote-control camera hidden in the body of an effigy situated outside the gallery. Viewers are invited to sit at a table in the installation and manipulate the hidden camera – in effect a surveillance system – and talk through the speakers to unsuspecting museum visitors. Termed "a simulacra system" by Oursler, this device tends to bring out "hidden personalities" in its operators who, screened from sight, often jeer, harass, and insult those in the camera's view. The fact that users act in ways outside their normal behavior demonstrates that we all have alternative sides to our personalities that only await the right opportunity to emerge.

In *Judy*, Oursler again seeks to engage viewers as active participants in his art. His empathy-inducing dolls and effigies go one step beyond the figures in *The Watching* or *Keep Going*, who relate narratives that viewers can visualize. Upping the ante, he elicits in *Judy* a visceral response to the suffering or abusive video-animated characters. Moreover, the remote-control surveillance device is entirely viewer-activated, providing a game-like, hands-on experience that is still rare in a museum setting. But on a deeper level the hidden camera and microphone encourage firsthand insight into the mechanism of personality change.

MMPI (Red), Let's Switch, and Side Effects

MMPI (Red), *Let's Switch,* and *Side Effects* are three other projected-video sculptures that deal with dissociative identity disorder. Oursler responded to the phenomenon of someone's being able to shift from one character to another in part because it fed into his long-standing interest in demonic possession, paranormal states, androids, and other identity introjection themes embodied in horror and sci-fi genres. Some of these fascinations, such as possession, can be traced back to Oursler's Catholic upbringing, with its emphasis on mysticism and the supernatural. Since there is a debate within the psychological community about whether or not DID/MPD is a media-generated disorder, his interest in the illness also ties into his obsession with probing the way humans are connected to media systems. Oursler has come to the conclusion that TV and film do not cause but can stimulate and amplify natural human tendencies to create alter egos. These tendencies are in effect "internal mirrors of media structures" and have the potential to spawn multiple personalities.

Since the premiere of the film *The Three Faces of Eve* in 1957, reported cases of multiple personalities have skyrocketed from a handful to thousands. More startling, the number of alters or personalities identified by DID sufferers has also increased, mirroring the proliferation of channels offered to television viewers. Whereas Eve had three alters, today it is not uncommon for those afflicted with dissociative identity disorder to report fifty or more; the switching from one persona to another invites comparison to channel surfing. Further, these added personalities often echo television "types" – another example of media introjection in which identity is absorbed from TV or film. Oursler quotes the philosopher Ian Hacking, "The alters are typically stock characters with bizarre but completely unimaginative character traits, each one a stereotype, or one might say TV-type, who readily contrasts with all the other characters."[44]

Oursler does not necessarily see multiple personalities as a disorder; rather he is open to viewing MPD as an alternate model for the mind and behavior – a survival mechanism that allows for change and variety. Along these lines, he notes that *The Three Faces of Eve* can be viewed today as a proto-feminist film, in which Eve White, a bored farm housewife, is able to break out and enjoy life only through her "bad girl" alter, Eve Black.[45] Thus, dissociated identities can be liberating in addition to reflecting our nonlinear, multi-informational age.

Oursler's early interest in multiple personalities was fueled by a copy of the Minneapolis Multi-phasic Personality Inventory owned by a friend. The MMPI is a test for dissociative identity disorder, and in *MMPI (Red)* (1996) Oursler recites its contents in a videotape projected onto a seventeen-inch doll in red pants and top whose head is wedged under a red chair (p. 71). People taking the test are asked to judge the statements true or false, but Oursler delivers the lines in such a way that one is not sure whether he is actually making statements about himself or asking questions. Spoken in a monotone with about fifteen seconds between each line, some of the forty-four true/false statements are: "I'm a moody person." "Loud noises scare me." "I never remember things the way others do." "I like to chat with

on shelf: *Black Light Props* from *Spheres of Influence*, 1985
on wall: *Organic Brain Damage*, 1985

Constellation Intermission, 1987

Constellation Intermission (detail), 1987

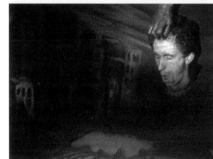

Sucker, 1987, video still

Psychomimetiscape, 1987

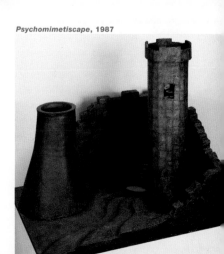

strangers." "Trouble seems to follow me." "I'm a happy person." "For me to succeed, others must fail." "I would describe my family as a disaster." "Sometimes I cannot tell the difference between my daydreams and reality."

Oursler says about the MMPI test, "What I enjoy about the attempts to codify the human mind, as in the MMPI test, is that it offers a direct way to engage viewers, which is always a goal of mine."[46] Listening to the questions, visitors can't help wondering if they are passing or failing the test. At the same time, the little doll, with its deadpan delivery and off-base facial expressions, is both funny and touching.

The same is true for the twin stuffed dolls that stand closely together, one with its arm around the other's shoulder, in *Let's Switch* (1996) (p. 63). The flowered clothes key us into their gender – in Oursler's iconography, floral patterns are for females, while checked, plaid, or monochrome clothing indicates males. Tracy Leipold plays both characters, literally a split personality, but they also bring to mind *Persona*, the 1966 Ingmar Bergman film in which two characters, played by Bibi Andersson and Liv Ullmann, switch identities. "I'm ready, bring on the pain," says one. "Shut your face, quiet!" replies the second. Rolling their eyes at each other and making faces, they continue the verbal volley of non sequiturs, and at some point in the dialogue they do seem to swap mannerisms and tone of voice. "I'd like to rip the wall down between us," says one. "I have parts of me I've never been introduced to," counters the other. They continue alternating: "Together we don't even make one person." "Let's switch." "I've got big plans for us, okay? Stick with me." "How can you tell the difference between me and you?" Some lines in the script, which was written by Oursler, derive from questions on the MMPI test: "I have to do these things to others to feel good about me." "I come out when there is a nasty job to be done." "I'm in no way crazy."

Oursler's little "Mini Me" dolls are endearingly cute and less scary than the larger effigies. Sitting atop tiny handless and footless bodies, their faces – bereft of hair, ears, and neck – are affectingly homely. With these smaller video-animated sculptures Oursler deliberately taps into the tender feelings of care and protection that dolls traditionally arouse. Even though the little dolls can have nasty personalities, the empathetic bond that he is always looking to stimulate is readily forged between them and the viewer.

The larger-scale *Side Effects* (1998) (p. 87) has no such charm. In this more complex work, Oursler orchestrates a single fifteen-minute tape of Tracy Leipold's face onto five fiberglass "heads" of varying sizes that are attached to a metal candelabra-like armature. The projections are different colors so that two of the heads are red, two yellow, and one green. The challenge for Oursler was editing the tape so that five different emotions are enacted simultaneously. With its angry and anxious faces, darting eyes, gnashing teeth, and voices talking all at the same time, viewers may well feel like they are in a psychiatric ward. But Oursler's initial impulse was to make visible an interior mental state – i.e., to show through head size the pecking order among one person's multiple personalities. Indeed, the sculpture conveys what it might be like inside a DID sufferer's brain where five alters bicker and vie for dominance.

The piece is open-ended enough to accommodate other interpretations. One viewer was reminded of what happens before going to sleep, when some thoughts elbow out others as they flutter through semi-consciousness. Another person conjured a room of TVs and radios, all tuned to different stations, where only snatches of sentences could be discerned.

Leipold varies her delivery in *Side Effects* so that her voice changes from high to low, slow to fast, calm to agitated. Since there is only one tape that is spliced to overlap, the tendency of viewers to try to peg one face to a certain voice and characterization is thwarted. For example, the high, babyish voice may be thought suitable for one of the smaller heads, but at times a larger head will speak that way.

While more complicated in this sense than the single-face effigies, in another way *Side Effects* demonstrates Oursler's evolution toward a more pared-down aesthetic. Instead of an effigy in limp drapery, the five video-animated heads float free, without drapery or bodies. The plain metal scaffold links the work to 1960s minimalism. In its "molecular," diagram-like form it compares with Oursler's chemical mutation pieces such as *Molecule Spectre* and *Molecular Méliès*. Reinforced by its drug-related title, *Side Effects* combines two of Oursler's interests – chemically induced abnormalities and psychological ones. Introjection is again the connecting thread in terms of substances or influences that can penetrate and alter our environment as well as our physical and mental selves.

Getaway #2 and Insomnia

Getaway #2 (1994) (pp. 60–61), perhaps Oursler's best-known projection sculpture, epitomizes the character that tries ineffectually to assert itself to an indifferent world. With her pillow head trapped under the corner of a single-bed mattress and a floral bed jacket and pajama bottoms spread out on the floor behind her, it is no wonder this figure mutters and rants discontentedly. The head is comprised of the projected video image of Tracy Leipold's androgynous face appropriately squashed where cheek meets floor.

Art critic Peter Schjeldahl describes the work: "The face simmers with disconsolate fury at the injury of its helpless condition and the insult of being trapped in public view. Occasionally its restless eyes fix the visitor and it speaks, 'Hey, you. Get out of here. What are you looking at?' After pausing for mournful reflection, it tries again. 'I'll kick your ass,' it hazards with measured venom but not much conviction, as is understandable under the circumstances." Schjeldahl goes on to describe his reaction, "Even realizing that the looped tape speaks whether anyone is nearby or not, I couldn't shake a sense of being addressed personally. I caught myself retreating out of intimidated respect for the creature's feelings. Then I had to laugh at myself. I went back – get a grip Peter! – and sat on the floor to contemplate my own emotional response, a tossed salad of pity and fear."[47] This is precisely the reaction Oursler hopes for.

Getaway #2, with *Judy, MMPI (Red)*, and *Let's Switch*, marks the next step in the development of Oursler's video-animated sculptures, a transition from sublingual or nonverbal emoting to scripted delivery. In *Getaway #2* the figure demonstrates a form

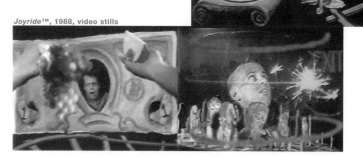

Joyride™, 1988, video stills

of paranoia. She brings to mind the kind of obsessive inner monologue exhibited by urban neurotics who often punctuate their mumbling to themselves with lashing out at hapless passers-by. People laugh at this piece in part because of the odd (uncanny) sensation it elicits: knowing that the head under the mattress isn't alive but somehow feeling it is. Also, there is something sadly funny about helpless characters who live on the edge of nonbeing, asking useless questions, powerlessly giving orders, and threatening violence; the result is a strange mix of farce and tragedy. Oursler shares with twentieth-century writers such as James Joyce and Samuel Beckett a feeling for the downtrodden, eccentric, and forsaken whom they nonetheless manage to make funny. They all are what the scholar Robert Bell calls "jocoserious" – humorous, but with a dark twist.[48] As a character in Beckett's *Endgame* says, "The funniest thing in the world is human unhappiness."

Insomnia (1996) (p. 67) is another small doll, this time with a green cast to its face, that arouses laughter and sympathy. Lying on its side, princess-and-the-pea-like atop a pile of six pillows covered with worn, flowered pillowcases, the tiny fourteen-inch dummy complains, between stream-of-consciousness meandering, about not being able to fall asleep. This scenario, which most viewers can identify with, accurately mirrors the frustration and panic interwoven with fragmented silly or scary thoughts that often accompany sleeplessness. Wearing avocado green and lavender floral pajamas, the doll, once again animated by Tracy Leipold, opines, "I'll never get to sleep. I'll be here forever and ever and ever and ever and ever. . . . " These phrases, which are repeated in high and low whispers and moans, punctuate other discontinuous thoughts: "Try not to think of it." "Cheer up, laugh a little, it won't kill you, will it?" "Are you the bad man?" "Here's some scenes from the next episode." "Oh, that smells good. Is it perfume or nature?" "Get off of me." "Call the police." Leipold flips through a repertoire of voices and inflections that conjure different interior states of mind from childlike to agitated to cynical. She recites a number of girls' names, becomes frightened, has night thoughts of intruders and asks anxiously, "Hello? Who is it? Who's there?" gets angry and chants the word "fight," and then tries to calm herself by repeating slowly, "breathe in, breathe out." After spending time with this piece, the viewer may feel like an unmade bed, rumpled and exhausted.

Underwater (Blue/Green)

The sensation of being trapped that is common to many of the video-animated sculptures is taken to an extreme in the *Underwater* series (p. 63). In them a disembodied fiberglass "head" submerged in a small tank of water is projected with a face struggling to hold its breath. The submerged heads manifest yet another kind of phobia and offer another kind of "empathy test." Viewers usually have a hard time looking at them longer than they can hold their own breath, and turn away gulping for air. One critic wrote, "The face, desperate for air, puffs out its cheeks, moans through closed lips and looks upward towards freedom. It is only an illusion, but the urge to reach into the tank and rescue this poor disembodied head is overwhelming."[49]

continued on page 34

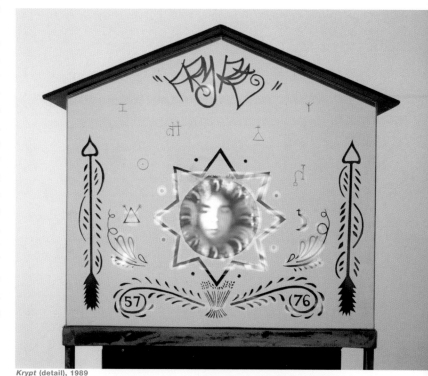

Krypt (detail), 1989

Krypt (detail), 1989

Krypt Kraft, 1989, installation view

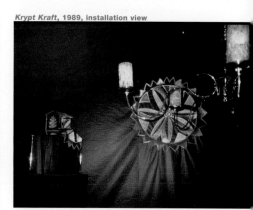

Krypt Kraft: Nutley, New Jersey, Road Map 1, 1989

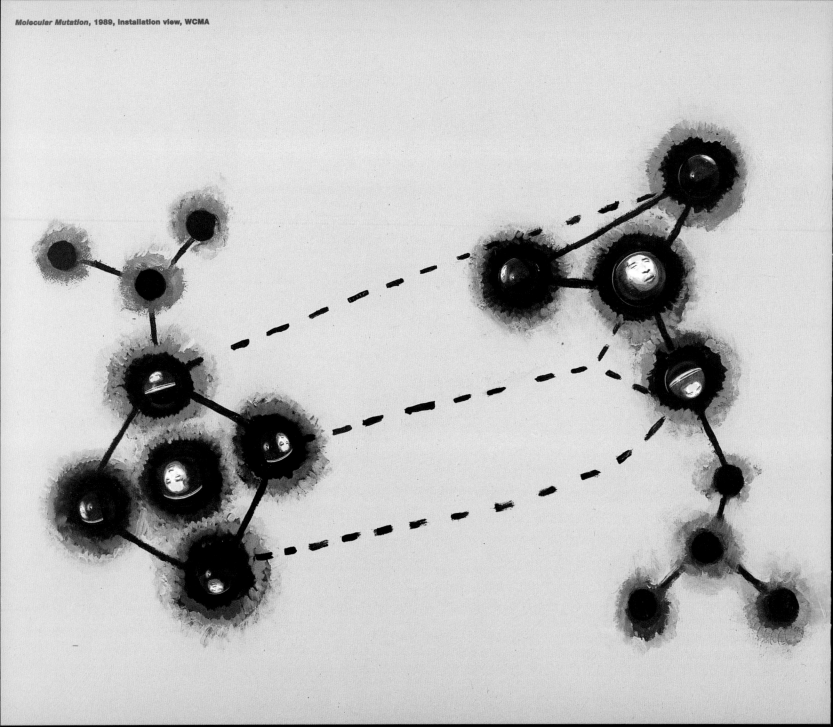

Spill Chamber I: The Product I, 1987

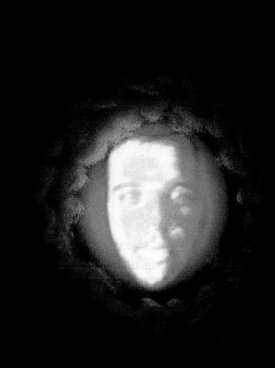

成 分

GLYCERIN, POTASSIUM CHLORIDE
SODIUM CHLORIDE, (MONBASIC AND
DIBASIC) WATER, EDETATE DISODIUM
0.05% AND BENZALKONIUM CHLORIDE
0.01% ARE ADDED AS PRESERVATIVES.

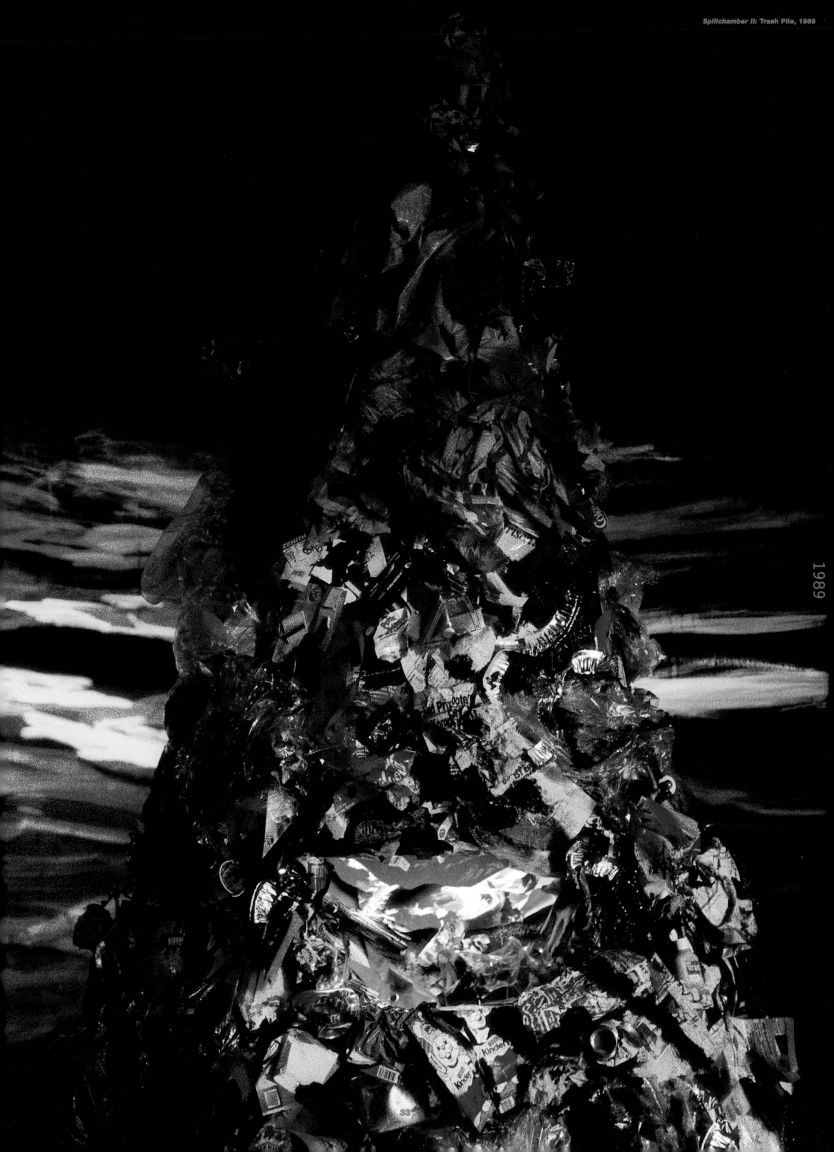

1989

In Oursler's world every affliction has its comical aspect. Here fear and spookiness are mitigated by the goofy facial contortions of the suffocating head (performed by the artist himself). The combination of slapstick humor and weird psychological terror in Oursler's body of work links him not only to Beckett and Joyce but to visual artists like Bruce Nauman and Cindy Sherman.[50]

The blue light blanketing the face of *Underwater (Blue/Green)* (1996) emphasizes the sensation of being submerged, chilled, and alone. It is details like this that not only contribute to the formal elegance of Oursler's work but also buttress its psychological effectiveness. It is the type of esthetic distinction that marks even the disjointed mismatch of grunge, thrift-store finds, folk art, and performance that characterizes the early props and the first projected-video effigies.

Composite Works

Molecule Spectre (1999) (p. 75) is an homage to early cinema. Like *Molecular Méliès* (1997) (p. 75) the work reflects the discovery of early filmmakers "that film need not obey the laws of empirical reality, as the first motion pictures had supposed, because film was in some sense a separate reality with structural laws of its own."[51] Taking this notion to an extreme, Oursler projects onto the different-sized nodules of a "molecular" armature a video collage that includes landscape footage, TV static, and close-ups of eyes and lips. These "impossibilities" that compress near and far, part and whole, attest to the magic of the medium, something Georges Méliès (1861–1938) and the unknown maker of the silent feature *The Red Spectre* realized early on. They were among the pioneer moviemakers who saw that the camera might be used to make the fantastic and the impossible appear real, rather than simply to record actual events passing before its lens. Oursler's regard for these trailblazers is understandable, since their most memorable productions concern the outlandish and bizarre. And like Oursler's videos, Méliès's films are acted out before inventive phantasmagoric backgrounds that he himself designed and painted.[52]

Formally this piece relates to *Side Effects* in its diagrammatic armature, and to *Composite Still Life* in its combination of close-up and distant shots. The vertical mouths present in both works (presaged in Picasso's oeuvre of the 1920s) create an unsettling image – the *vagina dentata* (vagina with teeth), a symbol of castration anxiety in Freudian analysis.[53]

Research has always comprised a large portion of Oursler's method. For earlier projects his interviewees ranged from government and corporate spokespeople to alleged abductees of aliens. Later he delved into writings, tests, and personal accounts related to mental disorders. More recently he has spent time researching the history of illusion and mimetic technologies. *Composite Still Life, Aperture*, and *Fear Flower*, all from 1998–99, are his personal response to the classic forms of still life and landscape representation – painterly illusions that utilized the camera obscura and other visual reproductive devices. In typical Ourslerian fashion, however, a gruesome and nightmarish spin is placed on these standard genres.

The multiple personalities of dissociative identity disorders

and the multiple voices of schizophrenia are given visual form in *Composite Still Life* (1999) (p. 91). The piece consists of a large white fiberglass skull, with one eyeball protruding from its socket, that is creepily brought to life by a mélange of projected faces and facial features. On the one hand, it harks back to seventeenth-century Dutch *vanitas* still lifes, in which a skull was the cue to thoughts about the fragility of life and the inevitability of death. But it also conjures up a scientist/cinematographer gone mad – Dr. Frankenstein on LSD – shrinking and then splicing a full face next to enlarged muttering lips, huge teeth, and a detached eye to create a living collage that is at once beautiful and terrifying. Not only is the human form violated, but its parts are out of scale and dislodged from their proper place. Thus, a bared set of teeth sits vertically on the skull's cheek, while an upside-down mouth speaks from atop its forehead.

Like Cindy Sherman's photographic series of dismembered dummies combined with prosthetic devices and props, *Composite Still Life* takes to a disturbing extreme Oursler's musings about identity in the age of morphing, cloning, and mutating. Both Oursler and Sherman depict unthinkable variations on the theme of shifting mutable selves, while challenging what is sacred (nothing, apparently) in the representation of the human form. In this way, their video and photographic montages look back to the pasted collages of artists such as Picasso and Hannah Höch, in whose work of the 1910s and '20s the rules of proper human scale and placement of features were first flouted.

The meaning of *Composite Still Life* is left open-ended. It can read not only as a horror film/science fiction experiment in hybrid surgery but as a physical manifestation of an interior psychic battle. It also accommodates the idea of ghosts returning from the dead to "squeak and gibber" their tales. One thinks of Hamlet encountering the ghost of his father, who intones, "I could a tale unfold whose lightest word would harrow up thy soul, freeze thy young blood, make thy two eyes like stars start from their spheres."[54]

Aperture (1998) (p. 93) also depicts a still life. Here the theme is kissing. The artist has arranged atop a plywood table a motley group of kissing "couples" consisting of objects covered in white plaster: a gargoyle and a skull, a saccharine cupid and a kitsch figurine of a kneeling nude, an écorché head used to teach anatomy and a ball-type mask, a fragment of a face and an egg, and a cherub lying face down, its lips pressed to a decorative rosette. Projected on the wall behind them is the silhouette of a large fly that annoyingly crawls around the screen, and a lens opening – the aperture of the title – also in motion, through which snippets of television programs are glimpsed. In addition, a text projected onto the wall rapidly scrolls disjointed phrases such as "These objects create a retinal image, in order to recognize the objects a relationship must be perceived . . . Be still, unburied we meet again, instantly whither fly invisible spirits . . . Beelzebub . . . Lord of the Flies . . . Camera obscura . . . Corpses did not linger some I know through yon dark grave . . . Light passes through . . . I give myself a pretty little sarcophagus . . . You must be from hell."

The phrases suggest themes of love, death, and illusion but remain enigmatic. In his personal cosmology Oursler associates

flies with the devil. An early drawing of flies bothering a young boy is accompanied by the lines, "One fly can cause more trouble. Zzzzz. Sent from the devil, all from Hell, so earatating [sic]." "Earatating" is a play on "a fly in the ear." The words "Beelzebub" and "Lord of the Flies" in *Aperture*'s projected text thus refer to Oursler's perception of the evil nature of flying insects.

The text for *Aperture* consists of random phrases taken from the index and bibliography of Walter Kendrick's 1991 book, *The Thrill of Fear: 250 Years of Scary Entertainment* (New York: Grove Weidenfeld). In his cribbing of "ready-made" texts from unlikely sources, Oursler looks back to dada and surrealist poetry.[55] Like dada poetry, the lines nevertheless resonate with Oursler's characteristic mix of introspection and black humor. The latter is injected through the kissing of incongruous figures and also through the fragments of popular television shows seen through the projected aperture – talk show host Charles Grodin, a 1950s crime re-run, someone demonstrating a Stair Master, a weather report, a cartoon, and so on. It is probably not accidental that one of the film fragments is a mobster flick with Edwin G. Robinson, leading us for a television moment to see the plaster figures as bestowing on each other the Mafia's infamous "kiss of death."

Fear Flower (1999) (p. 95) reprises the fleurs de mal motif seen earlier in *Judy*, *Getaway #2*, *Let's Switch*, and *Insomnia*, where floral patterns deceptively mask sinister conditions. Here, luscious lavender flowers are filmed close-up and projected large-scale onto a wall. The camera homes in on a bee flitting from one flower to another. The bee may fall into the category of menacing insects that, like flies, are to Oursler symbols of evil. Standing in front of the wall, looking like a docent describing a big modern painting, an effigy wearing a flowered dress is propped on a tripod. In fact, she recites numbers and phrases that coalesce around the physiological response in animals to fear. Quoting from evolutionist Charles Darwin's observations, the figure drones, "Terror causes the body to tremble, the skin grows pale, sweat breaks out, and the hair bristles. The secretions of the alimentary canal of the kidneys are increased and they are involuntarily voided. Charles Darwin, 1872." Again performed by Tracy Leipold, the video-projected face of the effigy speaks in a robotic, nasal monotone, punctuating the delivery with the repetition of "zero, zero, one, one, zero, one, zero, one" like some secret code.

Talking Light

Talking Light (1999) moves further in the direction of minimalism and provides a distillation of the essential Oursler – simultaneously funny and disquieting, paranoid and empathy inducing. Set into one of a line of museum light sockets, a green bulb pulsates to the vibration of spoken text. Museum visitors are in turn surprised, frightened, and amused to hear a deep droning voice address them as they leave the bathroom. Naturally, they wonder if someone has been watching them while they were in there. A deep voice and light emanating from above evoke not only Big Brother but also visions of the Almighty. The actual script, however, is not that lofty; the speaker whines and moans, making us feel either sorry for him or annoyed.

Relatives, 1989, video/performance in collaboration with Constance DeJong

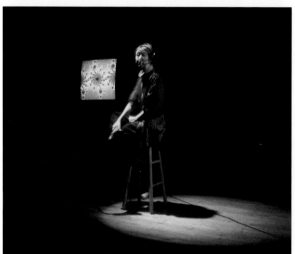

Relatives, 1989, video/performance in collaboration with Constance DeJong

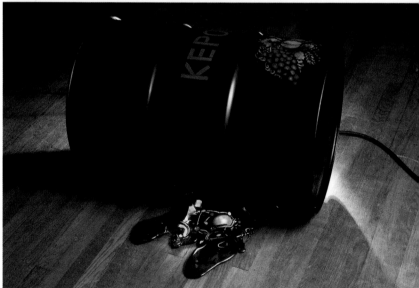

Kepone Drum, 1989

Kepone Drum, 1989, video production still

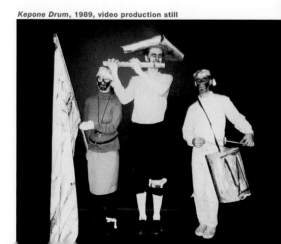

Optics

Optics (pp. 97, 99–101), a multi-part installation, marks a new direction for Oursler. It is an imaginative rumination on the origins of media through the harnessing of light for visual reproduction. Another example of what results when this subculture artist goes to the library, *Optics* provides a mystical and poetic spin on historical information (see Oursler's optical timeline, p. 102). For *Optics* Oursler researched the development of optical devices that over centuries have evolved into film, television, and video. Through various elements, described by Laura Heon in her essay (p. 96), Oursler traces the popular distrust of television, which has plagued the medium since its inception, back through time to medieval experiments with the camera obscura, which according to thirteenth-century manuscripts was seen as the work of the devil.

Glass devils set beside light fixtures pepper the gallery, making literal the biblical connection between Lucifer ("light bringer") and light. And they do behave devilishly. One casts a hazy red glow on the adjacent wall, conjuring up hell's fire and brimstone (pp. 3–4). Another appears to be crawling into a utility lamp, impishly leading one's eye directly into the blinding glare (p. 99). *Optical Timeline* (p. 101), a video of the artist twisting as his body is digitally distorted – now elongated like taffy, now compressed like kneaded dough – is projected onto a glass screen. It is mesmerizing to watch the figure's transformations as it moves through a pipe-like labyrinth, bringing to mind the distorted nudes of the photographers André Kertész or Bill Brandt. At times the body morphs into a skull as it is pulled and pushed along its path. It turns corners quickly, slows down, disappears, and then, Cheshire Cat–like, shows up somewhere else. Through all this, the viewer is simultaneously enchanted by the pure beauty of the imagery and disquieted by the sense that the figure has no autonomy but rather is being jerked and manipulated by larger forces.

Conclusion

The mutable pushed-and-pulled animated figure in *Optical Timeline* can be viewed as a metaphor for the loss of control over our minds and bodies that is the logical denouement of introjection. Modern technology has led us to a point of vulnerable permeability; we are open targets for all manner of co-option. As one critic has noted, Oursler's "message is that there's no such thing as a whole, intact person anymore. People who haven't been colonized by video have had their bodies invaded by aliens or ancient demons; by toxic chemicals or candy that's deliberately been poisoned."[56]

Oursler delivers this message, however, with a light touch. His own empathy for bumbling humanity, so apparent in person, also informs his work. The handmade, cobbled-together look that characterizes his oeuvre, even the high-tech CD-ROM *Fantastic Prayers*, reveals an affectionate regard for Planet Earth in all its makeshift, haphazard confusion. That affection extends to its clueless and eccentric inhabitants, particularly those who creatively improvise life against the grain. Alternating between moments of subtle insight and broad humor, Oursler leavens his warning of introjection, and the

diminution of the human soul that may result, by creating works that at once amuse, distress, and enthrall. In his tutorial at the elbow of mass media, he has learned well how to entertain his viewers. His audience pays attention and, wittingly or not, absorbs the message.

1. Tony Oursler, interview by author, 8 January 1999. It is worth noting that cable television is increasingly challenging network media monopoly. The Chicago cable show *The Awful Truth* opens with the announcer saying, "By the end of the millennium five men controlled the media," as we see Rupert Murdoch, Michael Eisner, Ted Turner, Sumner Redstone, and Bill Gates on top of a spinning globe.
2. Lynne Cooke, "Tony Oursler: ALTERS," *Parkett* 47 (1996): 38.
3. Oursler, interview by author, 8 January 1999.
4. Tony Oursler, interview by Mike Kelley, January 1999.
5. Oursler, interview by author, 8 January 1999.
6. Tony Oursler Biography, Electronic Arts Intermix Web site, http://www.eai.org.
7. Tony Conrad and Constance DeJong, "A Conversation between Constance DeJong and Tony Conrad," in *Tony Oursler: Dummies, Clouds, Organs, Flowers, Watercolors, Videotapes, Alters, Performances and Dolls*, Friedemann Malsch, ed. (Frankfurt: Portikus; Strasbourg: Les Musées de la Ville de Strasbourg; Geneva: Centre d'art contemporain; Eindhoven: Stedelijk Van Abbe Museum, 1995), 6.
8. Oursler, interview by Mike Kelley, January 1999.
9. Oursler, interview by author, 8 January 1999.
10. Tony Oursler, "Video Is Like Water," interview by Simona Lodi, in *Tony Oursler*, ed. Simona Lodi (Milan: Edizioni Charta, 1998), 23–24.
11. Tony Oursler, interview by author, 1 September 1999.
12. Tony Oursler, interview by author, 20 January 1999.
13. Ibid.
14. Ibid.
15. Oursler, interview by Mike Kelley, January 1999.
16. Ian MacMillan, "Expressway to Your Skull," *Modern-Painters*, spring 1998, 78.
17. Compare to Oursler's current interest in properties of light (rainbows, prisms) explored in *Optics*.
18. I am grateful to Mark C. Taylor for this point. Author's conversation with Taylor, 5 May 1999.
19. Jean Baudrillard, "The Ecstasy of Communication," in *The Anti-Aesthetic: Essays on Postmodern Culture*, ed. Hal Foster (Port Townsend, Wash.: Bay Press, 1983), 130–31.
20. For more on this issue, see Gertrud Sandqvist, "Privat," trans. Michael Garner, *Parkett* 37 (1993).
21. Tony Oursler, interview by Mike Kelley, January 1999.
22. See John Miller, "Tony Oursler, Diane Brown Gallery," review in *Artforum*, October 1990, 164.
23. Philip K. Dick, "How to Build a Universe That Doesn't Fall Apart Two Days Later," 1978 essay for IHISAS, reprinted on http://www.id-online.de/ufo/pkdhowt2.htm.
24. This incident relates to Oursler's series of enlarged boxes of *Poison Candy*, first shown at Diane Brown Gallery, 18 September–30 October 1992.
25. Tony Oursler, conversation with author.
26. Louise Neri, "In the Green Room. Tony Oursler and Tracy Leipold in Conversation with Louise Neri," *Parkett* 47 (1996): 22. These dishrag surrogates find modern art precursors in Jim Dine's *Green Suit* of 1959 and also Joseph Beuys's *Flannel Suit* of 1970, in which there is a psychological resonance to clothes hung on scaffolding without the presence of a body.
27. For more on Oursler's collaborations with Leipold, see Sidney Lawrence, *Tony Oursler: Video Dolls with Tracy Leipold, 2 July–7 September 1998* (Washington, D.C.: Hirshhorn Museum and Sculpture Garden, Smithsonian Institution, 1998).
28. Tony Oursler, lecture at Hirshhorn Museum and Sculpture Garden, May 1998.
29. Elizabeth Janus, "Towards a Pyschodramatic Grammar of Moving Images: A conversation with Tony Oursler and Elizabeth Janus," in *Tony Oursler* (Bordeaux, France: capcMusée d'art contemporain, 1997), 121.
30. MacMillan has noted in his article "Expressway to Your Skull" that "Oursler's projected videos dispense with storytelling and parable in favor of experiential methods of dealing with the world. . . . In accepting that things keep changing without a satisfying, determinist ending – it's about the human condition."
31. Lodi, 25.
32. From E. Jentsch's essay, "Zur Psychologie des Umheimlichen," quoted in Sigmund Freud, *The Uncanny* (1919), 132.
33. Hartley Shearer's term.
34. See Mike Kelley, *The Uncanny*, Sonsbeek 93 (Arnhem, Netherlands: Gemeentemuseum, and Los Angeles: Fered Hoffman, 1993) for a survey from ancient times to the present. I am grateful to Linda Shearer for calling this publication to my attention.
35. Neri, 22.
36. Tony Oursler, public lecture at Williams College Museum of Art, 29 May 1999.

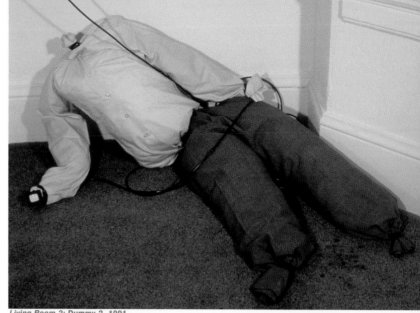

Living Room 2: Dummy 2, 1991

37. Oursler, conversation with author.

38. Regina Cornwell, "The Watching, 1993," in *Tony Oursler: Dummies, Clouds*, 49.

39. MacMillan, 79.

40. Tony Oursler, public lecture at Williams College Museum of Art, 29 May 1999.

41. Lodi, 26.

42. Tony Oursler, "Judy, 1994," in *Tony Oursler: Dummies, Clouds*, 12.

43. Ibid., 12.

44. Ibid., 12, quoting Ian Hacking, *Rewriting the Soul: Multiple Personality and the Sciences of Memory* (Princeton: Princeton University Press, 1998).

45. Tony Oursler, lecture at Hirshhorn Museum and Sculpture Garden, May 1998.

46. Janus, 121.

47. Peter Schjeldahl, "Get Out of Here," *Village Voice*, 29 November 1994.

48. See Robert H. Bell, *Jocoserious Joyce: The Fate of Folly in Ulysses* (Ithaca: Cornell University Press, 1991).

49. Sarah Ward, "Review – Tony Oursler at Metro Pictures," *Art in Context*, Center for Communications Web site, http://www.artincontext.org/artist/o/tony/commentary_and_reviews.htp, 17 May 1996.

50. See Michael Kimmelman, "Tony Oursler," review in *New York Times*, 3 May 1996.

51. See David A. Cook, *A History of Narrative Film* (New York: Norton, 1990), 15.

52. Ibid., 16.

53. See Robert Rosenblum, "Picasso and the Anatomy of Eroticism," in *Studies in Erotic Art*, Theodore Bowie and Cornelia Christenson, eds. (New York: Basic Books, 1970).

54. William Shakespeare, *Hamlet*, act 1, scene 5.

55. For example, Tristan Tzara composed directly from newspapers and billboards in an effort to subvert literary pretense and romantic notions of genius and inspiration. His famous "recipe" for a dada poem calls for cutting out words from a newspaper, shaking them in a paper bag, and taking out each cutting one after the other to create an "infinitely original" poem. Recounted in Mark Polizzotti, *Revolution of the Mind: The Life of André Breton* (New York: Farrar, Straus and Giroux, 1995), 145.

56. Christine Temin, "Oursler's Video Take on Life," *Boston Globe*, 16 July 1999, sec. C, p. 1.

Deborah Rothschild is curator of exhibitions at the Williams College Museum of Art.

Johnny Apple Treats, 1991, from *Poison Candy Series*

ONOUROWN, 1990, in collaboration with Joe Gibbons, video still

Heroin, 1991

3-Methylfentoanyl, 1991

Anhedonia, 1991

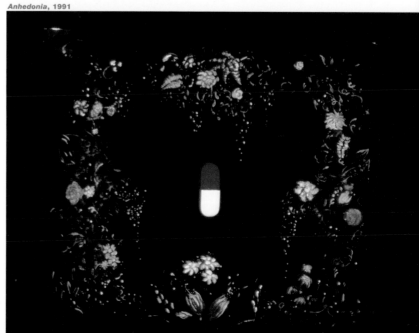

1990-91

an endless script:
a conversation with tony oursler
by mike kelley

Mike Kelley and Tony Oursler met as students at the California Institute of the Arts in the late 1970s. During those years they frequently collaborated on installations and performances, including The Poetics, a group formed by a number of younger artists at Cal Arts, and *X Catholic*, a performance at Beyond Baroque in Los Angeles in 1983. Kelley appeared as an actor in several of Oursler's early videos, including *Son of Oil* and *EVOL*. The Poetics was recently the subject of a two-person exhibition by Kelley and Oursler first presented at Documenta X in Kassel, Germany, in 1997 and later in Tokyo, Japan, at the Watari Museum of Contemporary Art, and in New York at Metro Pictures and Lehman Maupin galleries. It will be shown in January 2000 at the Centre Pompidou in Paris. Recordings from that period have recently been released by Compound Annex and Ludlow Street Records.

Mike Kelley: Let's start with how you were introduced to video. When you came to Cal Arts as an undergraduate student, you were a painter. Were you being shown artists' videotapes in your classes?

Tony Oursler: Let me start at the beginning. My mother, Noel, would take me to see all of the museums in the New York area. My grand-aunt Zita Mellon also taught me painting. I also studied with Korra Raffose at Rockland Community College. He took me under his wing and sort of saved me from myself and sent me to Cal Arts. When I arrived there I believed that painting was everything – everything could be translated through painting. My first-year teacher, John Mandell, questioned everybody's motives. Kids came in from whatever part of the country with all of their preconceived ideas about what art was.

John stressed content over form. It was a real revelation to discover that certain ideas were better translated through particular mediums. I started to think a bit more critically about why I was painting. The school provoked me to explode into other forms – photography, film, installation, music, performance, whatever – with a certain desperation, I may add. I realized that I had a very pop aesthetic. The medium I was attracted to in terms of pure pop was television, not in terms of content but for its vast potential. I didn't really watch television much then, but was very interested in it as a societal unifying factor. By chance I had seen the original broadcasts of some of Chris Burden's TV spots in my parents' basement but had no idea who he was – great! As fate would have it, as a teenager I was friends with the Breer family, and the artist and animator, Robert Breer, was very kind and showed me some of his films and Pat O'Neil's. I was blown away. This is the first time I realized that moving images could be art. But at Cal Arts, I think John may have taken me down to the Long Beach Museum of Art on a field trip to look at videotapes in their video library, where I later met curator Kathy Huffman, who was very important to the whole SoCal video scene. I remember, particularly, that the Kipper Kids made a huge impression on me. These guys were doing this completely insane stuff in jock straps, and it was okay to call it art. Around that time, I found out that the school had a video camera.

I was fascinated by the technology. Video seemed to fit my hyperactive state of mind. It was something that I could play back instantly, like an audiocassette. Instant access to a pop space that was unattainable, that was reserved for another part of culture.

MK: You mean television?

TO: Yes, actually getting into the box itself.

MK: Even though television is considered a populist and thus a "low" medium, psychologically it is an extremely exalted one, since the common person has no access to it on the level of production. The invention of the portable video camera, which is a relatively recent event, has done little to alter this conception.

TO: TV is a magical world – off-limits to the average person. I loved television as a kid; in my childhood memories, television is this incredible thing. But it is also a hollow, cold place – that's

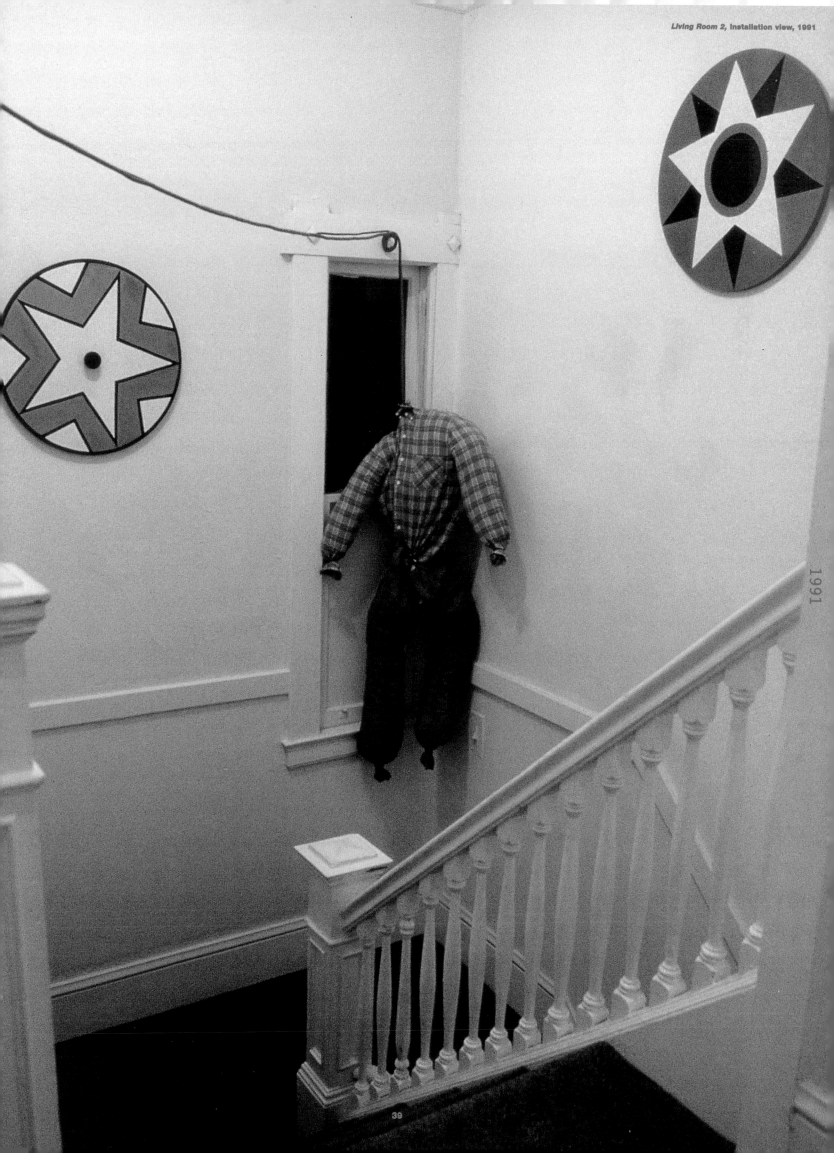

the beauty of it, the duality. I remember thinking that things were so real; the deaths – how could they get people to die for the camera? In my child's mind I thought actors were prisoners on death row and given a chance to die in, for example, a cowboys and Indians drama, instead of in the electric chair. Now this has come true; with reality TV you can see lots of snuff TV. It's all connected to the ubiquitous camera; between surveillance and home video there is an endless stream of material, yet always separated from the producer. You are allowed on if you are the production, as in exhibitionist "basket case" culture such as the *Jerry Springer Show*. Read a model release form sometime.

MK: But why else would those people go on that show and reveal themselves like that? Television must still be a super-ritualized space. People are willing to do anything to get into the box. They will commit murder just to get on TV.

TO: Or die trying.

MK: At Cal Arts you were doing different kinds of tapes. You were making tapes that were overtly narrative and evocative of television melodrama, though in a kind of puppet show manner, but you were also making tapes that had more in common with "art video." Those were shorter and often had sculptural overtones. They documented studio play, somewhat in the manner of early William Wegman or Bruce Nauman. Was your first tape *Joe, Joe's Transsexual Brother and Joe's Woman*, which is a kind of ironic melodrama, or were they the short, more playful and experimental tapes that later became parts of *Life* and *Good Things and Bad Things*?

TO: I'm pretty sure that the first ones were experiments – were about finding out what happens to things visually when you put the camera on them. Making images that moved. The very first thing I noticed about those early video cameras was the grainy, almost mystical space that they produced; they turned everything into a homogenized field of gray, very somber and beautiful. You could almost see the machine turning reality into shimmering approximation of itself. You could see the gray grain appear – just barely able to do justice to what it received through the lens. The first Portapak, which is what I was using even though they were ten years old at the time, transformed things in a way that made them look hyperreal, because they worked in real time, yet at the same time mutable, because it was a very low-resolution image. When things moved, they left these wonderful trails, streaks across the picture.

MK: Old black and white reel-to-reel videotape does have a ghostly, far-away quality. It's spooky looking.

TO: I realized the medium lent itself to easy image alteration. I would put a little bit of paint or tape on something and the camera would read it in the same way as the wall behind it – masking tape became dry wall. That really interested me, that I could collapse space like that; space was completely malleable. That

was the thing that I really loved about video right from the beginning: a shitty bucket with some fish and plants in it could look almost like a Japanese print. A lot of the graphic ideas that I had played with in my paintings were adapted to video, a mix of all sorts of styles and levels of symbolism. I also began to play with voice, sound and music, and narrative. I did see Wegman's tapes and other artists' video, but I was also looking at a lot of film. I took in every film I could. I was particularly attracted to Georges Méliès....

MK: What about it attracted you, that it was frontal and pictorial?

TO: One could argue that once an image is mediated by the camera it is frontal and pictorial, but also that it was about psychological states, about fantasy images instead of documentary concerns. Also, I saw the production of sets as a literal translation of the painter's quest, from the layered baroque stage to the simple props of early [Christian] Boltanski. I liked the use of sets in Robert Wiene's *The Cabinet of Dr. Caligari*, and also the early anonymous hand-tinted films such as *The Red Spectre* that were connected to magic shows and vaudeville. On film, they were able to perfect the theatrical effects they wanted to do in the theater but couldn't: guys levitating, heads coming off, explosions, going to different planets, killing devils.... I see all media as being involved with the willing suspension of disbelief on the part of the viewer that does not end with the formation of the image – it continues into endless levels of interpretation. So it seemed that inviting the audience to be involved with that right from the beginning by mixing the artifice of sets and live action was a way of pushing that.

MK: What about the fact that *Joe's* . . . [1976] is overtly a comment on the violence of mass media? The voice-over goes on and on about sex and violence and chastises the viewer for needing to be entertained. Was this influenced by some kind of media discourse present at Cal Arts while you were there?

TO: I think that it was the tone of the times. People were really concerned about the impact of the new American cinema: Sam Peckinpah and people like that who were really getting into this baroque violence. And there was concern about the amount of time that people were spending watching television. These incredible statistics were coming out about how much time people were spending in front of the TV. It was evident that TV was a major force, wildly successful and out of control. I wanted to make an artist's TV show so it should play with the sad icons and narrative elements of TV, and let them implode.

MK: In looking at *Joe's*. . . I feel that you are somewhat equating deconstruction with destruction. Your method of revealing the clichés of conventional narrative is through extreme oversimplification. The "drama" unfolds in front of a non-moving camera, the characters are standard dolls, postcards represent the scenic locales, and the narrative consists primarily of an increasing level of destruction. As the action progresses, the figures are literally torn to pieces. By the end of the tape there's

nothing left but a bonfire of parts. Another aspect of the tape that I find interesting is its vestigial nod to the "performative." All we see of you is your hand moving the props about, but you have a cigarette in it the whole time. It gives it a sense of "character," as if your hand itself is a dirty stand-up comic. I liked how that performative mannerism was evoked through such limited means. I thought that was very clever.

TO: A lot of things came together in that tape, the start. Dolls.... this was a big step for me, playing with dolls. Very proto-punk, no one at Cal Arts was doing anything like that, but there was a heavy influence of performance art that was ever present, even though I received most of it through documentation. Laurie Anderson was there but very involved with sound and music, which was inspirational. John Baldessari was and is always such an inspiration to me, and I see him in the use of postcards in this tape. I didn't even think about editing; in that way it was performative. I wanted to do the whole thing in one take. There could be no mistakes because the mistakes were built into it. I was just using the only apparatus that I had, which was my body, my body was a set. The hand as a device was something that I used forever after. I love all the implications.... But I really liked the fact that locomotion was connected to the hand – the way we all move things – nothing was really hidden from the viewer. I was playing with our desire to get lost in narrative space/time. We love a story so much that we will breathe life into it no matter how much it is degraded. In retrospect, I think a lot of that was a response to minimalism and the reductivist aesthetic of the conceptualists – playing with what is in the frame and what is outside. The origins of the word *obscene* come from what can't be seen by an audience, the invisible happenings off-stage. But I was also playing with scale, me and my hands are roughly the size of the viewer, and the dolls are the scale of TV stars as seen on TV. I wondered if people would sit through the whole thing. Yes, deconstruction equals destruction. Destruction of the passive position of the viewer.

MK: *Life* and *Good Things and Bad Things* [both 1979] are compilations of little tapes that are all quite different. Some are really beautiful, like the one where a romantic couple is represented by drawings on two pieces of tissue paper. They're dropped into a bucket of water and merge as they dissolve into a spiral of ink and a wad of primordial goo. It's such a gorgeous effect. Sometimes you use the fuzziness of the video medium as a signifier of romantic ambiguity, analogous to the filmic convention of representing a dream or super-emotional state of mind by de-focusing the image. This particular sequence is a good example of the tension that you described between the grainy quality of the video reading simultaneously as cheap and documentary, and as disembodied and ethereal.

TO: That's a great description of the tensions in those tapes, the latitude of the medium. Those two pieces of toilet paper with magic marker drawings on them merge in this very misty, elegant effect, although you know that it's just two pieces of toilet paper dissolving in a bucket. Video could really transform mate-

Dummy Behind the Wall, 1991

Antenna, 1991

70s/80s Relationship, 1991

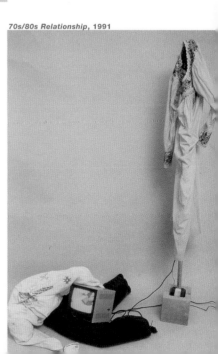

rials, and the instantaneous ability to capture ideas, sketches, play, made it a perfect studio tool. The shorter experimental tapes were vignettes, which I think were influenced by a tradition that is gone now but that I grew up with, which is the animated short. I remember how we always used to make jokes about the Canadian Film Board films....

MK: As I recall, they generally had musical soundtracks and often were social commentaries.

TO: There was a kind of visual Esperanto idea behind them: regardless of what language one spoke, anyone could understand them. They were really great but kind of embarrassing; they used grunts and other vocal sounds with music but no formal spoken language. My video shorts had some kind of relationship to that tradition, even referenced them. They were material, metaphysical experiments that were limited to what I could make in the studio or shoot out the window. The Portapak was not too portable. The tapes were often based on an optical phenomenon or some kind of physical effect, or the fact that insects tend to move in a special way. I would choose one material like an egg and a rock and see what kind of tape I could make with that, see how far I could mess with that one image.

After the shorts I wanted to do a sort of weekly TV show, *The Life of Phillis* [1977]. I liked the image of a doll on tape so much that I decided that my story would revolve around a desperate, young, abused girl character, someone out of the pages of the *National Enquirer*. She starts out as a victim, and from one episode to the next she transforms through revenge, plastic surgery, travel and cosmic escape, lots of art, and art historical references. I got very involved in set making and painting, and then finally the whole thing – dolls, props, and sets, along with a monitor and reel-to-reel VCR – was made into an installation, my first video installation, and shown at Cal Arts – a different episode was shown at noon every day.

MK: A lot of your tapes address romance, sometimes ironically by parodying tawdry soap operas. Yet at other times it strikes me that you are actually attempting to seduce the viewer and produce truly emotional affects.

TO: In some of them, yes, definitely, and in others, like *Joe's . . .* I'm doing a complete punk-out, the exact reverse: ultra-violence. That one is anti-audience. But the grimmer it gets, the more the audience wants to watch it. But in others, like *Diamond (Head)*, I was trying to play out a suburban soapy story; some of it is generic, some of it is experiences from my own life, supermarket tabloid stuff which influenced me a lot, family, sex, romance, death. I was after a feeling of the suburbs gone bad, sweet and sour; I lived it.

MK: *Diamond (Head)* [1979] is the first of your videotapes that is a more lengthy narrative. It mimics traditional filmic construction to a certain degree: different scenes follow one upon another, and there are consistent characters. Can you talk a little bit about why you went from doing short pieces in real time to this play

with compressed filmic time and somewhat traditional editing.

TO: You hit on the two traditional filmic constraints, but I think it ends there. After the shorts, naturally I wanted to string some together into some sort of fractured narrative. That's how the episodic tableaux developed for me and stuck for some time as well. I wanted to work the suburbs, neurosis, family; I chose the diamond shape or symbol as a unifying factor. It was to be the perfect conflicted signifier of bounty and beauty, but one which is seldom real and always in question if not overtly false, as in rhinestones. I worked the flaws, the theme, and let it evolve in text or sound or image, built up scenes which echoed throughout the overall structure. I was talking to Judy Pfaff a lot then.... Special effects were visual poetry for me: poured liquid pools would reflect images of greed, water flowing upward, anti-gravity, inside the diamond figure by inverting the camera. I wanted to change the image into an idea. Intuitively. I really was not trying to tell a story; it was something else I wanted the viewers to do. I wanted to relate to them in a way that was conversational, rudimentary, and always inviting them to decode the image as it went along, inventing it with me. In that way it would become their own story. They allow the mother to be a diamond shape with a brooch as a mouth. They are in a composite department store/Sears catalogue. We all understand the Sears catalogue that was my vocabulary.... That's how *Diamond (Head)* came about.

MK: As I said before in relation to *Joe's . . .* , some of your early tapes have a socio-critical edge. *Diamond (Head)* is a lot about consumerism. Then you go into a period where you're working more with melodrama and psychological overtones. I'm thinking of tapes like *The Loner* and *Grand Mal*. After that, you go back to themes that, once again, are more overtly socio-critical, like *Son of Oil*, to a certain extent, but especially *Joy Ride* and *Kepone*.

TO: I always thought that the politics of interpersonal relationships was connected to a larger world of concerns – kind of a food chain in effect – moving in the direction of desire and the power of the idea, not logically from small to big, as with insects to humans, but more chaotically, which is what makes it interesting. Everyone is eating or being eaten: one man's dreams become the world's problems and vice-versa. The CIA did test LSD on unsuspecting citizens. So for me the pendulum swing was natural from personal to political; as the feminists of the day put it, "personal is political."

MK: You were pushing the limits of empathy by having these cheap materials like cardboard, bits of clay, or balloons filled with water read as a tragic figure. *The Loner* [1980] is one ridiculously tragic scene after another. It's pathetic, and very funny. I've found that when I screen a selection of your tapes for people, *The Loner* is almost always the crowd-pleaser. In contrast, I think that *Grand Mal* [1981] actually is tragic and psychologically moving. It's one of my favorites of your single-channel tapes. It's more abstract than *The Loner*. It operates very much like recollection; scenes are linked in a very believable way emotionally, but it's hard to explain why. It's a really different kind

of tape than *The Loner* or *Diamond (Head)* in terms of its narrative structure and how it flows along.

TO: Yes, I was playing with situations the viewer may see as worst-case scenario, humorous but in some way believable, because they came in part from life. A guy walks through a needle park in NYC and is shocked to see a fetus on the ground and is moved to tears and then decides to bury it and picks it up with a napkin and smells something strange and sweet: it's really just a big hunk of bubble gum. True story. A guy, very romantic setting on a cliff, writing poetry, gets attacked by some biker types; they threaten to throw him off the cliff if he doesn't dance and shit. True story. In the earlier tapes like *Diamond (Head)* and *The Loner* I was really thinking about what constituted a character, various psychological states treated as character studies. The overall theme of *The Loner* was pathos, coming of age in light of the absurdness of experience – a universal-interchangeable person. Everyone is The Loner. I worked the materials, the visuals, to the point that they could be as informative as the language. But it was nonlinear, like a satellite passed over the earth tracking these pathetic situations, so in each scene I changed the character, the shape of the character. There were only one or two unifying factors: the color white, and...

MK: ... the big, sad "Keene" eyes.

TO: Yeah, I loved those sad eyes. I remember Jim Shaw had a vast collection of pop imagery always around which he worked from.... but Keene had a special place for me and all Americans, the velvet paintings of lost kids, the point of white paint which highlighted the almost tearful eyes.... I used them throughout *Loner* and wore a big set of them on my rock-video-song section and lip-synched to the *Loner Song* – the one you played sax on – this was inspired by Alan Vega, whose music with Martin Rev in Suicide freed me to do a lot of my soundtrack work. I loved making the music. It was becoming relatively complicated – thick – I used three or four cheap cassette players playing back at the same time to multi-track.... Perhaps because of the creepy tradition of soap opera music, I fell in love with the organ. It's so basic, all you can do is go up or down on the emotional scale – Suicide was essentially organ and voice. I had seen them live in NYC and it had great impact – they were amazing. As Alan went wild he wore giant Jackie O–type sunglasses, which caught the light in such a way as to generate the Keene effect.

MK: [Years later] I thought about that relative to people's relationship to stuffed animals and dolls. They are not seen as particular things but as generically humanoid. Their individual morphologies seem to have little consequence on how one responds to them. They are simply objects to project interior narratives upon. As long as an object has eyes it becomes a body, even if it bears no relationship to the shape of the human body.

TO: Exactly. This is the key to media: the viewers' ability to project into what is flashed before their eyes.... Film and TV continually deconstruct the human body, cut after cut, yet the viewer

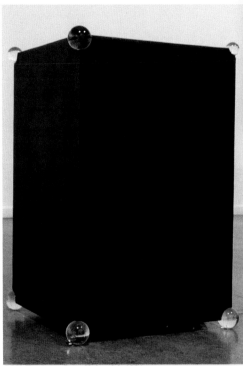

DDM (Designer Drug Molecule) (detail), 1991

DDM (Designer Drug Molecule), 1991

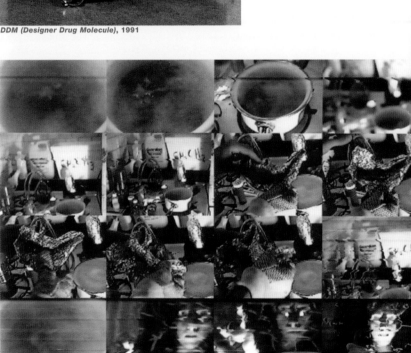

DDM (Designer Drug Molecule), 1991, video stills

Station Project, 1991, video still

Station Project, 1991,
collaboration with James Casebere

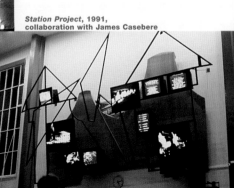

allows its hobbled form to crawl forward through the plot. So the fun of it is how much can you get away with in that regard, how far will the viewer go? This is my visual subtext.... it was the basis for the dummies later. But you can see it early: in *Diamond (Head)*, for example, there are little specks of paper that talk. *The Loner* is played by a full human figure, a penis stuck up through a hole, and sometimes by inanimate objects. But in *Grand Mal*....

MK: ... there isn't even a character that ties the narrative together. The tape is not structured around a central figure; it's a selection of scenes that run into each other and are only tied together by a kind of mood. I would be hard-pressed to describe what the theme of the tape is, yet it doesn't read as a collection of disparate vignettes; it somehow seems to progress narratively.

TO: I believe, at that point, I thought of the viewer as the character. He or she is actually participating in a state of mind. I had seen Kabuki theater, [Samuel] Beckett, and [Bertolt] Brecht by this point, and they inform all of my work; I still think of them today. That was the goal, to collaborate with the viewer, give them enough room to dream, to read into the signs yet to follow a loose path. *Grand Mal* was inspired by the medical condition of grand mal seizures, which could be induced by blunt trauma to the head, overdose; it causes all your synapses to fire at the same time, it all happens, the ultimate climax, full potential – which of course the victim has no memory of. My sister, Theresa, and her husband, Michael Rey, are in the medical field, so we always had great discussion – of life and death situations and how people put themselves into them – emergency room parables were somehow the background of the tape's structure. The scenes are flashes that one might have during a seizure. I really believed at that time, passionately, that Hollywood was communication that reduced life to close-up, medium, and long shot – a dead end that excludes other ways of depicting thought. If one thinks about the way he or she looks at the world, the way one combines remembrances, the voices going on inside your head, eye movements, then one realizes what a falsehood Hollywood editing is. It leads one down this road of narrative, but it cuts most human experience out.

MK: That reminds me of William Burroughs's intentions when he started utilizing the cut-up method in the production of his novels. He wanted to destroy the structural clichés of narrative that he saw as being in the service of a death culture. By cutting up and reconfiguring these clichés he hoped to reveal the perceptual limitations those codes induced. What's amazing about some of his most fractured novels, like *The Soft Machine*, is that the fragments of genre that he includes – bits of detective or sci-fi story lines, are enough for you to fill in and accept the text as standardized narrative. And this is the case even though his intentions are obviously at odds with those structures.

TO: It's incredible; you know that Mr. B. lifted the idea of the cut-up from visual art. I guess people were doing that to some degree with experimental film. But I think that there is a magic

in the way that people interpret texts, which is different from how they take in film images similarly put together in a cut-up manner. Text becomes part of you while you read; images can allow one to be a voyeur safely on the outside. There is no such thing as a narrative, only a human predisposition to construct narrative from disparate elements.

MK: It's true. If you look at the earliest Bruce Conner movies, like *A Movie* and *Cosmic Ray*, that are made up of film fragments, they just seem amusing. This is not to demean Bruce Conner, whose films I love. But *Grand Mal*, despite its nonsensical structure, is not simply funny; I find it very moving. Perhaps what allows one to have an experience with that tape that is more akin to the experience of literature is the fact that it is made up of painted elements. Your earlier work is very sculptural, very present. You can tell objects are being moved around in real time. With *Grand Mal* there's a real shift in approach. The tape doesn't come off as much as a puppet show as some of the earlier ones. Because of their coloration, the objects are very inexplicable; it's hard to discern what their physical basis is, even though it's obvious that they are often just pieces of painted cardboard. You had made a number of tapes in color by that time; *The Loner* is in color. But your painting skills really rise to another level in *Grand Mal*. It's like a moving painting; it's not flat like a cartoon. There is a real spatiality to it.

TO: Interesting.... At the time I believed that all the elements of the picture could be sensitized – colors were highlighted, even subject matter, in that tape. The colors were coded Christmas green and red opposite Catholic plaid, melting into a fun house mirror. One segment was based on the famous schizophrenic cat, another on Hieronymus Bosch. There are Christian themes.

MK: It has a lot of "Lent purple" in it.

TO: Exactly.

MK: I remember watching you work on the sets for the tapes at that time. It was fascinating to watch you look at the monitor while you were painting them. You would shift the color on the camera itself to affect the image. You would mix the paints "on camera" and use the camera color controls as well to produce an optimum color effect. I think that's how you ended up with colors that are so unusual and intense. They are not natural at all. We are not seeing a "documentation" of colored paint. The color is intensely video-friendly and very unworldly. You cannot get such color in a painting.

TO: No, you can't. Video is projected light, not reflected. It's so bright you can see an image on a small TV from blocks away. There is a candy richness that comes from a combination of lighting, color juxtaposition, and actually tweaking the camera. Back then, cameras had all sorts of different controls on them. I fell into the habit of painting while looking at the monitor instead of looking at what I was painting. I came to realize that if I made the sets without looking at them on the TV, I would

have to rework them later, because the camera changed the color so much. Conversion from real to video space was a big part of my process.

MK: Wasn't *Grand Mal* the first tape that you made after you moved back to New York from California in 1981?

TO: Yes, though the stop-action animation scenes were shot in your place in LA. The bigger scenes were shot in New York. Mitchell Syrop, you, and I all lived in the same building, and we were all looking at a lot at cliché media images then. That's obvious in that animation segment that's related to the famous CARE advertisement that pictured the starving child with the bloated stomach, which evoked extreme guilt for a whole generation. Educational films were on my mind. I was fascinated by the use of neutralized graphics to deal with highly charged subjects such as mental illness, sex....

MK: You mean that very ironic, anti-racism story about the pink and gray worms that live in the child's intestines? *Grand Mal* has a lot of very black humor in it. I particularly like the "sex education" animation that is so abstracted that it is barely recognizable. It's a hilarious takeoff on those extremely stylized and sublimated hygiene films that used to be shown in schools. And the entire tape is overlaid with this pseudo-Canadian Film Board cornball "happy" musical soundtrack that gives it a very creepy effect.

TO: When I got back to Nyack I was looking for a place to live in NYC. In the meantime I shot *Grand Mal* in my friend Michael Leahey's basement, whose brother Edward had just died. The tape has a really somber feel. I always felt it was somehow permeated by my friend's demise, so I dedicated it to his memory.

MK: Even though you were playing a lot with media clichés at this time, the writing in the tapes begins to get much more complex and rich, more abstract and poetic. And this abstraction further intensifies in the following tapes, like *Spinout* and *EVOL*.

TO: *Son of Oil* was the tape done immediately after *Grand Mal*.

MK: *Son of Oil* [1982] is also more overtly thematic, held together by its use of oil metaphors. Again, it's one that has somewhat political overtones, even though it's very surreal.

TO: It was inspired somewhat by the oil embargo. I was interested in systems at the time and following them as far as I associate. Those three tapes were really traumatic; they were incredibly hard to make. I moved a number of times and was free-lancing a lot – NYC was much more difficult financially than LA.... The tapes were getting more and more elaborate; I wanted to get away from the stigma of small scale. With *Son of Oil* there were larger "full scale" sets, like the red, white, and blue bedroom with the dark-eyed, gasoline-sniffing counterfeiter who is visited by the Irish belly dancer.

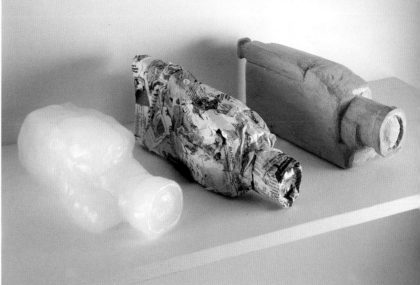

Three Cameras, 1991

U4EUH, 1991

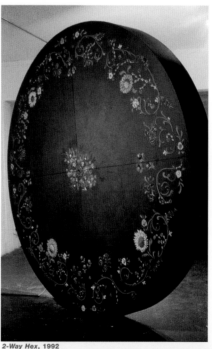

2-Way Hex, 1992

2-Way Hex (above) and The Watching: F/X Plotter (right), 1992, installation views

MK: Well, *EVOL* [1984] is your masterwork in that regard, with all of its multiple sets and elaborate camera shots designed to move from set to set. Everything is on a much grander scale in that tape.

TO: That was my Busby Berkeley, but that came later. The *Son of Oil* tape was part of a larger body of work. I would heavily research a topic and then generate works around that. For instance, with *Son of Oil* I did my first public installation with a videotape embedded into one of the sets, which was the grave-yard gas station. That was shown at P.S. 1. I built the set there, shot the scene there, and then I showed a version of the tape there, with folding chairs around the set. Maybe it was more of an installation than a videotape. All throughout this time I was doing paintings, drawings, but was mostly identified as a video maker, which had been an amazing way of working for me. The ephemeral aspect of video – the fact that it could be plugged in and played back in Europe and Asia – was a wonderful thing. At the same time I was making all these physical objects and images for this electric nether world.... I was ready to fuse the two spaces in installation. At the same time I showed other ele-ments from the project at Artists' Space – fluorescent tableaux with melting petroleum jelly, and a jet black bubbling pool.

After *Son of Oil* I had ambitions to do projects with more actors and bigger sets, but I wasn't able to. I didn't have any money and I didn't have any space. I basically had a room, with a desk and a TV, that I folded my bed up in. I said "fuck it," and I made *Spinout*. I shot the entire tape in that room. The whole thing was done by pointing the camera out of my window, or shooting miniature sets on the floor. I had a lot of fun with the soundtrack.

MK: *Spinout* [1983] is one of my favorite tapes. It's your most complex one as far as the sound goes. It's so dense with all of its multiple tracking, and the stereo channels are completely differ-ent. It's a mind fucker. I showed it once in a theater with a real-ly good stereo sound system, and people were just freaking.

TO: Well, I edited it split like that, with the headphones on. It's sort of a problem, because it is so dense that unless it's pre-sented using a really good sound system, it just muds-up.

MK: *Spinout* introduces some new elements to your image vocabulary. Sci-fi imagery makes its appearance. I would almost call the tape cyberpunk, though I don't believe that term was in use at that time.

TO: I was living in the East Village then. I became very con-vinced that science fiction was it: the future.... I was more inter-ested in what it meant in the culture than as literature. People were so excited about the space program, the alien fascination was just beginning. And I guess *Star Wars* was an influence; I don't remember when that came out, but I felt somehow person-ally offended by it, that it had soiled or colonized a special niche.

MK: That was such a throwback sci-fi movie, basically *Flash Gordon* warmed over. I can't believe how popular it is. An artist I know recently asked a class of art students what their favorite film was, and many of them said *Star Wars*! I don't understand it.

TO: Some have made the argument that science fiction is a kind of open territory in popular culture. I was treating it that way.

MK: I just read an essay by a writer named Stanislaw Lem who repudiates that argument. He cites Philip K. Dick as one of the only worthwhile writers in the field. He says science fiction pro-motes a façade of being progressive when it is by and large con-servative. It makes pretentious claims, but when it is subjected to serious criticism it excuses itself as a form of entertainment. I would say your work has more in common with the works of Dick, Burroughs, or J. G. Ballard than standard science fiction. What about that text you wrote in relation to the *Psychomimetiscape* sculpture? You interviewed yourself in the guise of Philip K. Dick.

TO: I went really crazy over him. I did that as a way of develop-ing an interview, a way of explaining the sculpture and having fun with it. He was long dead at that time. I don't think the edi-tors of the catalogue knew that it wasn't a real interview. I liked the idea of a false interview as a way of getting out all of the information you wanted to. Sci-fi does reveal something about people's belief systems and fantasy lives now. To a great extant it has replaced religious mythologies in our culture.

I used to carry around a little tape recorder and I would go out to a bar with some friends and get them to talk about their thoughts on ghosts, science fiction, recount acid trips, aliens, or UFOs. I'd just let them go off while they were really stoned or whatever, and I would tape it. Different portions of those record-ings ended up on the soundtrack of *Spinout*.

MK: *EVOL* has sections of recordings like that, too. There's a lot of lifting from television and radio broadcasts mixed with your recordings of people talking about various things. It's incredibly thick.

TO: At that time that was my state of mind. I was really recep-tive. I stayed up all night long and slept all day. I always had audio or video devices around to record with. For television, I had to use my camera; this was before you could record with a VCR directly off of TV easily. I developed a very paranoid state of mind; everything was interconnected. I would write hundreds of pages of stream-of-consciousness texts around a given sub-ject. It seemed that every time I turned on the TV, there was another bit of information that fit into my structure. Then there was a lost journey to SF and LA for the final edit.

MK: It was synchronicity at work.

TO: That's how *Spinout* became so layered. Which led to *L7-L5* [1984], which was my first big installation, done at The Kitchen. *L7-L5* was an organization of individual video sculptures relat-

ed to that body of research. It was installed in the Williams exhibition as well. Did you see any of that material, the interview with Gloria? I took out an ad in *The Village Voice*: "Firsthand accounts of aliens or UFOs – fifteen dollars an hour paid for your story." That's how I ended up with that interview.

MK: Yes, I saw that tape. She's the woman who was visited in her bedroom by aliens and by the spirit of the murderer.

TO: In *L7-L5* I started to remove the video image from the television by reflecting it onto glass. The interview with Gloria was in a glass house, reflected onto pieces of broken glass.

MK: I think that this is very important. Tell me why you were trying to separate the image from the monitor. I was thinking about it in relation to that generation of video artists like Nam June Paik and Shigaku Kubata and Wolf Vostell, who tried to treat the monitor itself as a piece of sculpture. In your case, it seems more like you were trying to treat the light emanating from the monitor as sculpture, trying to produce disembodied things, reflections.

TO: For that preceding generation of artists, it was really important to sign the apparatus of television. Nam June Paik took what I consider a piece of household furniture and turned it into art, as did [Marcel] Duchamp, but his strategy had radical implications in the media/home context.

Reflections…. The space after the light leaves the monitor, where life begins and the machine ends – the living rooms and bedrooms – these are the interesting spaces. The reflections are then trapped to resonate in sculptural form, so in essence the disembodied is re-contextualized in the installation. I was trying to take images off the TV screen and put them into a new situation. It's an experiment that started in the tapes, in special optical effects, and then moved into 3-D space…. I would reflect my video onto glass, which became Gloria's bedroom's architectural diagram – documentary of alien abduction and perhaps mental illness…. In the video-game-reflecting-water screen, a boy and a girl child play with spin-off sci-fi toys in a pseudo-psychological text situation…. Mirrors turn into stars which reflect live broadcast TV above the horizon… and finally the inverted flesh/green American flag becomes animated with Claymation as all things are invaded by the green. Here my conspiratorial research came together in my first total-immersion installation. The light of the TV illuminated a dark space – which in 1984 was not as common as we think of it today. It was my own little theme park made of one by twos, fluorescent paint, photo backdrop paper, cardboard, bits of string…. This was my first installation in Europe and led to the commission of *Spheres of Influence* by Christine Van Assche at the Pompidou Center the following year. From then on all my bigger projects were done in Europe. Thank god for Europe.

MK: Earlier in your work, when we talked about this in relation to *The Poetics Project* with its evocation of the DIY [do it yourself] punk aesthetic, you maintained a certain utopian attitude

continued on page 50

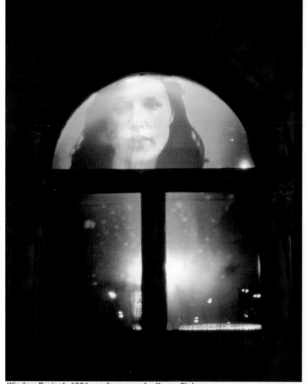

Window Project, 1991, performance by Karen Finley

Tunic (Song for Karen), 1991, video stills, in collaboration with Sonic Youth

Toxic Detox, 1992, video still, in collaboration with Joe Gibbons

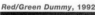

Red/Green Dummy, 1992

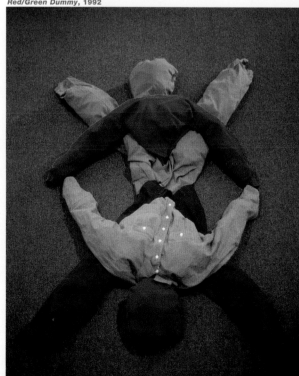

47

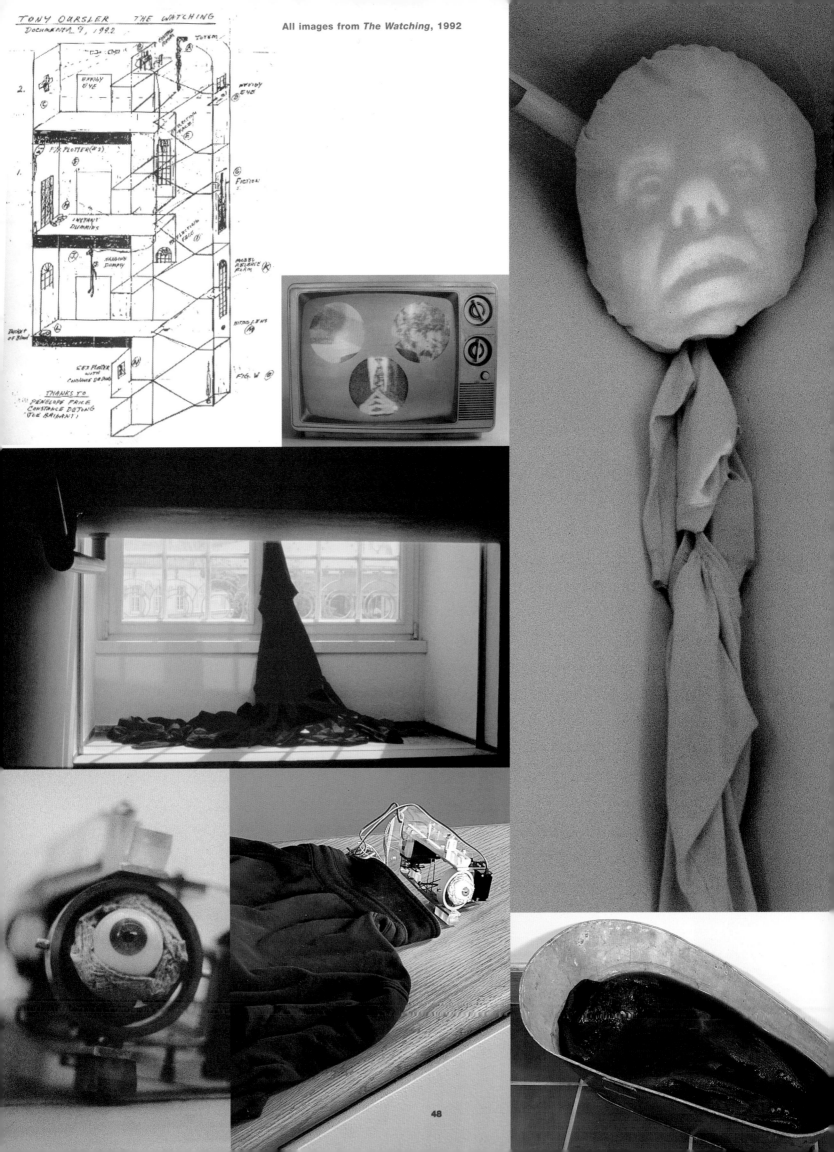

All images from *The Watching*, 1992

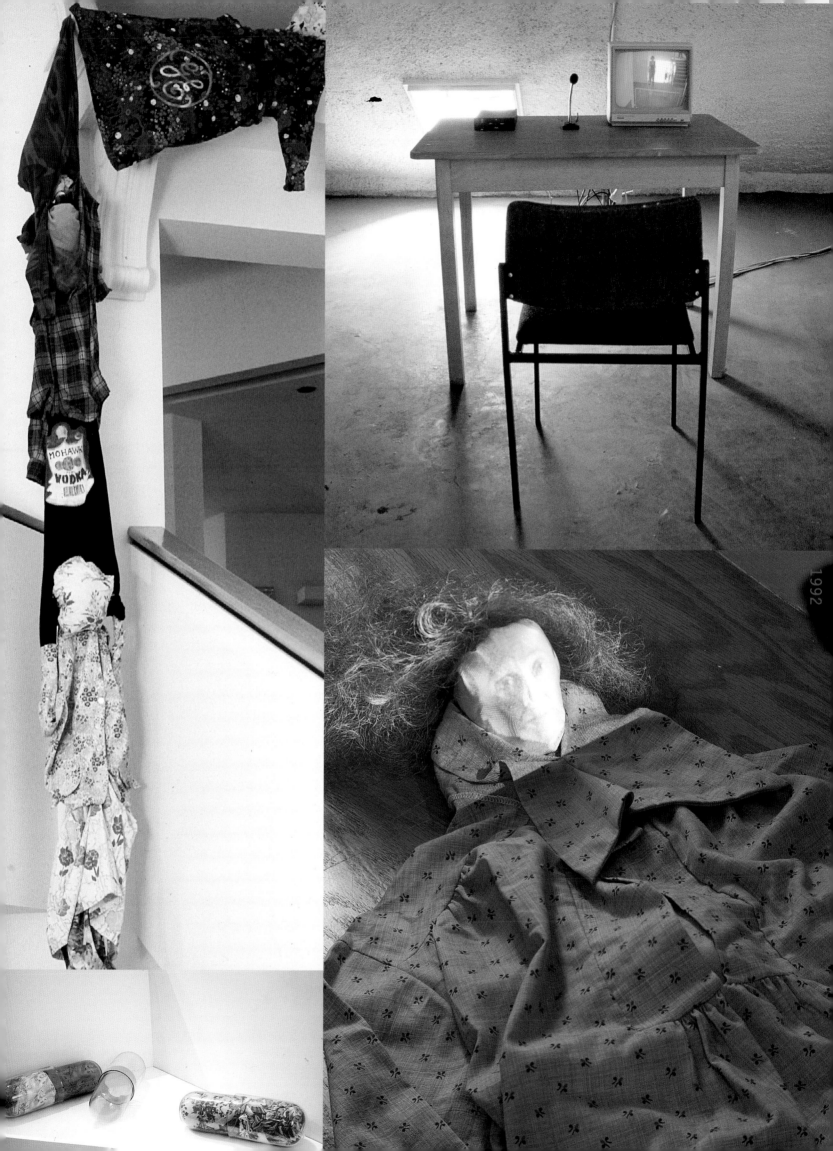

1992

relative to "alternative" media. For example, you were interested in the idea of creating your own TV shows that could be sent out, like mail art, or be presented on cable television. Do you think that your move toward this sculpture of disembodied television images was a sign of the death of that technological utopianism?

TO: It could be. By that time I had been making tapes and installations for eight years. In that time people like Devo, Alice Cooper, *Saturday Night Live*, had heard about my tapes and requested copies, meetings, which was all very exciting, but nothing really came of it.

MK: In the late seventies we both were very interested in the first wave of homemade rock videos, like the ones made by the Residents and Devo. By the time you started making your more sculptural works, MTV was in place, and that presentational form had been co-opted by the entertainment industry.

TO: I had been really active in the club scene in New York as a video artist – it was just another venue which we naturally gravitated to. I always got into the clubs for free because they showed my tapes.

MK: There was a time in the early, pre-MTV eighties when rock videos were projected onto the walls of discos as a kind of light show. That didn't last very long. Almost all of these tapes were homemade; record companies were producing very few videotapes then.

TO: Its amazing to see those early rock films or videos, how simply fantastic. All of the VJs were hip to the fact that the most interesting videotapes were made by people who called themselves video artists. Some video artists were even hired by the clubs. John Sanborne was at Danceteria; John Miller did some exhibitions at the Mudd Club.... This was post-Poetics, so I was making music alone in my studio for things but still very interested in rock as a social system and alternative to art. Although I had known of his art for years, I had the good fortune of working with Dan Graham on his tape *Rock My Religion* and also worked on a lost video project with Kim Gordon about the architecture of rock clubs. In retrospect it was a magic in-between time in a lot of ways, performance, music, video, all in the clubs – but it was too loud to talk.... MTV came along and siphoned off much of the video talent from that world and marketed it safely to the suburbans.... Nothing else existed. Artists saw it as a way to get some of their images out there. There was no way to get so-called video art onto real TV.

In the early eighties I did show my tapes on video art shows on public access. Around the same time that I was showing tapes in the clubs, pre-MTV, there were a few people who mixed video art tapes and rock videos and interviews on these sort of bricolage cable shows. Haimie Davidovich had an art-related show on public access in New York. My tape *Theme Song from Sci-fi* was done live on his show.

MK: That tape was done live on public access!

TO: That's a live tape; that's why it's so quirky and fucked up. I made the sets and prerecorded the soundtrack, then my brother Mark and I and a friend of his went to the studio and did the actions live. There were only two dissolves, and during one of them someone walked in front of the camera. I don't know why I wasn't more interested in public access at that time. I just wasn't. You have to understand, no one in New York had cable then. Now I see public access, and especially the Internet, and my interest is rekindled. Anybody can send a live stream of video out of his or her house at this point. It is very low resolution, but it's still kind of great. There is a level playing field now that there never was back then. I was pissed off.

I just finished a new videotape relative to all this. It's called *Off*. It's composed of material that I've appropriated from public access. It's an hour-long compendium of self-produced TV. I was formally attracted to the way that the images looked. The amateurs who do the shows don't seem to care about how they look; they are just trying to get information across. The camera work is really idiosyncratic: heads are cut off, people are talking but you can't see their mouths; the image is constantly going in and out of focus. There is a real beauty to it, so I began taping it.

I did a lecture where I showed an excerpt of this material and talked about the politics of public access, how it came out of the seventies utopian ideas that we were just talking about. Because so few people had cable at that time, it was regarded as a pathetic attack on dominant media. But now there are literally millions of people who have cable. How many people actually watch public access, I don't know; probably very few. Anyway, I want to imagine that public access has this never-ending potential. It's a metaphor for making art. It seems that there are endless variations of amazing and eccentric images emanating from it.

MK: Can you elaborate somewhat on your interest in the "wrongness" of this amateur TV? I'm reminded of Jim Shaw's collection of thrift-store paintings. They often point toward recognizable aesthetic models but seem to miss the original point, and in missing the point, produce something else that is very refreshing formally.

TO: I look outside for inspiration, to Sunday painters, sign painters, The Shaggs, whatever; as a kid I volunteered at a mental institution to do art therapy. It's always been a part of my process.... When I wanted to work with the figure, I could feel the art historical weight of it – until I considered the scarecrow.

With this new tape, it's a similar approach but related to television. I haven't made a single-channel tape in a long time. Rather than emulate the look of folk television, I like the idea of the structure of the tape being like channel surfing.

MK: Do you think that this relates somehow to issues of "postmodern pastiche"?

TO: There are ways of reading information that television implies. You can instantly crop information streams. I think that this is probably a really important part of a narrative development in this country. This quicker pace of reading information

and reorganizing it in a nonlinear way is very postmodern, even postmortem – the viewer constantly searching for meaning, for more, edit after edit, cut after random cut.

MK: Relative to your "appropriation" of public access television, when you appropriate things they are usually radically disassembled. We talked about this in relation to the fracturing strategies of William Burroughs, as a kind of destabilizing practice. But criticisms have been made of the fractured aesthetic, that it ultimately fails as a strategy of resistance because it emulates the sped-up and ecstatic effects of the media itself.... which is addictive. And since we are talking about the addictive qualities of the media, drug addiction is a common theme in a lot of your work. I was thinking of your tape *Toxic Detox*, which is a sitcom about two drug-dependent roommates in a halfway house, or your sculptures and paintings of various medicines, alcohol, and drugs. Could you talk about the relationship you draw between media addiction and drug addiction, if there is one?

TO: Originally, a lot of my interest in toxicity came out of ecological concerns and personal phobias. With chemicals, sometimes only a fine line separates them from being good for you or killing you. The classic story of industrial chemical poisoning in the *Kepone Drum* sculpture videotape [1989] is all true, a colorful documentary. Petrochemicals transitioned from a moneymaking machine in WWII to peacetime usage in agriculture. This war machine ended up producing incredible pesticides. In a few years, animals started to become extinct. That was a mentality, a situation which bridges later with the introduction of powerful mimetic drugs of the next generation, set against the background of the cold war. I've always been interested in drugs as a system which extends from the individual to meta, and here lies the connection to media. They both share escapist, visionary, dissociative qualities which are tragically human. I love that. We were....

MK: ...the drug generation.

But I also remember how upset you would get when people talked about the fractured nature of your tapes as being representative of a drug-user's consciousness. That always infuriated you, that they attributed the structure of your work to the mind set of a druggie. It was just the opposite: the fractured structure wasn't supposed to emulate a fucked-up mind; it was meant to emulate how consciousness actually operated. This brings me back to the question of addiction and style. In *ONOUROWN* [1990] and *Toxic Detox* [1992] you adopt the look of traditional TV narrative. The lives of these incredibly damaged characters revolve around television. They watch soap operas on TV, but they also tape themselves constantly. Their entire connection to the outside world is through television. It seems like you are associating "straight" narrative structure with pathology and substance abuse. *ONOUROWN* and *Toxic Detox* are the closest you've ever come to making a straight narrative, and they are about media and addiction.

TO: It's taken me a while to get around to some of these questions. Going back to *The Loner*, there is a scene where he gets

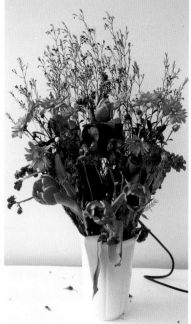

Private: Private, 1993

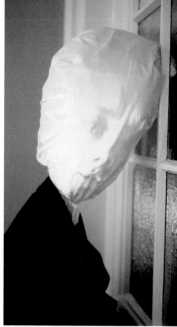

Private: Jim Shaw's Dream, 1993

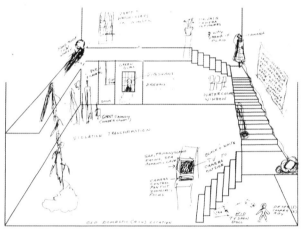

Private: Plan, 1993

1993

Private: Model Release Form, 1993

Crying Doll, 1993

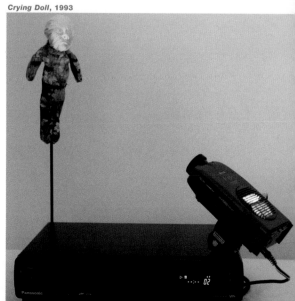

spiked with LSD and the visuals get really psychedelic. At that time I was completely straight, but people thought instantly that the scene was biographical. I was using something from pop culture, but it was immediately taken as something personal.

Later, I went into a collaborative phase. I started working with Constance DeJong on *Joy Ride* [1988]. She was always keenly aware of the battle of authorship and identity as her generation of writers played with gender and sexuality. At that time I wanted to get out of myself, my default settings. CDJ and I wanted to address the collapsed public and private space of theme parks in this tape and enjoyed it so much that we went on to do a video performance, *Relatives* [1989], which we quite unexpectedly were able to tour extensively here and in Europe. It was formally very simple, elegant: one performer (CDJ), one TV, one hour. A sort of history of media as seen through the eyes of under-painters and extras. That was a real transitional period for me. I worked with James Casebere on an installation, did things with Sonic Youth and Joe Gibbons. I was living in Boston with Joe at that time. He shoots amazing videos and films of his monologues while pointing the camera at himself; he's really a genius at it. This was around the time that the small High Eight cameras were introduced, which are small enough to carry around with you. We decided to try to make a hyperreal TV show, somewhat like a documentary but using extreme camera work.

The basic plot is that some mentally ill people, people who cannot fit into society, use video as a therapeutic device, just the opposite of what we were talking about before. Instead of video brainwashing you, making you spend money and waste time, video would be used to heal. They would use video for self-awareness. An absurd idea! The characters are supposed to document their lives on video and then send it to a doctor, who would give them advice.

It was a sitcom, but it had a very loose, open structure. It was an experiment in working with traditional editing and narrative construction, which I hadn't really done before. We would always shoot with two or three cameras, so we had lots of footage to choose from. We wanted an inexpensive documentary look but with high-paced editing. It was about drugs and problems with fitting into society, and I thought about it somewhat as a fable about being an artist, about chipping away at something that you can never achieve.

There is enough footage left to do another whole episode. One section I'd really like to edit has my two nephews playing Joe and me when we were children. It's like a time machine; we go back in time to try to find out what happened to us.

MK: To find out how you became mentally ill?

TO: Yes, they pretend to be Joe and me. It's really funny. They are so demonic. They're at that age where all they want to do is talk about death and killing people. Those tapes were farcical, fairy tales, but they led me to a more serious interest in mental illness and multiple personality disorder.

Joe had a lot of drug research books. We looked up all of the drugs that we mentioned in those tapes to see what their side effects were. The Internet was just starting then, and I would

look up various things related to drugs and toxicity on it. I looked up chemical castration devices for my installation work. Keep in mind this was also around the time I started my work with dummies and *The Watching* at Documenta 9. Also I helped write and acted in *The Genius*, Joe's 16-millimeter feature film starring himself and Karen Finley.

MK: That last scene in *Toxic Detox* where you and Joe have simultaneous castration nightmares is hilarious.

TO: That model of the penis was really scary. It looked so real when I cut it off – I was looking at the monitor as usual – it went right to my core. You ought to try it sometime.

MK: I've been very interested in repressed memory syndrome. I think that something about the rise of these disorders is pertinent to art production. The controversies surrounding repressed memory syndrome have raised questions about the veracity of memory. I believe this is very important relative to art, since art is the practice of "re-presentation." Now some psychologists claim that there is no such thing as repressed memory syndrome, that it is a byproduct of analysis itself, or influenced by the popular media.

TO: It's the same with multiple personality disorder. MPD has gone through a whole cycle of popular interest in it. I've seen it charted in the medical literature. In 1957 *The Three Faces of Eve* came out, and it was a bestseller. When it was turned into a movie, the actress who played Eve won an academy award. It was a big hit; it has affected the culture. Since then, a massive number of movies have been made on this subject. When you go back and watch *The Three Faces* of Eve, it's very much a liberation story. Feminists have been attracted to MPD as an example of an alternative to Freudian patriarchal analysis. MPD also went through the cycle of name changes, popularity collapse, and backlash, which is difficult to believe could happen in the medical profession so easily. MPD is presented as a kind of liberation, not an illness at all.

MK: It's interesting that the fractured qualities, which are popularly thought of as pathological, are positive ones in art production and psychoanalytic theory. They represent an attack against outworn notions of a unified psychology.

TO: That really horrifies some people. At first I was just drawn to the psychology of the person who changes into different people. Stories of possession and multiple personalities go all the way back to the Bible. There is a story where Jesus drives a legion of devils into some pigs. That's one of the first known accounts of multiple personalities.

Relative to television, no one has ever been able to prove that television makes people more violent, or does anything to one's psyche. Nobody can prove that morals are devolving because of it. No one can prove what the right wing Christians are always claiming. But you have to admit that there is something going on, a kind of feedback system, that is really intense:

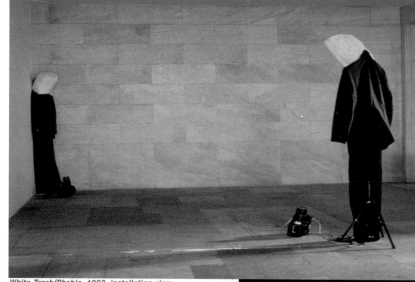

White Trash/Phobic, 1993, installation view

channel surfing, bonding with electronic entities, having a kind of interior surrogate family, escaping from your past by creating a psyche that can change.

MK: I saw a famous MPD case on a talk show recently. She talked about her various personalities as her "flock." Through years of therapy she has become conscious of these supposedly separate selves, and now they work more in unison with each other. She has quit trying to integrate them. It struck me that she has made them into sort of an internalized support group. R. D. Laing wrote in the sixties about how schizophrenia should not simply be seen as a pathology. It is, to a certain degree, but he politicized it. It's a normal reaction to our culture; it is some sort of attempt at a self-curing in response to a pathological social system.

TO: It is a reflection of the desire of the people. They willed it into existence.

MK: Could you talk about your writing methodologies? As your single-channel work progressed, it became more and more text-heavy. Some of your recent sculptures utilizing projections seem almost like framing structures to present poetry. How do you go about writing?

TO: Like I said, the early writing really had a lot to do with the codes of Hollywood, with communication of a mean. There is a form of communication that everyone understands. But I was also interested in the voices inside your head, in the mixture of memories, sounds, and images that represented the way I felt I really thought. I felt that the culture industry underestimated what the brain was capable of doing and what people were able to understand.

The Watching: Model Release Form, 1992

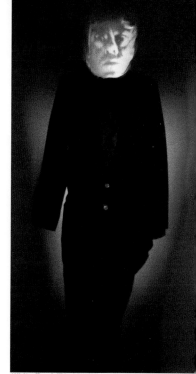

White Trash/Phobic: White Trash, 1993

Later on, my writing became much more subject-matter driven. The themes started to dictate the writing. For example, *EVOL* was a response to love songs and letters, the frail expressions of human bonds. Graphically this tape was large scale as well as small. I wanted to play with that psychologically – to invert the situation by using large sets and great distances. In the sound stage I could treat people as scalable; the performers became dolls, insects, or sperms. I was interested in how these clichés were able to make one cry. There was something so beautiful in that: the most horrible Foreigner pop/rock song or a Hallmark card can actually relieve you in some way.

MK: It is amazing that empathy is possible relative to such material. I think you play with that in relation to reduction as well, as in certain of your dummy projection pieces where a single emotion – crying, for instance – is presented.

TO: Those works were designed as empathy tests or traps. Scale was also used; the adult (Tracy) is scaled to the size of a doll or elf. Her big eyes cry endlessly.

MK: I read once that certain biologists believe that the big eyes of babies promote an innate nurturing response in people, which is why people respond to figures with big eyes. That might

1993

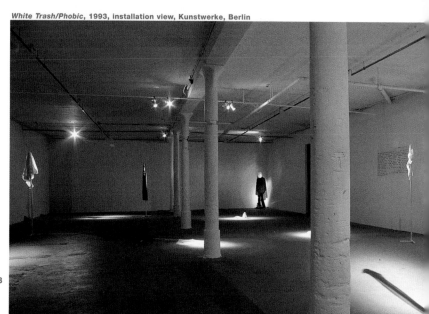

White Trash/Phobic, 1993, installation view, Kunstwerke, Berlin

explain the big-eyed "cuteness" aesthetic of Japanese cartoon characters, for instance.

TO: Maybe that's why ravens kill baby sheep by poking their eyes out.

MK: So they don't feel empathy anymore? *[laughter]*

TO: Yes.

MK: When I was a child, I heard folk stories about crows that eat people's eyes. There's an R. Crumb story about that. Maybe these stories have something to do with the negative magical qualities associated with the eye, like the superstitions related to the "evil eye." Perhaps TV is a kind of evil eye that provokes an immediate negative response to its influence. It makes one want to poke it out.

TO: "If thine eye offend thee, pluck it out." Was that from the Bible or some of the psychology literature that I came across: for instance, the MMPI, the Minneapolis Multi-phasic Personality Inventory. That really affected the way I wrote. I wrote one piece that Karen Finley performed, called *Window Project*, which was based solely on my memory of the MMPI. I was just amazed at what a crazy document it was. It's the most beautiful poetry ever. It's so inspirational. At that time I was really interested in the way language could operate as a hallucinatory device.

Around the time of *ONOUROWN*, I was working on a script for a feature-length videotape. I became disenchanted with the idea, because images themselves were giving me a real problem. I had stopped working with sets. I had pretty much given up painting. Moviemaking was so visual, and I felt lost regarding that. I was questioning the whole idea of the handmade; it wasn't doing it for me anymore.

MK: It seemed as if part of your dissatisfaction with the look of the handmade, which led you to abandon the hand-painted sets that were a trademark of your early work... But recently you've gone back to making things, like the dummy sculptures, that have a very handmade look and relate overtly to folk traditions.

I think it is easier now to see the difference between expressionist distortion and "folkish" distortion than it was in the eighties. It's easier to distinguish between distortion that is meant to reveal a personal psychology and distortion that is more "public domain." There is one dummy that sings a kid's street song...

TO: I've always liked to work with such material, the small voice calling out from a private space in the face of overwhelming cultural odds. This thinking led me out of my image dilemma to reintroduce the hand in the work with a more conceptual approach. It was an identity shift in terms of the hand. It was no longer my hand but a common hand, if you will. I wanted to make figurative work that people could relate to on the primary level of body recognition as well as on the level of production. Anyone can make a dummy; it is made of everyone's used

clothes. Again, it goes back to my interest in the ways in which the individual interfaces with the corporate, how the individual puts his mark on something.

MK: Kind of like a homemade détournement (the situationist term for taking a pre-given, a corporate or media image, and fucking it up to suit your own agenda)?

TO: I've always believed one could work with media clichés, that they can be made to self-destruct if you play with them and unlock their meanings. Perhaps this is at the root of the artist's attraction to the production of the feature film. A lot of the work that I have done throughout my career has had something to do with media critique, though in my own idiosyncratic ways. At the time I was going through my crisis regarding the image and the handmade, I was re-shooting my videos off of the TV screen, turning it in on itself, creating layers of feedback. The *Window Project* was done that way. It produced really beautiful color effects. I was thinking of doing the feature-length video I mentioned in that manner. But I found the idea of making a movie just too retro.... I realized that I was much more interested in what people thought about movies than I was in producing one. I was more interested in hearing someone describe a movie they had seen than watching it. That later led me to actually videotape movies reflected in the pupils of people's eyes. But then I started writing pieces that were movies that took place in your head.

MK: Like the *FX Plotter* text?

TO: Exactly. A total destruction. I wanted to describe a movie for the full length of it, to do a two-hour description of the movie, including all the camera angles, the soundtrack, etc., and you would just sit there and visualize it. I thought that would be better than making a movie; it would unfold pictorially, uniquely within each viewer, and that's what I felt my job was. I don't just want to spoon-feed somebody images. That idea resulted in the project called *The Watching*, for Documenta 9 [1992]. This was followed by a series of texts drawn from my research in MPD. I would paraphrase or write in the style of the plaintive statements or poems written by people with MPD, or their testimonials of abuse.

MK: That's very similar to some of the writings that I have done in my *Timeless/Authorless* series.

TO: I love that series. I was taking those MPD testimonials and breaking them up and mixing them together so they became more like poems. This led to more extreme abstraction. I would write with the TV and the radio and all these psychology books in front of me.... I've worked so much with language, experimented with it to find out what I was comfortable with, to discover what there is about language that is so powerful. If you tell people too much, they don't go inside it to collaborate in the production of its meaning. That was the great thing about the MMPI test. It is written in the form of a series of questions that you are sup-

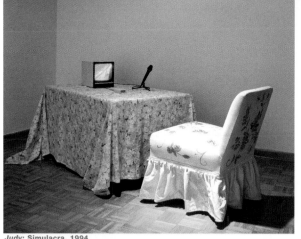

Judy: Simulacra, 1994

posed to answer as true or false. That's what I think a successful artwork can do; it provokes people to answer a question. The poems, which I'm still writing, are super-fractured but add up in different ways. Imagine a film script you never have to finish. It is always in the process of being developed.

MK: Yes, an endless script, constantly reworked.

Mike Kelley is an internationally recognized multi-media artist whose work has been exhibited in many solo and group exhibitions, including a survey exhibition organized by the Museu d'Art Contemporani in Barcelona, Spain, in 1997. He lives and works in Los Angeles.

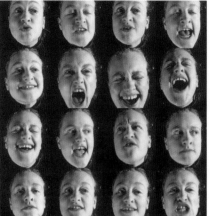

Judy, 1994, video stills

Judy: Sketch, 1994

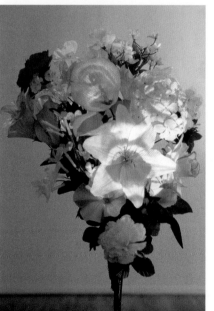

Judy: The Boss, 1994

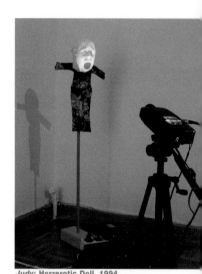

Judy: Horrerotic Doll, 1994

Judy: 1994, installation view

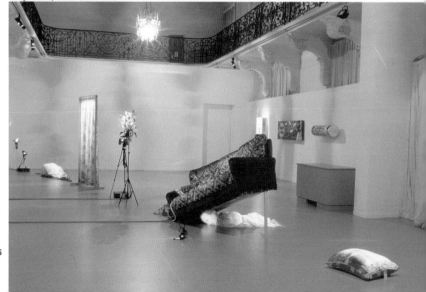

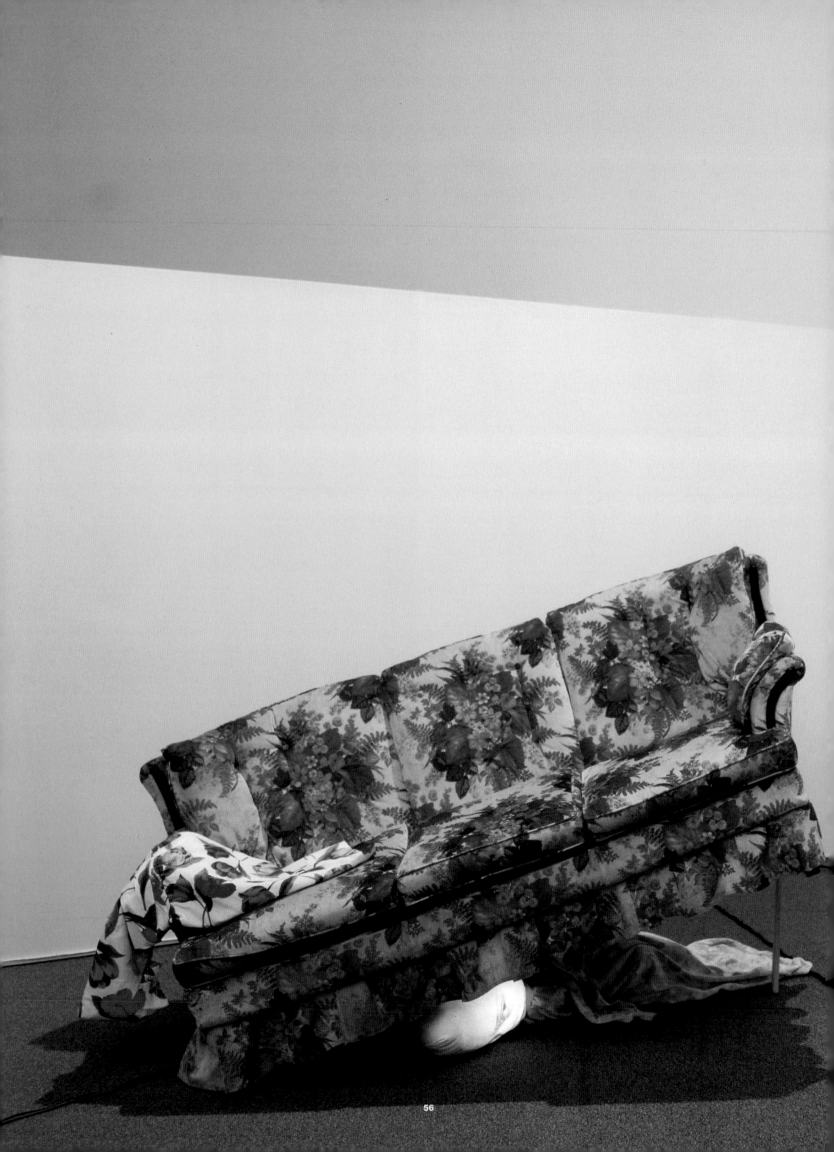

1994

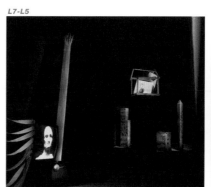

L7-L5

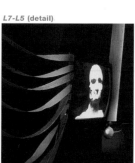

L7-L5 (detail)

tony oursler:
L7-L5, 1984

by constance dejong

The following essay was written in 1984 in reaction to Tony Oursler's installation of *L7-L5* at The Kitchen in New York City in March of that year.

Seeing this installation set off a chain reaction, a host of divergent considerations. It might be called "seeing at first sight," this unexpected cropping-up which in all its diversity seemed to spring into being all at once. If there is anything to designate in the first place, it's the place where seeing begins.... in the dark.

According to the artist, there's a reference being made here to domestic darkness, to houses and rooms where the night is lit by television. In the installation room.... maybe it is night. All is definitely dark and the only light is the kind only a television emits. Yet gone are the TV sets, the monitors. Television is all around and nowhere to be seen; not directly, not on the familiar rectangle, not as anything except reflected light, images let loose.

They're released onto tinfoil, tinted water, pieces of broken glass. It's on these unvalued, everyday materials that Oursler's video images play; materials turned respectively into a colony of stars, a miniature lake, a glass house – each of which is a local viewing site illuminating an otherwise darkened scene:

Over a cityscape of cardboard buildings dangles the colony of stars glinting with colored light. An undisclosed television receiver is the sender of light, projecting on-air broadcast images. Parts of these projections bounce back as colored glints. And as the eye can focus only on one thing at a time, these fragments ricocheting off tin foil can be either the shape or a star of the twinkling of an image. As for television-the-sender.... it's an emissary that's got its eye on colonizing the skies, an agent that would be king. It would be hard to imagine any child any longer looking up to the night and questioning, "twinkle, twinkle, little star, how I wonder what you are." In a second scene, there are children left to imagine what they will.

Encased in cardboard, in an eccentric video game/peep show, sits the miniature lake reflecting images of a boy and girl at play. Their toys are from the realm of science fiction, and very noisy toys are these. They're part of a picture, which is not asserting an entirely lighthearted world. The world of child's play is linked to an adult counterpart, to an industry which is making a lot of noise about science fiction in films and TV programs and candy and comic books and a succession of goods invented by a now outsized enterprise. By contrast, evidence of inventing science fiction as a subject of any import or significance is dwarfed and marginalized and would fill a space about as diminutive as the miniature lake. On its surface it's the moment when questions are set in motion. Will the children with their playings engage in the invention of themselves and their world, take some role in that process? Or will the goods of a science fiction enterprise supply the oppression, the domination of imagination? At a third site in the installation, there is evidence of the flip side of science fiction, which is no fiction at all to those who in real life have had encounters of an extraordinary kind.

Atop a black paper boulder rests a house of broken glass receiving a taped visitor who got there somewhat by chance. She is the sole respondent to a request for accounts of first-person experiences with aliens, a request the artist ran in a local New York newspaper. Though only one respondent came running, this woman has accounts enough for what seems to last forever. For an installation seems an uncommon context in which to be faced with videotape that requires sequential attention; a tape of consecutive images with sound-synch spoken text. Undifferentiated, continual time is not of the essence here, is not a principle by which videotape is made to reinforce its static context, made to mix consistently with a plastic medium. To set aside this historical issue is one of the strengths of the work: the relationship between tape and object is allowed to shift basis. Hence, the broken glass house is a structure related to the subject of the tape. The woman's accounts and drawings are of her home invaded by aliens, her life shattered ever after into pieces that won't fit comfortably together again. But something is befitting here. The relationship between mediums is shifted onto a site where tape and

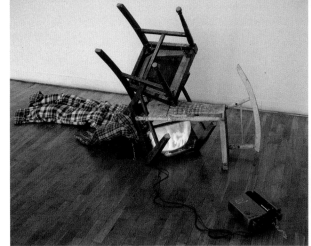

Broken, 1994

object become a collapsed, an integrated image. It's an image partly made by video, partly made by hand, and the parts reinforce each other on the basis of content.

It's a strength of the artist's throughout this installation to mix mediums uncommonly and to be a highly original kind of matchmaker. For example, it's through the unlikely union of electronically produced images and those unvalued, everyday materials that Oursler released video images from a viewing instrument and has them arriving as integral elements of his original constructs. The dislocation of video images has a number of implications.... and *L7-L5* has one exception, one work where tape plays on a monitor.

It's set into a paper-made American flag stood on end with its broken pole sticking up in the air. In place of the flag's field of stars there's the monitor with the videotape starring Oursler's idea of characters – little clay figures pixelated into action. They always can be seen as yet another instance of technology wed to a homely material: clay electronically induced to life. And as always, there's something uncanny about Oursler's idea of artmaking, his made by hand/by video process. Its simplicity pokes a hole in the over-inflated emphasis commonly placed on special effects, industry-derived values, countless state-of-the-art tools and techniques. It's not from buying this line of goods that Oursler achieves the complexity evident in every one of the installation's scenes.

And in the end, the dislocation of video images from the tyranny of technology begins to seem like a subtext. It's an idea that crops up upon seeing the integration of unlike mediums, upon discovering the subject of these relocations achieved by a vision of art.

Reprinted from *The Luminous Image*, ed. Dorine Mignot (Amsterdam: Stedelijk Museum, 1984), by permission of the author and the publisher.

Constance DeJong is a writer and artist who works frequently with spoken word, audio, and digital forms. She has collaborated with Oursler on several major works since 1984.

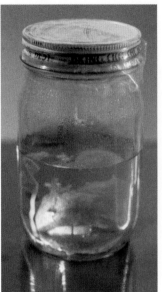

Organ Play #2 (detail), 1994

System for Dramatic Feedback: Horror (detail), 1994

System for Dramatic Feedback: Mutation (detail), 1994

System for Dramatic Feedback, 1994, installation view

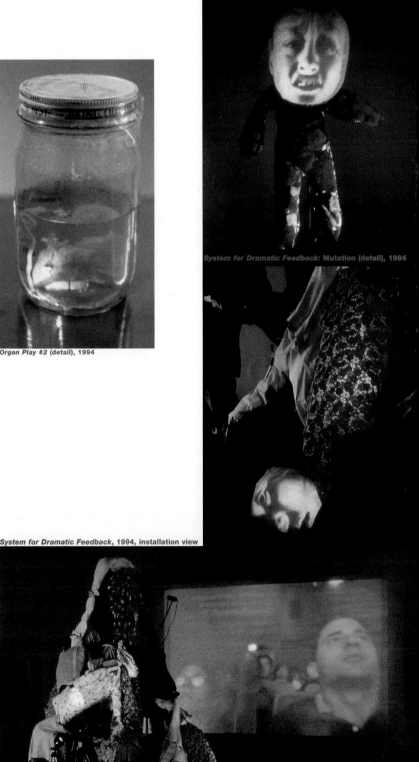

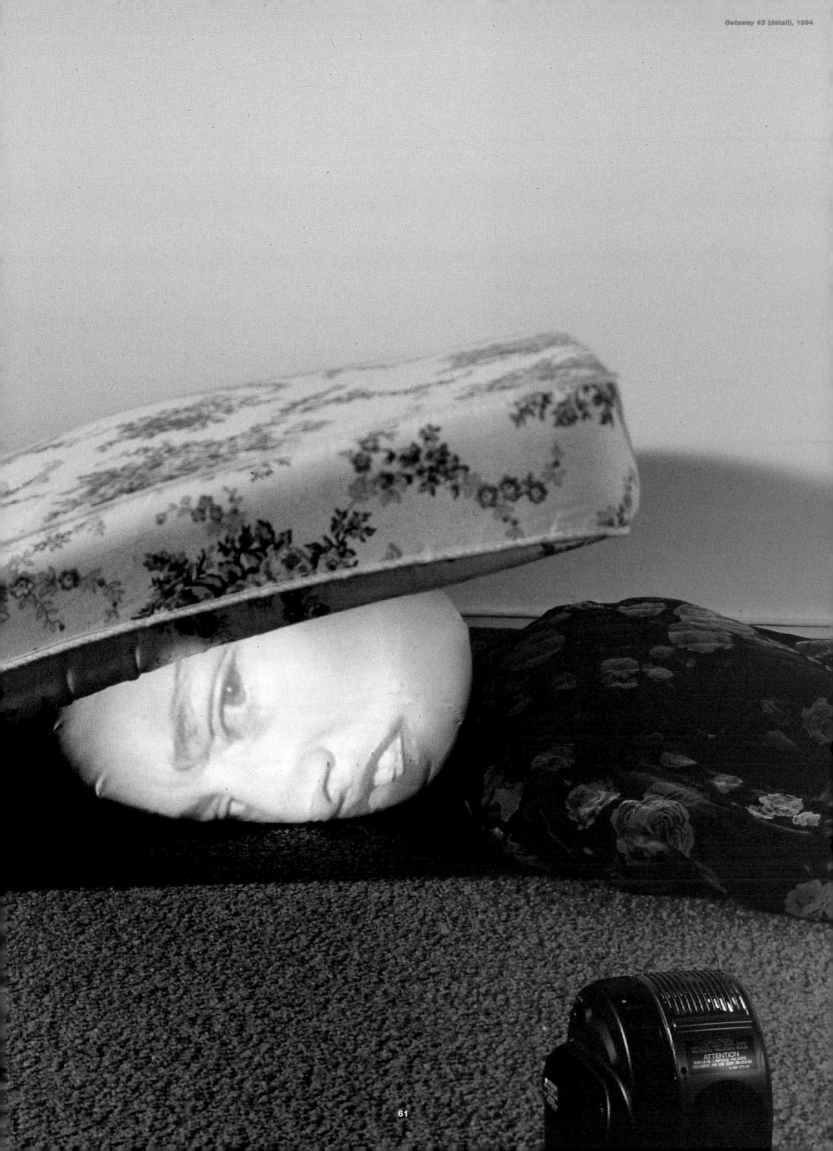

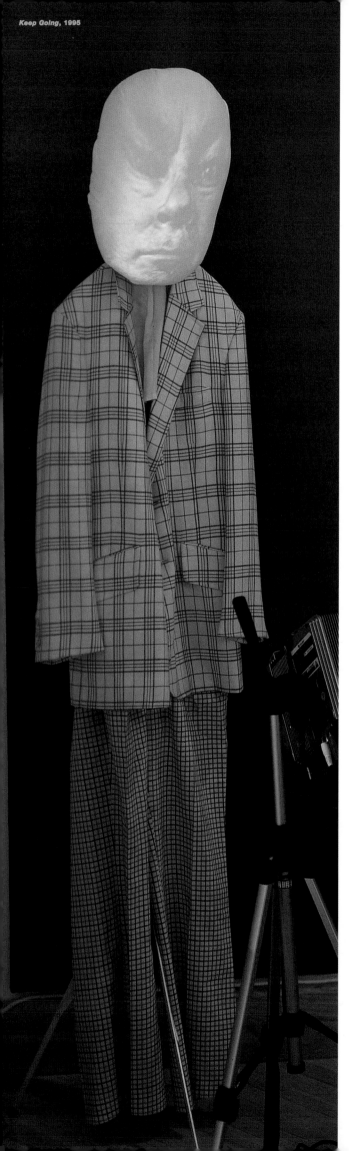

keep going

The following transcription is one version of the performance by Tony Conrad in Oursler's video sculpture *Keep Going* (1995). Conrad, in this unscripted role, depicts an eccentric movie director with impossible goals and over-the-top pretensions.

You! You don't remember having been given a line, do you? No, well, have you looked at the script? It will help if you looked at my directions ahead of time, then we wouldn't have to design everything on the spot. You! You! Everyone! "Rhubarb." Everyone walking around, if you do not have a line, "Rhubarb." I thought everyone understood, "Rhubarb, rhubarb, rhubarb." Just like that.

Light! Let's have orange on the left. I want an orange light over there, by the volcano, and we'll have an eruption in five seconds. Five, four, three, two, one. Ugh. That's not an eruption! An eruption! I want an eruption! I want to see people coming out of the volcano. I want to see lava, rocks, lightening, thunder – I want to see something that changes the essence of our.... being. I want to be moved.

Okay, we'll go to the close-up. Now, come in, come in, don't look at me. Turn to the other person. Move closer together. No! No, no, no, no! I'd like to see.... Oh, we need a makeup person. Look at that! Look at her! Let's get more makeup or less makeup. I don't know, but that's a monstrosity. Oh, no. I'm sorry. I mean him, obviously.

Let's everybody stop and take a look around you. Don't look at me. . . . Is anybody out there looking? Are you listening to each other? Can you hear anybody talking? Do you hear a line? Does anything seem familiar to you? Is this completely unfamiliar? Maybe you should not be here!

Let's remove everybody – everybody away! Everybody just move aside, I'm coming through. Step aside. Wait! What's that? Are we getting something.... what, music? There's music in the trees? Oh, my God, I don't want alpine horns! No, no! We told them accordions. They didn't have the accordions, they had the horns, I know. We do not want them. Send them back. I don't care how far they go. We wanted them yesterday. Why, you still think we need to have music in the trees? How about bird calls, like I wanted?

Okay. Everyone start at our reference point. Okay, it's 1832, it is fifteen minutes before seven in the morning. Here they are coming out and walking across this space here, and now what happens . . . Take it away. But keep walking, and dub this. No, the walking, dub the walking. Walking, walking, keep walking. Good. Not so much there, yes a little more. Put your arms into it. Get the shoulders loose and hang those arms lower.... and the epaulets? If they don't have epaulets yet, that's perfectly okay, it just signifies you haven't earned them. The scene survives.

Now I want to see lust! Lust everywhere! I want trees to bend with passion toward each other. I want birds to fall from the sky with anxiety about the fate of their lover. That's the kind of feeling I want you to project toward each other. Walk. Feel passion, interest. Make this a little livelier. Can you do anything to build in a little energy here, because this is flat – I'm not getting anything here! Maybe a little hail, electronic lightning, and the volcano again. No, no, forget the volcano. I'm not getting enough here. Let's try an alien landing. I think an alien landing.... No, I don't like improvising! We had this worked out yesterday and you're still.... You people are good. You stick with me even though I know I change my mind. I change my mind all the time, but you have to stick with me I love each and every one of you. You! You! Hey, you know, I want to talk to you in particular. You did a really fabulous job. I enjoyed everything that you did. Up until

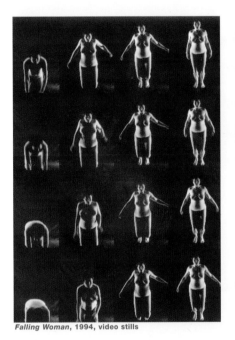

Autochthonous, 1994

Phone Block, 1994

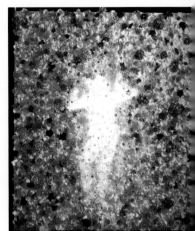

End, 1994

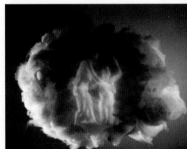

Lost and Found, 1995

today. But we have to get something going here today. There's no energy here. There's nothing happening. I can't make out what we are doing. Look, let's just stop and think about this. If you came upon this scene, you see what you see in front of you today What do you see? Nothing! There's nothing happening. Think about it!

Everybody quiet! Listen to me. I want to tell you a little story. Get it? It's like a little story-telling session. Think of your mother. Think of some time when you felt good You're on your way to work, you're thinking of something else; you have a quality experience. Why can't you do it here! I want it now! I want it on cue! I want you to do it for me! If you can't see a way to do it, then stop looking at me and turn away. Do something different. Change your profession. Drop dead! Buy cars, sell cars. There are a lot of cars out there. That reminds me.... just cancel. Cancel all of this, we'll move on to something else.

I want a car chase sequence right here. Terminate on that plot over there. The car is going over that and into you. Well, if you splash open a little bit.... we've got a few.... yeah, yeah, yeah. We have a double, we have a triple, we have a quadruple, we have everything you need, so just take it easy. It's okay. We're going to work it out. If you can get up to sixty with the camera on it.... Okay, okay. I'm in front of you, take it easy. Just be calm, be collected. We're going to have a lot of noise now; it's going to be difficult. Wait! Let's take a drink. Can we have a drink? Can I have a drink, please? Cancel that! I don't want any drinking here! I don't want to see a single person do anything other than what we've asked you to do If it says "fuck" in the script then you do that, and I don't want you doing anything else. Cigarettes! No, no cigarettes! Well, okay, one cigarette.

Erase! Erase! Let's go back. We'll come at this again. We'll put in an electronic background here and we'll put you in prison. Now, where are the other extras? We can keep the bus. Use the bus this afternoon when it hits the train. That's it. The train here, the wheat field has to be burning. It has to be in flames. We want to see smoke, and flames. Yellow flames a mile high, Okay? Now kiss. Yeah, in the field. Not in there! Come out! I want a light on you. Yes, you. Get out of that shadow. Just turn, turn a little more, get the shadow just right, now kiss! No! I'm not talking about kissing each other. You didn't read this part, did you? I'm talking about.... yes, kiss the whatever you call that thing. Yes, that's right, kiss the thing. Where is the thing? Oh, sometimes I don't think I'm working with human beings here. I really don't. Sometimes I'm gratified. Sometimes I feel good. But not now! I'm going to fire you all! I'm going to send you all home. You can all just take it and leave! We don't really need to have so much of this, you know. We can have a little less sound. And now let's be quiet, okay? [*Makes noises through closed lips.*] Not bad, not bad. What? I think we'll have to cut. Cut! Cut! Stop the sequence. We have to put this together with the thing from yesterday. Maybe we can just loop this around and start over.

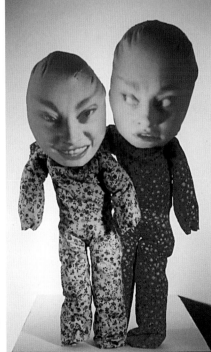

Let's Switch, 1996

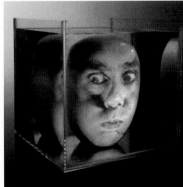

Underwater (Blue/Green), 1996

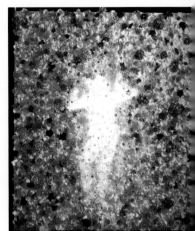

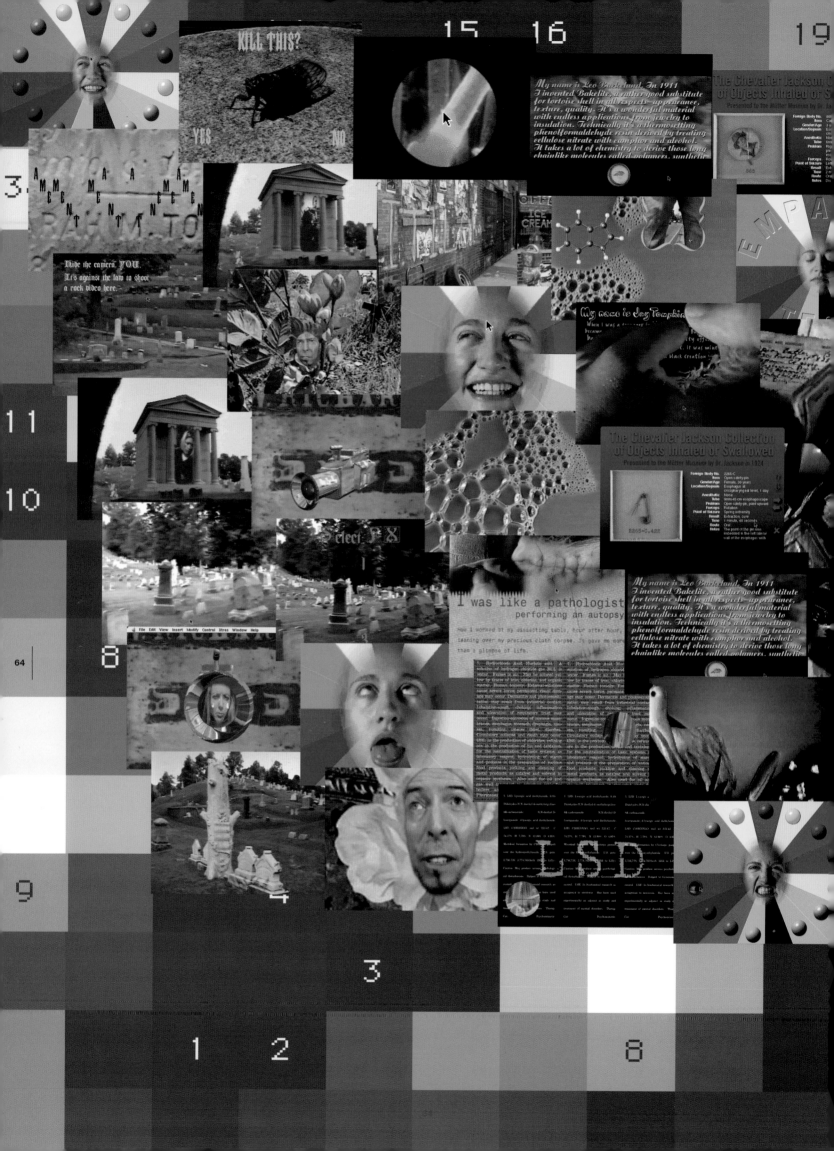

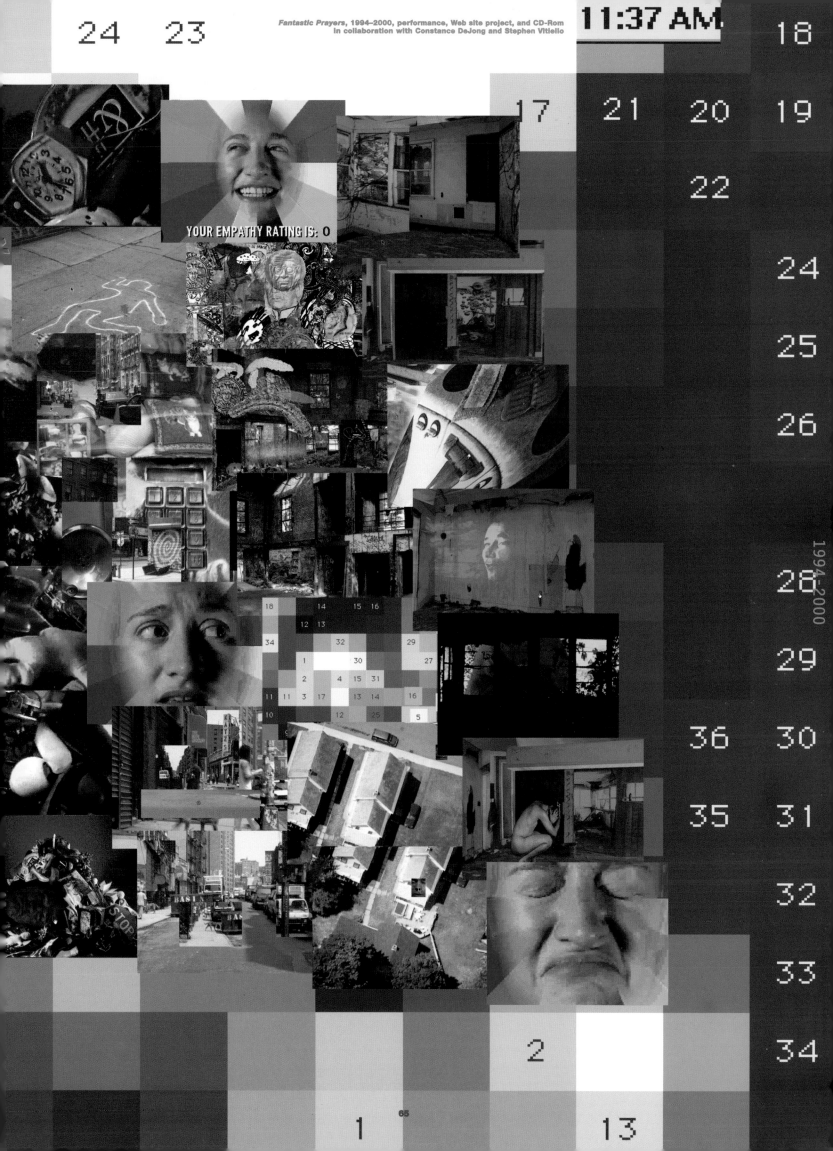

Fantastic Prayers, 1994–2000, performance, Web site project, and CD-Rom
In collaboration with Constance DeJong and Stephen Vitiello

YOUR EMPATHY RATING IS: 0

1994-2000

studies of a troubled world:
the drawings of tony oursler

by ian berry

Shooting Star, 1983

Camcoder, 1993

Losing control, whether by drugs or other chemical contaminants or through the influence of advertising and television, is a thread that weaves through much of Oursler's eerie and engaging artwork. Drawing has served as an integral part of his multimedia output from *I'll Get You*, a loose pencil sketch on a torn-out page of notebook paper made in 1970 when the artist was thirteen years old, to collaborations and several different series. The past few years have witnessed a resurgence of Oursler's interest in his works on paper, inspired in part by the artist's first drawing retrospective exhibition held at the Kasseler Kunstverein in Kassel, Germany.[1] The accompanying catalogue, which resembles an artist's book, was conceived and designed by Oursler as a visual record of the many forms of work the artist considers drawing. As an introduction to the plates, Oursler selected quotes from influential figures such as John Baldesarri, Otto Dix, William Burroughs, and Marshall McCluhan to be printed amongst his own writings. Oursler writes, "Each object I touch has a text. Like it or not, I hear it, I see it. Each touch throws me hopelessly out of my time, out of my mind. In this fractured psychological state I'm amazed that this fragile scribbling on paper survived."[2]

Oursler continually makes drawings to serve a variety of functions such as storyboards, sketches, props for videos, and simply to record ideas, much like a diary. His drawings are more spontaneous and less controlled than his painting, sculpture, or even improvisational performance and video. In their immediacy, his drawings manifest what we consider to be the medium's most recognizable function and feel: drawings exist as the product of the most direct connection between mind and hand. Roughly executed and unencumbered by the need to be finished works, these pages are where Oursler's mind is most laid bare, most open to the inner spaces of creativity – and in his case, the farthest reaches of the psyche.

Common elements of drugs, money, sex, and obsessive fears revolve around a central autobiographical voice. In one scene two anxious, disembodied eyes watch as two hands pull at a

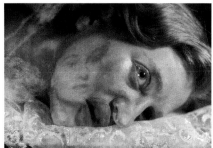

Talking Photo, 1996, edition for Artists' Space

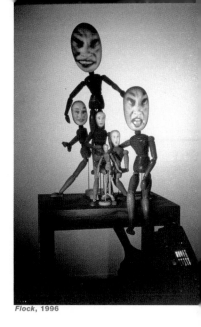

Flock, 1996

Sketchyblue, 1996

wishbone; the caption reads, "Wait – don't crack it, I've got a wish." Two cartoonish thought balloons float above, one with a naked female torso and the other with a handful of dollars. Another page includes, "You may never know what will become of your actions – let's say you leave a sheet out on the clothes line and you live on a corner. This may cause an accident at your intersection." The captions provide us with glimpses at the over-the-top paranoias that help uncover the dysfunction of the world around us: "Sanity is suspect." Television, advertising, and both physical and psychological poisons invade our world. Oursler chooses to dive headfirst into the abyss. He enters as an artist-observer taking notes on our everyday maladies, but occasionally he gets dragged so far undercover that it becomes difficult to decipher where control begins again.

During the late 1970s, while a student at the California Institute of the Arts in Valencia, Oursler began forming his mature body of work. There he was first introduced to the work of William Wegman, who taught at California State University at Long Beach and who also saw the rich connections between video and drawing and delighted in the immediate play afforded by both: "By drawing I could deal with really far-fetched content, subjects that were awkward for photo or video recording. Drawing opened up the realm of possibilities."[3] Wegman's quick one-liners with their subtle critique of 1950s America and 1960s minimalism engaged Oursler by both their style and content.

Fellow artists Raymond Pettibon and Jim Shaw have also exploited drawing as a means to create powerfully twisted visions of our world. Pettibon's captioned sheets and early punk album covers and comics and Shaw's lengthy compilation of pencil-drawn dreams include what critic Benjamin Buchloh recently referred to in Pettibon's work as "the vast pandemonium of sexual disorders, pathologies, and phantasmagorias."[4] The fractured subject matter of their drawings reflects the cacophony of contemporary culture that similarly drives Oursler's images of characters in distress.

Oursler comes from a family of writers; his grandfather

Daisy, 1995

Insomnia, 1996

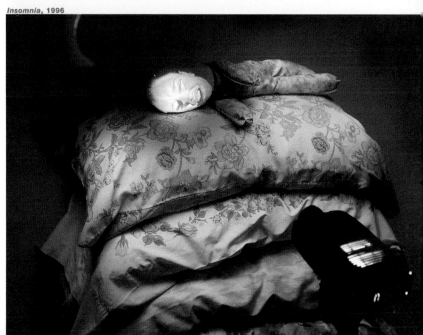

Fulton Oursler wrote *The Greatest Story Ever Told*, and his father, also Fulton, is a former editor of *Reader's Digest* and continues to edit journals. This lineage is exposed in Oursler's own penchant for creative writing, often incorporated in the many pages of sketches and notes. One page alone includes Dreams, Death, Religion, Ghosts, Hallucinations, and Psychic Experiences. The stories underneath each category form the outlines of narratives that may be developed further and acted out in single-channel video, or remain as notes unrealized in any other form, such as "Problems of a Man," "Join the Paranoid World," and "Things Tony Has Done in Other's Dreams," all from the early 1980s.

Oursler's works on paper remained as loose sketches, writings, ephemeral painted cardboard props, and more refined storyboards until the early 1990s, when he embarked on several watercolor series: *Designer Drugs, Closet Paintings*, and *Camcorders*. All feature finished studies of single objects, often without accompanying captions or texts. *Designer Drugs* is a pun on the recreational drug fad of the 1980s, with images that mix floral stencil patterns and chemical diagrams of the drugs. Heroin, for example, is paired with a brightly colored country border pattern and suggests the activity that might be occurring behind the façade of a smartly clean New England home. *Closet Paintings* is a large series concerning poisons or things hidden away, such as PC-7 epoxy, prescription pill containers, shoe polish, feminine wash, spot remover, Wild Turkey whiskey, and Coca-Cola. Prominently featured is the packaging of each product, with brand name and logo; advertising is just as poisonous as the corrosive chemicals in soft drinks and the toxic solvents in shoe polish. The *Poison Candies* series, also created in the early 1990s, similarly features brightly copied logos and packaging but adds almost-hidden details of tampering and decay. Each piece is a wooden, three-dimensional object, hung on the wall or placed along the floor, that reveals some sort of creepy disintegration, alluding to Halloween candy scares and drugstore product recalls. The *Camcorders* series is a more sober, monochrome series of watercolors of then-current models of video recorders. Each camera floats on the page like the catalogue advertisement from which its image was taken.

Drawing is often the best means for Oursler to visualize the collided and morphed images made by mixing television, movies, science-fiction, historical research, advertising, and all the other sources that flow in and out of the artist's consciousness. The collaged nature of his influences manifests itself physically in two recent drawing series, created by taking carefully chosen images from encyclopedias, manuals, and newspapers and projecting them via overhead projector onto twenty-by-twenty-four-inch sheets of paper. The images are painted or sketched one at a time onto the paper with acrylic, pencil, or pen, alternately by the artist and an assistant.

One of these most recent series includes images of nineteenth-century projection devices superimposed over skulls; the other is a monochrome series of six of these early projectors. These drawings are born from the artist's current research into the history of projection and the curious reappearance of devil imagery found in these sources. As in the *Camcorders* and *Poisons* series of the early 1990s, single objects are presented head-on or in profile in the center of the page. But in the recent drawings, these central objects are overlapped by other elements – maps, electrical grids, and TV news anchors – that swim together in a new mass of imagery, symbolic of the media onslaught we wade through each day. The seemingly random combination of images from unrelated sources mirrors Oursler's interest in channel surfing and in the proliferation of public-access cable television programming.

Oursler has described his drawings as attempts at "capturing an idea." Viewed separately, his sketches and notes form a hallucinatory stream of stories, fantasies, and dreams; taken together, they reveal the tension that fuels his work in other media. Oursler's own heading from an early 1980s notebook illuminates this tension: "Deep psychological creativity and underlying themes of essential human hopes and fears."

1. Tony Oursler, *My Drawings 1976-1996*, was shown at the Kasseler Kunstverein in Kassel, Germany, from 24 November 1996 through 5 January 1997. A catalogue of the same title was published by Oktagon.

2. Bernhard Balkenhol, Tony Oursler, and Kasseler Kunstverein, eds., *Tony Oursler – My Drawings* (Cologne: Oktagon Verlag, 1997), np.

3. William Wegmann, http:// www.wegmanworld.com/art-drawings.html.

4. Benjamin Buchloh, "Raymond Pettibon: Return to Disorder and Disfiguration," in *Raymond Pettibon: A Reader* (Philadelphia Museum of Art, 1998), 232.

Ian Berry is assistant curator at the Williams College Museum of Art.

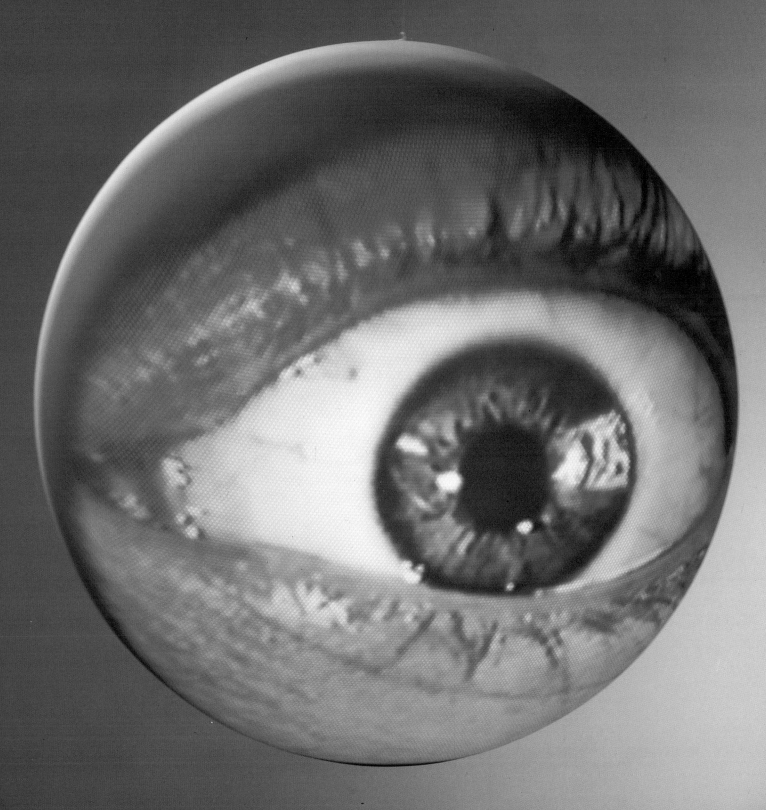

1996

talking back:
a conversation with tony oursler

by elizabeth janus

The history of this "conversation" dates back to 1993, when the Belgian magazine *Forum International* asked me to interview Tony Oursler. After discussing the prospect with the artist, we decided to put on paper segments of a real conversation that we had started when he was at the Centre d'art contemporain in Geneva that same year, working on his installation *White Trash and Phobic*. This interchange revolved specifically around Oursler's latest work, which was at a crucial turning point at the time, as a few years earlier he had stopped producing the single-channel videotapes for which he was best known and had begun to concentrate almost exclusively on more elaborate installations comprised of human-like figures onto which he projected emoting or talking faces.

We discussed, at length, larger questions about the evolution of video as an art form, especially the fact that more and more artists were turning to the medium and incorporating it as one means among many into their general output. Another issue that we addressed was how video had begun to move out of its "ghetto," one in which specialized curators, critics, and other interested cognoscenti traveled the circuit of video festivals, which at the time were the primary venues for most video art. Already having a prominent place within this specialized scene, Oursler was in the process of breaking out of that tight-knit circle by showing his works in a number of European Kunsthallen and museums.

When *Forum International* abruptly stopped publication, Oursler decided to use our written conversation as one of the texts for a catalogue accompanying his exhibition in 1995 at the Kunstverein in Salzburg, and it was in this publication that it first took shape. Since then, Oursler and I have continued to discuss the ideas behind the development of his work, publishing the text in a variety of forms: as part of a special issue of the Swedish periodical *Paletten*, which was dedicated to Oursler and Öyvind Fahlström; and for the catalogue that accompanied his one-person exhibition in 1997 at capcMusée d'art contemporain in Bordeaux.

The version published here incorporates these earlier texts with more recent insights into Oursler's art. – *E.J.*

Elizabeth Janus: When I first saw your early videotapes, particularly *Grand Mal* [1981], I was struck by how familiar they seemed. This is partly because your early style was consciously childlike – using garishly hand-painted sets and body parts for characters – but also because the tapes typically revolve around simple stories about good and evil. I find these moral tales not at all didactic partly because of your use of irony, which is at the same time funny and unsettling. This lack of preachiness tends to make one focus less on what the stories can teach rather than how children's stories, fairy tales, etc. (and children's television!) are used as powerful instruments of moral and ethical instruction. I was hoping that you could talk about the source of these early narratives.

Tony Oursler: I am a bit defensive about the term "childlike." There is a heavy reverence for the very male and very adult use of the tools of technology, and many people have categorized my work as childish, which to me is like saying that regression in psychoanalysis is childish, or that the shadow plays of Bali are childish because of the use of hands.

But in retrospect, these early tapes do have a celebration of youth culture in them. Like a dramatic play that reveals large issues in broad strokes of black and white. This I still find profound. Like a kid who is constantly asking, "Why? Why? Why?" over and over again.

I was trying in this early work to create a mental space through the use of narratives and images. Some of these are about events that date from the ages of six to thirteen and up to maybe twenty-four, which was the age I developed this work. I was, and still am, interested in a psychodramatic grammar of moving images (cinema and television), and it seems that dating information and characters is part of that. Also, there's a shorthand to express many of the images – places, people, things. I tried in this early work to make images move with the means available to me, in other words, my body, which is at the core of what I can move. But I should say above all that the early video-

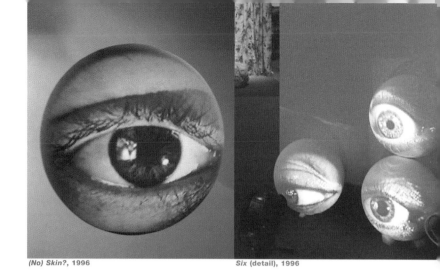

(No) Skin?, 1996 *Six* (detail), 1996

tapes were designed to mirror a thought pattern or process. This is in opposition to a film grammar, which is about looking outward and attempting to replace the eye. My work is designed to work *with* the way we really see, which has to do with a very complicated referencing system full of memory, conjecture, and multi-voxed narratives.

As you said, good and evil play a big part in my early work, and that may be because I tend to see things in black and white. This is, of course, a major aspect of the Catholic Church world view with which I grew up. The rules are intended to make life simple and "good" and to order one's thoughts and, above all, to *focus fears* in a direction for the good of the countenance of the church. But I don't know what happened with our generation: it just didn't take. I do have a very active spiritual mind, but it seems to me that most people wanted to be "bad" when constrained by the foolish strictures of the church. I could see the hollow aspects of various rituals, the hypocrisy, the lies. I could go on, as I'm sure that you could, too. But the biblical style of narrative was – and is – of great interest to me personally (I plan to read the Bible soon!) as well as American culture in general.

It seems to me that the Catholic Church is at the end of an era: its narratives are so at odds with the cultural setting and the lives of its "followers" that it's in a state of total restructuring. I'm thankful for my early connection to the church because it's given me a mystical side to counteract the techno-materialism of our age. It's given me an ability to show reverence for systems and things unseen: conspiracy theory, paranoia, etc. But back to your big question. It is also the root of my interest in questions of good and evil in narratives. I'm interested in involving the viewer in the drama – one must make some judgments, empathize, place oneself in the picture, so to speak. But in the early work, I was attempting to work with pseudo-universal themes in a way that would make a connection with the viewer – a comfortable space for them to enter, to react, and to complete the text. Thus, how they feel about themselves is part of what they make of it in real time. And, as you say, we become aware of what the story is trying to do to us, we invent the overall meta-narrative. My use of irony, thus, is designed to be read on many levels but mostly as a kind of deconstruction mechanism.

The early sources for my narratives were what I call personal/pop: a combo of supermarket tabloids and personal experience, mostly things that I picked up aurally from others. I was like a narrative antenna in the early work – studying and collecting urban legends, fables, folk tales. The only unifying factor in these tales is that they never really happened. They are always told second or third hand: "Listen to this: a friend of a friend had

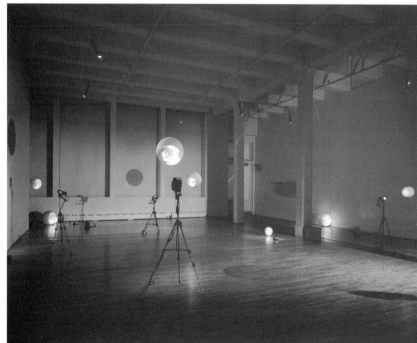

Eyes, 1996, installation view, Metro Pictures

1996

MMPI (Red), 1996

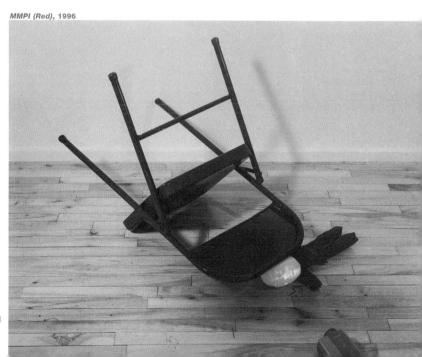

this happen...." A pseudo-scientific collection has been made of these, giving great detail to history, religion, etc. But I am really interested in how one's own narrative history is created: what you did, what was done to you. Somewhere there is an inner guide to good and evil. Everyone must make a choice, as we are all subjective. Maybe the attempt to codify these two forces has something to do with art making. Is that crazy?

EJ: The stories that made up these early tapes were also grounded in an intricate and highly articulate narrative structure, suggesting a deep-rooted interest in language. Could this have anything to do with the fact that you come from a family of writers and editors?

TO: My family history has been a great influence on me, which is something that I would not have admitted when I was younger, as there is always a struggle of separation. All of my relatives are storytellers, some are professional writers, some are just great at orally recounting a story, and this, no doubt, has been of consequence for me. . .

My own use of narrative was always intended to trap the viewer: a structure to build upon, play with. As with my use of "actors," my narratives are constantly falling apart. The more I study narrative structure, the more I become convinced that there is no such thing. What we know as narrative is really a mental or physical predisposition in the reader/viewer rather than a structure.

EJ: Video has been your medium of choice since the beginning, even though I know that you paint and draw quite a bit. Video seems to have become one of the most relevant tools for an artist today, given that ours is a largely visual culture and television has become, as many of the early video artists predicted and Benjamin Buchloh articulated, "the primary social practice of visual meaning production." Though your use of video has evolved over the past decade, from the tapes to more complex installations, have your reasons for using it changed much?

TO: I think you know that I see a direct link of relevance, in terms of medium, leading from cave paintings up to video. Now I see digital technologies as the great unifier – but this is the technical side of things, and basically I have no respect for solely technology-based work. The cultural value of these technologies is always a distorted reflection of desire, which perhaps is why I was attracted to video in the first place and why I continue to use it. Maybe it's like a miner finding gold – no, that's too romantic – it's more like a junkie finding a fix. Anyway, how we make art with moving images is our only hope of remaining vital in this culture.

The problem is that it takes time to watch video works, and most other art doesn't. People have a hard time focusing their attention for any length of time, and it is very difficult to make anything with video that will hold the viewer's interest. It's a form that creative people should pass through and return to when they have to. It's a very hot island. I have to keep leaving or else....

When I look at the short history of video, most of the best work was made by artists, not video artists, for example William Wegman and John Baldessari. It wasn't until the 1980s that artists gave up the conceptual torch to make some money and thus to fracture the art world into separate mediums. Now it's great to see things changing and video is back again, just in time for it to dissolve into a big binary code – black and white again.

My use of video has changed over the years in the sense that the early tapes, like *Grand Mal* [1981] and *The Loner* [1980], were interior worlds that we could all meet in. Now I am using dummies, which are agents that enter the world in a more aggressive way, more as catalysts. This was already happening with the hybrid sculptures, such as *Spillchamber II* [1989] or *Kepone Drum* [1989], which were physically fragile.

But back to my early tapes.... These inner worlds were very much a psycho-landscape, and I thought a lot about the nature of places, sets, landscapes, and how these could be made to "talk." The classical approach to video space is within a Western hierarchy, which means that the head is the center – eyes and mouth – and the rest of the picture is background or is part of the frame. Video is also a hypnotic medium and leads to a neutral space – this is the place inside which we grow, and it is important that we swim into it, make it two-way, violate the power structure of technology. Now I'm interested in putting the video *into* the exterior world and letting it function there. The dummies are one solution to my transition into that world; they are mirrors of the body in it. They take the space of the screen and displace it. The storyteller has come full circle. Language and image become one, as they do in the human body. Video no longer acts as a window to look through but is somehow made physical.

A few years ago, when I made my first dummies, I was thinking a lot about how movie time – media time, the camera, the narratives – has really punctured our world, how it is the fourth-dimensional space of our time. I tried to make figures that could exist in between the interior and exterior worlds, literally, like seers that we can't see and can't see us. You can begin to see this in the two dummies that were installed together in 1993 at the Centre d'art contemporain in Geneva, *Phobic* and *White Trash*.

EJ: Several of your installations from the last few years have made direct references to identity formation, states of mind, empathy displacement, phobias, and multiple personality disorder. I was thinking specifically about your early installation *Model Release/Par-Schizoid Position/Test* from 1992, which was shown at the Institute of Contemporary Art in Boston, and the piece that you just mentioned, *Phobic*. Perhaps you could talk a little bit about your general interest in psychology and about these pieces in particular.

TO: Coming back for a minute to *White Trash* and *Phobic*, these works are a bridge between two subsets of dummy projects: the "movie" series and the series based on psychological states. These two subsets intersected in a sea of blood, so to speak; or, more simply put, in my ongoing interest in violence. I'm questioning the impulse to re-enact extremely elaborate violent trau-

ma – a violence that takes on ritual dimensions – and whether this is somehow a positive service that the media performs for the public or whether we are involved in some kind of sick cycle. Anyway, death and the fear of death seem to be great motivators.

What I enjoy about the attempts to codify the human mind, as in the MMPI [the Minneapolis Multi-phasic Personality Inventory – a test used to determine personality disorders and the basis of *Test*], is that it seems to offer an interesting, direct way to engage the viewer, which, in general, is always a goal of mine. I think of it as a trap, in a way, exploiting the nature of the mind, much like persistence of vision in film. People have to answer questions; they have to complete the picture. So I was attracted to the systems of tools designed to define pathology. One thing that has become very clear to me recently is that I use a method of connecting systems: personal to public. This is why I'm intrigued by psycho-history, how paranoid schizophrenic theory is used to explain the oppression of groups of people, like the Nazis against the Jews in Europe and the Puritans against witches in America.

EJ: Your interest in MPD [multiple personality disorder], besides being a continuation of your psychology-directed works, seems a natural consequence of these investigations into the relationship between violence and the media and more specifically between the media and memory. As Pierre Janet first recognized in studying the symptoms of hysteria, multiple personalities are the result of a pathological fragmentation of memory, usually the memory of a violent trauma.

For the installation *Judy* [1994] at the Salzburger Kunstverein and later at the Institute of Contemporary Art in Philadelphia [1997], you created a visual essay on MPD, incorporating its causes and effects, such as the dissociation and fragmentation of trauma and the development of alters, into an interactive environment. Perhaps you can describe how your ideas for this installation came about and how it relates to some of the recent emoting dummies and dolls, for example those that weep or have fits of hysteria or rage.

TO: The emotive works came first – they are an attempt to distill mental states. For me these works became the embodiment of the link between the media and the psychological states it is capable of provoking: empathy, fear, arousal, anger. I have always wanted to be able to cry at will; the idea has always fascinated me, but I could never do it. I work with actors, sometimes artists, writers, and performers to crystallize these states, like directing a movie consisting only of the most extreme psychodrama localized in a single figure. Mostly, I've worked with one actor, Tracy Leipold, who does some work with the Wooster Group and lots of other things in New York. We have developed an understanding, and she is really able to go into some amazing places and to take us with her.

These experiments led to an informal catalogue of emotions and states, some I call sublingual. They are interesting to a larger audience because they don't need to be translated. Anyway, each of these states or combination of states became a work or entity. Seeing these entities multiply over time was a natural

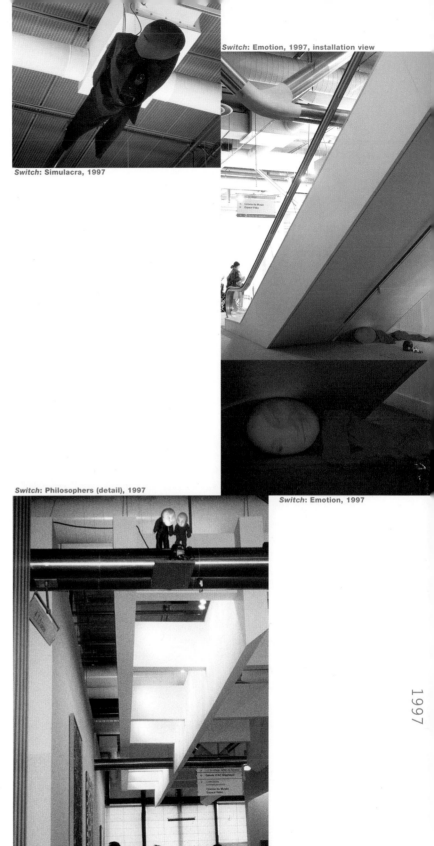

Switch: Simulacra, 1997

Switch: Emotion, 1997, installation view

Switch: Philosophers (detail), 1997

Switch: Emotion, 1997

1997

Switch: Plan, 1997

bridge into the subject matter of MPD. At this point, I should mention a few features of this disease. As you said, MPD generally occurs in victims of the most extreme cases of sexual, violent and/or psychological trauma. A defense is developed to protect the "core self," which creates personas to accept aspects of the unbearable torture inflicted upon them. Dissociation is the unconscious mechanism in which a group of mental activities "split off" from the main stream of consciousness and function as a separate unit.

There are many analogies between MPD and the media-viewer relationship, the multiple switching unknowingly from one personality to another like a hypnotized actor. They can be seen as a collection of characters acting out a horrible, true-life drama. In fact, some psychiatrists theorize that multiples are really just experts in self-hypnosis. It has also been theorized that since the U.S. seems to be suffering from an epidemic of MPD while it remains unknown or rejected in the rest of the world, it is a mass-hysterical epidemic fueled by pop cultural accounts in the media.

I would suggest a deeper relationship: an internal mirror of media structures and individual practice in relation to it. The viewer's ability to empathize and evoke vicarious hypnotic psychological states for the sake of enacting archetypal dramas is the logical foundation. Physicians have even likened the multiple's ability to shift personalities to channel switching or "zapping." Perhaps, for some, the television interaction is a model for a new psychological frontier. Certainly, the accounts of MPDs, the destructive manner in which they live, have been a steady narrative in popular books, TV, and movies.

Originally, I wanted to work with an actual multiple, but working with Tracy seemed wiser and more to the point, which is not to emphasize the exotic aspects of the disorder but to see how our culture is reflected in it. In *Judy* she represents three alters/personalities: *Horror*, *Boss*, and *Fuck You*. A fourth, silent figure, performed by Catherine Dill, returns naked to the womb. The fifth is created by an interactive, or should I say symbiotic, situation where the participant enters into the work. Tracy and the flowers, which are everywhere – a sort of mock feminine camouflage or skin – are the unifying aspects of the installation.

The surveillance simulacra (remote control camera and audio system) situated above the entrance of the Kunstverein in Salzburg could easily be controlled from within the installation; it allowed the participant to "see through the eyes" of the figure outside and to speak through it.

EJ: Besides your individual works and the recent large-scale installations like *Judy* and *System for Dramatic Feedback* [1994] you have done a number of performances, such as *Fantastic Prayers*, which was shown in the U.S. and in Europe, became a CD -ROM, and was part of the Dia Center's Web site. I know that in the past, collaborative projects have been very important for you and that you have worked with such artists, musicians, film-makers, and performers as Tony Conrad, Constance DeJong, Karen Finley, Joe Gibbons, Kim Gordon and Sonic Youth, Jim Shaw, Mike Kelley (most recently on *The Poetics Project* for Documenta X), as well as many others. Perhaps you could talk a

little about your past performances as well as future projects and the importance of collaboration for you.

TO: In 1988 I got really involved with collaboration as a strategy. This is especially true in relation to the videotapes, which, after ten years of making at least one tape per year and expending lots of extremely personal energy, I felt I had finished with. In a way, I thought that I had nothing more to prove and that I would start to repeat myself, as I had certainly developed many habits after years of making tapes. So, rather than stop producing them altogether, I thought that working in collaboration might be a way to go. The fact that I prefer to "use" artists in my projects is because they are always willing to experiment and often have an authenticity that actors do not; the exception being Tracy, who is like my alter ego, and we have learned to experiment together.

Constance DeJong and I had worked together on some major projects in the past, but in 1988 we decided to really try to produce some hybrid works. The result was *Joy Ride*, a fourteen-minute videotape, and *Relatives*, a sixty-minute performance incorporating live performers and television monitors, which toured extensively throughout Europe and the U.S. These are works that neither one of us would have produced individually, so in a way they are quite mysterious to me. At the time, I really liked the idea of creating a new artistic identity by working with someone else.

These two projects then were followed by the Sonic Youth music video *Tunic (Song for Karen)* in 1990 and two situation comedies, *ONOUROWN* [1990] and *Toxic Detox* [1992] with Joe Gibbons. These last two really pushed my personal identity to the point of discomfort and, though I really enjoyed the results, were the end of my making videotapes.

EJ: In 1995 you produced a series of human-scale double figure projections, the first of which was titled *Autochthonous* and consisted of a male figure whispering to a female one who, staring blankly ahead, was protesting emphatically, as if the voice she was hearing was somehow coming from inside her own head. In this case, you try to visualize an autochthonous experience – one in which ideas or thought processes arise independently of one's own train of thought and thus seem to come from some external or alien source – by giving a human form to the voices she's hearing. As such, this piece seems related to your work on alters and multiples, but in another, very subtle way it functions analogously to the process of artistic creation itself, the so-called artistic imagination, which, as we have seen throughout the history of art, literature, and music, is often the result of artists' psychoses or induced by drugs or alcohol. Is this reading way off the mark?

TO: Well, at last you have brought up the question of that split, the second one, the reflection, the twin, the darkness, the other, which lately has been present in my work. I don't know when I first became interested in the subject, maybe in reading *Donovan's Brain* as a teenager, or living in New York City when the city government decided to release large numbers of psychi-

atric patients from the hospitals, which was a cruel civil rights act for the mentally ill. I was fascinated by the person that I would see walking down the street holding a very animated, one-sided conversation, so I tried to imagine what the silent partner was saying. This open conversational structure, as we have already discussed, has been an ideal model for me: a model of the relationship between the viewer and the work of art. I have always fantasized about a dialogue that invites a creative engagement on the part of the viewer.

In any case, these two-figure works, which I call the *Autochthonous* series, add a twist to this idea as they imply that there is a darker drama going on precisely because the viewer can't hear but rather is compelled to *imagine* an aggressive, antagonistic voice; in other words, there is a collaboration with the darker side.

I did write very specific texts for these works, which were inspired by the concept of violation. I was thinking about aliens and demons because there is a real ambivalence about responsibility in those cases, and there are certain questions that remain open, often without an answer: Is this self-imposed? Have you done this to yourself? Are *you* the dark side of yourself that you are fighting? It would be just too easy to target a murderer or a torturer. What if you yourself are the figure back there, just out of sight, that one whispering into your own ear.

Ironically, [Alfred] Binet first wrote of *dédoublement*, or the split consciousness, in relation to a patient in Bordeaux, so I was really pleased to have one of my *Autochthonous* works in the museum's collection in the city where it all started. The texts or half-texts for these pieces were written in the spirit of hypnotic recollection, a blend of past and present time, for example: "Don't make me do that again – NO, NO – I don't like it, I'm not listening, I'm not listening, I'm not listening to a word that you're saying. Don't make me go up there again, please." I really love the recounting of alien abductions, which are rich in religious and sexual connotations, and back in 1993 this really informed my writing, as it did ten years earlier with my installation *L7-L5*.

But I tend to think of artistic creation as generally marred by drugs and alcohol rather than enhanced by them. Perhaps psychosis may have shaped some basic artistic impulses, but where is the follow-through, the discipline, the craft? I can only think of a few productive artists who are chronic, because for most artists, all of that stuff just dampens their fire. I always wonder what people would have done if they had managed to clean up, how much better the work could have been. On the other hand, there is a fuzzy line of distinction between addiction and other forms of mental illness. Often it's a "which came first" sort of guessing game, with free will at the core of the problem. People with various classical organic conditions achieve the status of "outsider" artist, but really it is just their form of expression that we respond to, the fact that they paint or draw, which makes it fall into the acceptable category of Art. Other activities could be just as interesting but are a little more scary. The fact is that the thinking involved in these conditions is truly fascinating, regardless of its manifestation. But I don't see madness as whispering into the ear of the tormented artist. Sadly, it

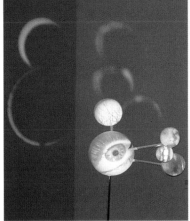

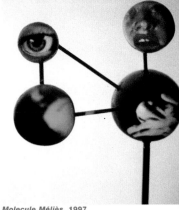

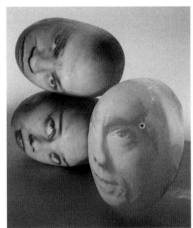

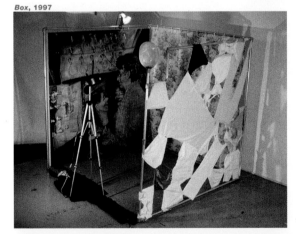

Molecule Spectre, 1999

Molecule Méliès, 1997

Man She She, 1997

Guard Booth, 1997

Box, 1997

Street Light, Münster, 1997

1997

seems that most people don't even have the luxury of that much distance. Madness equals total saturation. No way out. Home alone for a lifetime, like Henry Darger. He certainly was able to capture a pure streak of illness and convert it into a most amazing secret art. Can a dialogue with illness translate into the larger context of art? I really wonder. I would like to see Darger in the context of the Museum of Modern Art, New York, or perhaps eventually in a Disney-like context. Imagine the spin-offs, the dolls and computer games, and, of course, the theme park with rides. Someday we may see a history of art from the last hundred years rewritten to include so-called Outsider Art, the Lost and Forgottens, the Firsts and Thirds, and the Pop (but without the term *art* attached to it). Then we would really see a whole new list of artists. Most people I know have this expanded list already in their heads.

EJ: At the beginning of 1997 you did an elaborate site-specific installation titled *Switch*, which was commissioned by the Musée National d'Art Moderne in Paris. In most cases, when you do installations, and even when you do exhibitions of individual pieces, you always seem to try to integrate the works into the specific context of a place. I imagine that this is to a large extent necessitated by the fact that your work tends to be fairly intricate in nature and often there are complex technical aspects to be considered, but also I think that you are genuinely interested in context and how a place will act upon the audience's understanding of your work. Perhaps this comes out of your conceptual art–influenced background.

The site-specific installations so widespread during the 1970s were intended not only to evoke a history, a political connection to or some other association with a particular place, but they also had an intentionally ephemeral quality to them, the result of a wish by artists to focus on the "here and now" of an art action or intervention rather than on a final product. Obviously these utopian days are long gone, and we know that even some die-hard conceptualists had to document their actions, to make related objects or images, in order to survive.

But back to *Switch*, which is a fairly complicated installation involving interactive sound and image functions, light bulbs that speak, a huge eye, and several of your dolls and dummies, which in this case take on the characters of an omniscient director spouting cues and stage directions and a pair of "philosophers," who release a stream of axioms and philosophical propositions. Perhaps you can talk about some of the ideas behind this piece and how you would situate it in relation to earlier site-specific installations.

TO: Site is really the crucial term for this work, regardless of the seventies baggage that comes along with it. Most of the time, working in a specific idiosyncratic space is a bittersweet experience. One tends to spend most of the time collaborating with the site, researching it, extending it into the work and vice versa. I say "bittersweet" because after investing in a given exhibition and space, one feels compromised to some degree by what you call the "ephemeral" aspect of a work, the fact that it is eventually removed when the exhibition is terminated and may never

feel quite the same when installed in another context. Some even question the validity of site-specificity: "art should be able to exist in any context, be universal," and all that blah-blah-blah.... When it does work, though, when the art really resonates, then it can reach a pitch that is beyond the sum of its parts, and it can turn out to be something greater than either art or architecture.

Working with a particular site has been an interest of mine for many years, as in *The Watching* [1992] for Documenta 9, which was in a staircase in the Fridericianum, or *Private*, an installation I did in 1993 in an old house in Oslo. So when Christine van Assche asked me to propose something site-specific for the Pompidou, I was delighted because the work would end up in the national collection, which meant that it would stay on-site forever – even if not exhibited forever – instead of being taken down after a month or so. This added a new level to the project.

Switch was designed to fit, or rather to work with, the Pompidou Center. I spent a lot of time just looking around the building, taking in its energy, which I was already quite familiar with after having worked there with Christine in 1985. I love public space in general, and the Pompidou Center is a wonderful example of a cultural public space – the people really use it, hard. I remember visiting it as a kid when it first opened, when there were people having picnics with blankets, wine, smoking – whole families sitting on the floor of the paintings galleries. It was wild. In 1985, while installing one of my dark room works, I got to know some of the technical assistants working there who told me some great stories about how they had to design screening rooms that were not too dark and without too many nooks because they had found people fucking in the museum. I was hoping that people would do the same in my installation. Maybe it was this experience that led me to some of my decisions for *Switch*.

So it was the inaccessible spaces of the museum that attracted me. In fact, the set-up there is basically like a giant warehouse, with very high ceilings and the legendary exposed pipes. The gallery spaces are merely a set of walls, so that you can see the ceiling from almost everywhere. But the gallery space seems very small in proportion to the rest of the space, and most of it is inaccessible, above your head. It's funny that way: you can't get to most of the space. So invasion was in order.

I started to envision the installation as having something to do with the difference between the theoretical and the actual, the instructions and the execution, the map and the place. While watching people move around this building one wonders: Have they been fulfilled by the cultural events that first attracted them here? The struggle to transcend is really evident there. At the same time, I began to organize the work as a loosely related set of pieces to be spread across two floors, occupying the off spaces. By "off" I mean the spaces that have no direct use. For example, I placed an emotive red figure under the escalator, hidden below this endless stream of people ascending and descending . . .

I had been working on the notion of truth and how we equivocate about reality, so I wanted two small twin dolls arguing or discussing in various verbal forms, ones that would go on and

on. They would basically be talking over each other, ignoring what the other was saying, almost chanting. It was with these two figures that I had some fun with French stereotypes. For these figures I worked with Warren Niesluchowski, who translated and performed the texts in French; he has a great mind and a presence on camera. The text came from several sources, as I wanted a high-low conversation: everything from philosophy 101 to pop stuff, personal improvement junk, and very technical proofs of truths like the following universally quantified sentence formula:

(c) (c will go bump in the night)
All cats go bump in the night,
Any and all cats go bump in the night,
All cats are such that they go bump in the night,
Every cat goes bump in the night,
For any cat, it goes bump in the night.
– Richard L. Kirkham

EJ: Recently you've started to break away from representing full figures to concentrate on individual body parts, for example the group of individual eyes first shown in New York [1996] and the disembodied heads that were included in the 1997 Whitney Biennial. If I'm not mistaken, the precursor to these works is your installation *System for Dramatic Feedback* [1994], in which you projected various body parts, such as an erect penis, a punching fist, and a pregnant belly that twitched periodically, onto a pile of clothing meant to represent bodies.

The eye pieces, which are oversized spheres onto which you project a single, blinking eye, initially give the impression of having a symbolic or totemic value – I'm thinking of the little amulets in the shape of an eye that are carried or worn to ward off evil. On the other hand, the "talking heads," which are individual faces projected onto oval-shaped smoked glass, are very minimal representations of a human presence that more directly focus the viewer's attention on what the heads are saying (the spoken text) rather than on the sculptures' likenesses to real people. Interestingly, the label "talking head" originally was used to describe the close-up of a person – such as a news commentator – on a television screen and still has this connotation. Taken in combination, these two sets of works suggest a tendency on your part to move away from the uncanny aspect that has so fascinated viewers of your dolls and dummies.

TO: I guess it was a natural process of breaking down the body – or rather, rearranging it while at the same time not letting it die completely. The piled-up figures that you mention in *System for Dramatic Feedback* were amputated and connected at the same time: both aspects diminished by an emphasis on individual actions yet expanded and designed to flow in a way that made it impossible to tell where one part ended and the next began. It is a sculptural representation of a psychotic point of view, "I can't tell where I end and you begin," as well as a hippie point of view, "Look, we're all connected by a shared physical state."

But the way I used the space for this installation was also very important. It was divided into various areas through which the viewer had to move. Besides the pile of figures, there was also a large wall projection that showed a film audience seen from the point of view of the movie screen – a reverse-angle shot that showed them in their theater seats, munching popcorn and watching. This was very "situationist" in a way and difficult to shoot, but it cast the entire room into that of a media space. The pile of bodies was placed off-center, and a small "horror" figure that was screaming was placed on the floor in the corner. But as I said, the final layer of the project was the viewers, who wandered in and around the space looking at the various parts.

As you say, the individual eye pieces did come out of that project. Your likening them to amulets is lovely, and from this idea you might even see them in relation to those ex-votos representing a sick part of the body that one finds in churches. What I was trying to do was to simplify and to personalize some of the ideas found in *System for Dramatic Feedback*, try to make them more exact. One could say that the recursive relationship between the viewer and the movie screen, which in the case of this installation is doubled by its being projected onto the wall, is all concentrated in the eye. And, of course, the body. But the thought of making an eye on the same scale as the body would be colossal! So I used the macro function on the video camera to shoot the eyes; it was the only way that video could ever approach the resolution of film or create something that is larger than life in extreme close-up. Somehow that translates into a medical – and almost pornographic – intimacy. Each piece was created by first videotaping a person's eye and then projecting it onto a sphere. The video image wraps around half of the sphere as though it were a rounded movie screen, allowing us to see the eyeball in great detail. And, reflected on the surface of the iris, one can see a very small image from a television or movie screen. The pupil expands and contracts with the light from the media that is reflected in it, almost as if it were reflexively feeding on the light, opening for the dark parts, closing for the bright ones. The eye as an object is a model for a number of systems and, of course, machines.

As you point out, with the eyes and with the talking heads there is a move away from the uncanny. Though, to tell you the truth, I just stumbled onto figurative sculpture. It was, and remains, a very perverse challenge for me and a way to get to the place where only they can lead. But really my point is that the body has never been made "flesh" in a media state. If you look carefully at the talking heads, they are perfect metaphors for a free-floating self. Media like television and film were invented to mentally take the body outside of itself: whatever the brain wants it to be, it will become. But the free-floating head is a trope that is ever-present. I guess I first noticed it in early American political cartoons.

My talking heads, which are pre-recordings that are slowed down, fast forwarded and sometimes freeze framed, are mostly spouting found texts like "the worms crawl in, the worms crawl out" and other types of children's rhymes on the edge of everyone's memory, on the tip of everyone's tongue – you know, the sing-songy things from childhood. Each head says something different, and when they are put together in the same room, they

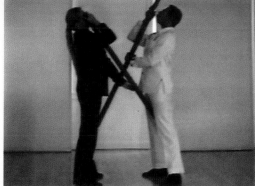
Pole Dance, 1997, video still

talk over each other. So hearing each individual text is not nec-
essarily so important but rather how such rhymes have entered
into our consciousness and have stayed there. I am interested in
how such things occupy a rare, almost democratic – by the peo-
ple and for the people – niche in the collective psyche, and I real-
ly believe that they can give one insight into a particular nation
or culture.

EJ: For your exhibition at Metro Pictures in the fall of 1998, you
took on the theme of the *vanitas* as it was elaborated in seven-
teenth-century Dutch still-life painting, using a collection of
plaster skulls onto which were projected mouths and other body
parts as well as scrolling texts about the aesthetics of death. It's
interesting that you have turned to such a rich and ominous sub-
ject now, since the end of the millennium has been – at least in
the past – a moment when many began reflecting on and prepar-
ing for the Apocalypse. While this may not be literally the case
for you, such a vision can be seen as analogous to current, con-
flicting attitudes about technology's potential as either a savior
of the human race or, because of its presumed alienating quali-
ties, the cause of civil society's downfall, and your combination
of the skull's symbolic weight as a *memento mori* with video
images makes it the perfect sign for this duality.

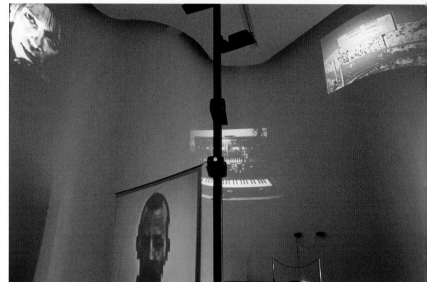
The Poetics Project, 1997, in collaboration with Mike Kelley, installation view,
Museu d'Art Contemporani, Barcelona

What also struck me about this installation is that, like tra-
ditional images of the *vanitas*, there is an ambiguous moral
undertone, one that allows a double take on the fleeting nature
of life: on the one hand suggesting that we behave ourselves for
the coming of Judgment Day, and on the other hand inviting us
to indulge in the pleasures of life before we go the way of all
flesh.

TO: About a year and a half ago, I started thinking about the
nature – both abstract and symbolic – of objects and about the
sign's physical manifestation. One thing led to another and I
began to think about the ways that objects are brought together
to form a composition, eventually arriving at the concept of the
still life.

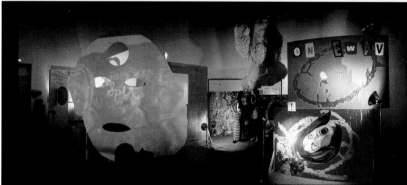
The Poetics Project, 1997, in collaboration with Mike Kelley, installation view, Documenta X

Usually I develop a body of work related to a topic very
much outside the art world, but in this case, perhaps because I
had been drawing and painting a lot for *The Poetics Project*, I
became fascinated with the potential of a sort of meta-artwork,
which the still life seemed to embody. I envisioned a project
involving sculpture, found objects, painting as well as moving
images, some of which I would produce, others that were pre-
existing, but all of them tightly edited, like images within
images.

While looking for that essential "object" onto which I want-
ed to project the images, I discovered in various shops around
the city these highly charged but also very generic plaster casts
used as craft items or kitschy, kinky curios. Guns, flowers,
clowns, dragons, phalluses, skulls: an endless catalogue of the
world as blank icons scaled down to an obtainable size.... Since
they are blank forms devoid of any surface treatment or color,
they suggested a kind of screen that I saw as something between
the mental and the physical.

As I continued, I started to mix in more personal items, like

The Poetics' Re-enactement Rock Videos, 1997, video still

Synesthesia:, Interviews about Rock and Art, Alan Vega, 1997, video still

1997

a landscape painting that I found in my aunt Zita Mellon's studio and some handmade things that looked like DNA nodes of viruses.... So I began experimenting with video projections on these "compositions" of blanks and non-blanks that quickly became very complicated. While mining my massive archive of videotape, I built up layers or zones of imagery that corresponded to the composition, and as the subject matter of each work became evident, I shot new material: poems, scans of my body, explosions taken from TV....

The end result was a suite of three of what I call viruses that were shown at the Kunstverein, Hanover.... First, a virus is the smallest living thing that transmits information, and their exponential reproductive potential is a rudimentary form of communication. As [William] Burroughs said, "language is a virus" – a metaphor I love that suggests ideas flowing in vectors, amplifying, mutating, and affecting the host. There is a universality to the process, and somehow when you look at the structure of the actual virus as a sculptural form, so much is reflected in it, like the cold spartan utility of a plague with the circuitry of a computer chip. This became the subject matter: collage, mutation, composition, the cyclical nature of ideas, archetypes, along with some personal references....

As you said, the presumed alienating qualities of technology were certainly at the heart of my strategy. After Hanover, I took some months to do nothing but read and research. I had been collecting quite a bit of material on the history of television and the technologies that preceded it. Most of my recent work has had to do with current trends – day-to-day life in relation to technology – but digging into the recent past made me really curious, and I read further into the psycho-technological aspects of art and history.

At first, I started making a big timeline of the social implications of technology that showed technological developments alongside various cultural trends, particularly those connected to horror and fear. Surprisingly, these led me directly back to the still life. The ever-present skull – the *memento mori* – in many of the compositions seemed to be the harbinger of a death culture, and its shape implied the false or surrogate consciousness that is at the heart of media.

In looking back at the history of the still life, the skull kept getting bigger, overwhelming all the other objects in the composition, and the blank white surface seemed to dominate the picture. At the same time, certain technological advances were having an ascendancy, [such as] the camera obscura. It seemed to me at this point that the skull was only one step away from the camera obscura: a dark chamber with light streaming through an opening – the empty eye socket – into the lost sea of consciousness. A frightening cliché, but it was an icon that kept returning.

At the height of its popularity, the still life was an example of an art of the everyday – something new at the time – that was also in confluence with the development of the camera obscura, which facilitated the ability to mediate reality, capture it, codify it. But the presentation of information at that moment – the narratives, the images – was all within the system of signs and symbols intricately intertwined within the delicate composi-

tions of the still life. I find it really interesting that this language is possibly the basis for a system of reading images that can be considered the first "virtual space." This was year zero for me; the advent of what we now know as media.

You also mentioned the ambiguous moral undertone of the *vanitas*, which implies a duality and can be seen as well in the "technology" of the camera obscura; in other words, how do the dark inside and the light outside meet? I guess when I was tracing this history, I was looking at the dark side, the representation of death or more exactly the consequences of the representation of death: its psychological and physical manifestations, the rush associated with fear and how it is triggered.... But in every era the skull has been all-important due to the effects that it produces, namely fear and excitement, whether it be a Clive Barker horror movie, the Victorian interest in displaying a murderer's tools, a text by one of the Graveyard Poets, or [Edward] Robertson's Fantasmagoria. Make me laugh, make me cry – the skull is everything and nothing and the most overcharged icon that I've ever tried to rescue.

EJ: There are two other qualities that I found interesting in this installation: your use of feedback as an aesthetic tool, and a greater emphasis on light, for example in the wall projections with insects flying around – flies and moths, I think. Certainly the fly with its connection to putrefaction and decay fits in with the fear/death combination.

TO: One of the works in the Metro Pictures show, *Feedback*, was inspired by the feeling of being bleached, washed out, flooded with the light of media – like when you've had too much sugar and watched too many hours of TV and you start to feel ill. I asked myself, How is it possible to record such a light? The answer was simple: just create feedback by recording directly off the TV, which is one of the oldest tricks in the video art book but still very interesting. The recognizable images are amplified and their over-modulation turns them into meta-images: you can even see patterns in the spiraling light that seem to be coming at you. In capturing this light, I thought of a text that I had read about the stereoscope, written by Oliver Wendell Holmes Sr.: "Form is henceforth divorced from matter. In fact, matter as a visible object is of no great use any longer except as a mold on which form is shaped. Give us a few negatives of a thing worth seeing, then from different points of view, and that is all we want of it. Pull it down or burn it up, if you please.... There may grow up something like a universal currency of these bank-notes or promises to pay in solid substance, which the sun has engraved for the great Bank of Nature." I took this as a departure point for the skull that became *Feedback*, in other words, the twaining of matter and form: a frightening parting of the ways but an essential one.

The fly figures into two of the works: *Aperture*, which is a still life, and *Camera Obscura*, an edition consisting of only a black and white projection of a fly that filled the back wall of the gallery. The projector was situated behind the exact center of the opposite wall and projected through a hole; it turned the space into an actual camera obscura, with the light catching people in

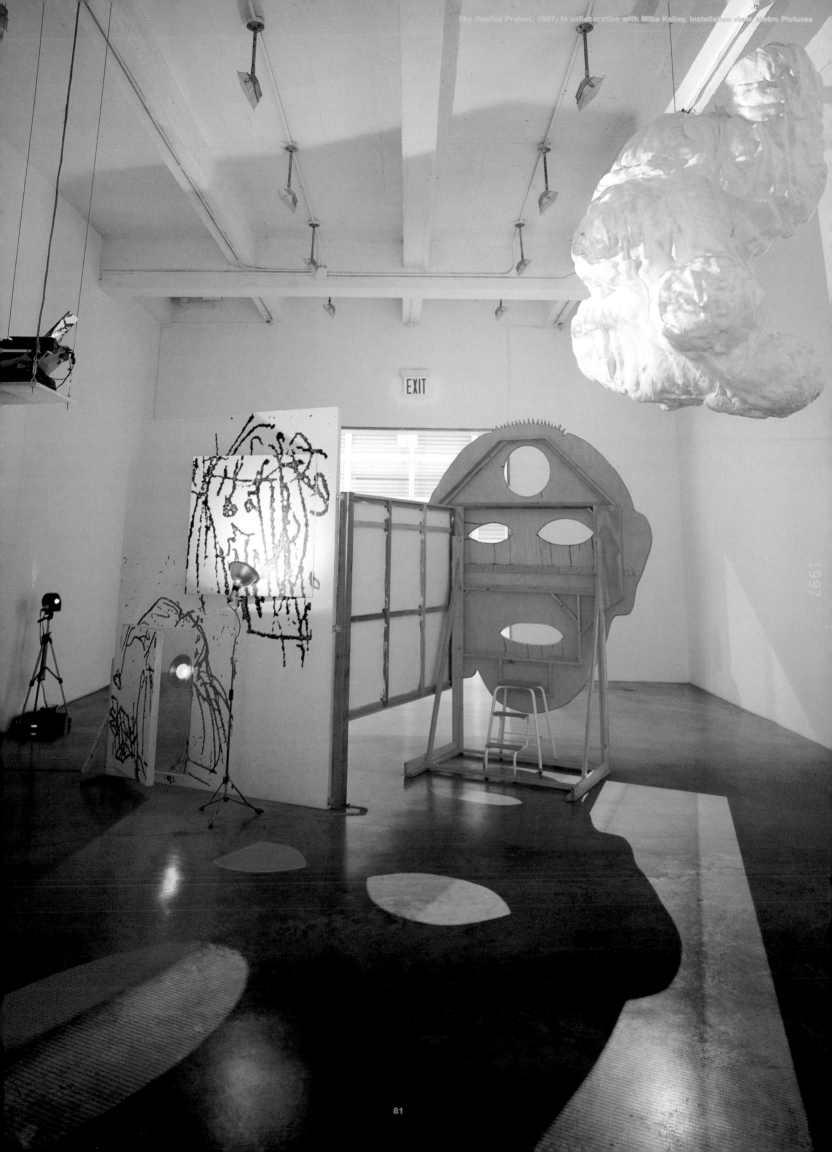

the eyes in half of the room. Much like the scrolling text, the big fly crawls all over the place, searching, ever searching. "The butterfly as a symbol of salvation and resurrection is in opposition to the dragonfly which, according to Ulisse Aldrovandi and Thomas Moufetus, was seen as a sub-species of the common fly. With reference to Kings 1: 11 (Beelzebub – lord of the flies) they considered flies to be creatures of the devil." – Norbert Schneider, *Still Life*.

EJ: There is one particular skull – the one with the jewels gushing out of its orifices like maggots – that has on its surface the projection of a talking mouth. It is obviously the most luscious, even decadent, of the group but also the most unsettling because it takes the skull outside of its solely symbolic context and reanimates it in a way that suggests earlier representations of a "living" skeleton: the grim reaper as well as the image of mortal illness.

TO: As I mentioned before, the skull is an ever-present icon, but it became important for me to shift the context. I wanted to "dress up" death, if you will, for different occasions. In the piece that you mention, *Hole*, I tipped my hat to the sixteenth century and the question of afterlife, using a moralizing, warning tone from a Latin text found on the painting *Vanitas: Still-Life* by Barthel Bruyn the Elder, which is on the back of a portrait of Jan-Loyse Tissier from 1524. Translated, it reads: "Everything decays with death/Death is the final boundary of all things." On this skull I fused and altered this idea with other references to evoke the sensation of life as dream from which we wake into death, and Tracy Leipold's mouth is seen projected on the piece, performing wonderfully in Latin and English.

There is very little spoken text in these works, but I still wanted to create the sense of a dialogue, as if death couldn't only talk to us but that we could also talk back. I really became fascinated by the ways that text was incorporated into the *vanitas* paintings. Language was somehow worked into the design, for example a winged figure that often holds up a scroll over someone's head. This spurred me to include the scrolling or rolling text as a layer in these works, and I really like the way that the moving texts crawl over the three-dimensional objects. This forces one to read it on many different levels, to focus on the process of reading, how text *really* works, which is something I've often discussed with my friend Constance DeJong. In the process of reading, the context of sound and image are changed, which was really a breakthrough for me.

EJ: I remember many years ago reading about the band called The Poetics that you had formed with fellow students at Cal Arts in the late seventies. At that time, I thought it was very much indicative of that decade, when artists were actively trying to work through some of the formal constraints of minimal and conceptual art by moving among disciplines and media as a way of figuring out how to use their conceptual heritage but in new and different ways. But I also thought that your participation in The Poetics shed a lot of light on the performative base of many of your early tapes and, in fact, even more recent works in which you are often the sole performer in some of your "talking heads."

When you decided to remix some of The Poetics' songs, resuscitate some of the early videos, and re-create the performances for your collaboration with Mike Kelley in Barcelona and at Documenta X (1997), it became not merely a reconstruction of those actions but an elaborate revisionist look at the art and music – and its critical reception – of that time. As a result it became a complex melding of fact and fiction.

The late nineties seemed a particularly ripe moment for this type of revisionism, since fashion was just then beginning to romanticize seventies counterculture as a quasi-mythical movement of unbound freedom and creativity. And the paintings that you and Mike made for the project also came at a time when new interest in that medium, especially its connections with electronically produced and manipulated imagery, was on the rise. Was this project an important turning point for you?

TO: In *The Poetics Project*, the story is the art work, so where do I begin? As you say, it's a mix of fact and fiction, and in retrospect, I wish that there were more facts available to the viewer, but ironically it's a matter of sound mixing the information that we had, and the viewer had to be willing to spend some time with it so that it could "seep in."

Let me begin the facts as I see them. There was a band called The Poetics that Mike Kelley and I started when we were at Cal Arts. It was a project that began as a rock band – with me usually singing and playing the organ, Mike on the drums as well as other things. We also produced radio, performance, dance, and sound pieces. We were a loose-knit group, and the members changed between 1977 and 1980. I moved to New York in 1980, and after that the group's activities declined. As you suggest, the seventies were a time of expansion in the art world, and we were definitely picking up on the so-called post-studio ideas so prevalent at the time at Cal Arts. Conceptual art was and is very important for me and set the tone for The Poetics' strategy as well as my own work apart from the group. We were all over the place musically: punk, psychedelic, no-wave, noise, and sound track. At the time I was very interested in the master, Bernard Herrmann, and Nino Rota, and I was doing all my own sound tracks at the time.

After we drifted apart, Mike and I talked several times about putting out some sort of recording of the group. I had kept all the band's materials because I was the one who recorded all of our practices; I did this so that I could listen to my voice and to the songs' structures, etc. Unfortunately, this was all done on fifty-cent Kmart tapes in a ten-dollar cassette deck – though we did do a few 1/4 sessions and once went into a real studio. So, I decided to dig up some of the old tapes, and we eventually compiled and released a three-CD set that captures some of our best sounds and some solo stuff, too. The filtering and re-mixing was a major effort, and some of the material was too degraded to even use, but who knows, maybe one day we will re-record that lost material. Around the same time, I was doing an extensive drawing project for Bernhard Balkenhol of the Kasseler Kunstverein, so I had been looking through old shoe boxes full of stuff: thousands of papers that I wanted to preserve, to date,

to photograph. Among these materials I found "The Notebook," which is a black and white, marble-covered, lined notebook that was The Poetics' bible. Inside, there were notes for all the lyrics and performances, even some installation and sculpture designs. I had been focusing so much on the musical ideas of the band that I had forgotten all the other elements that were evident in the notebook. For me, it was a window into the visual side of the group.

In 1977 I was only dimly aware that there was an art school band thing. I knew that bands like the Talking Heads had come out of art and that many British bands had been formed in art school. Through the years, this phenomenon interested me, and even when I was teaching it still continued. Part of *The Poetics Project* was historic, and we wanted to look at it in that context: to try and understand it and process it overtly. From this point of view, the project fit well into my research habits even though I have never been interested in autobiography. I usually like to keep a little more distance in my work and find that the individual as subject is interesting only as an interchangeable sign. Besides, The Poetics experience had some very painful moments for me, which I was not interested in reliving. Of course, the other side of *The Poetics Project* was personal. We wanted to look at the material produced by the group – it was so long ago and there was so much material that we had forgotten how much we were attracted to the perversity of completing something that was twenty years old. But there was plenty of material to dig into on both the personal and the historic levels, and that became our working premise: to do an installation based on our experience in and around The Poetics.

Mike and I decided to present the project in 1997 at the new Richard Meier-designed Museu d'Art Contemporani in Barcelona. For the exhibition we decided to make a minimal arrangement of large video projectors attached like flags to tall poles that stood in the center of a room with very high ceilings. This was our first attempt to use The Poetics' material for a collaborative project. I have been very interested in the idea of re-enactment, and Mike and I decided to play around with a "pseudo-documentary" as a way of developing the work. We both had vivid memories of the places where we had worked and played as a group – important Poetics locations – and we decided to try to visit and shoot them on video. Mike did a lot of the research since he still lives in California, and he even went to shoot material at Cal Arts as well as some old apartments, houses, and restaurants where we hung out. We even went to a few "swap meets" – those great markets of used goods that were inspiration for us and a way to collect art supplies. Then we looked for a compound that at the time had been inhabited by artists, where we used to party and the band had played. We looked and looked for the place but never found it, so instead we decided to shoot the search itself. The journey, then, became the subject matter: looking for the lost architecture, lost locations, lost events, and it was all very poetic. California is one big changing set without a past.

Mike and I shot some interviews with Poetics members or friends, and we had them recount different performances or memories of the music we had played. I masked their faces with

Early Cinematic Device in Red, 1997

Poetic (Coda) #41, 1997

Rating System, 1997

Reception, 1997

a digital video block effect as if they were criminals or afraid of being recognized while they made their comments. Mike also shot the famous Vasques Rocks in the desert, which was a charged location on many levels since it has been used by the film industry as a prime location for westerns or sci-fi flicks. I then "psychodelicized" this footage during the editing in homage to the acid parties of the period. Mike wrote a text that I can only describe as based on the relationship between personal history and music, which he had his old landlord (who is an actor) perform on an old synthesizer – very annoying and in keeping with our music. We even used footage of the sound mixing of the three-CD set. Finally, I hired Robert Appleton to play a generic Poetic, and he re-enacted some very simple rock videos. Since most of The Poetics stuff predates MTV, I wanted some very in-studio, chroma key–looking lip synching, so I collected some footage of LA freeways and some video that I had shot of Cal Arts in 1977 and used these as backdrops for Robert's performances. In them he does some rock moves, some stripping moves (which I used to do) and singing in his underwear, all to our songs. He does a great job of it and it's very funny. The whole thing ended up as a mixture of time and landscape, reality and fiction, with the result being cryptic yet generic and something that could seem familiar to most people.

In the installation, we had at least three of The Poetics' tracks phasing and blasting at once. It almost obliterated the interviews, so later I added subtitles. This became the Barcelona version of *The Poetics Project*, which was later shown at the Patrick Painter Gallery in LA. Mike had special screens made to resemble the walls in Barcelona. Later it was shown in New York at the Lehman Maupin Gallery, where we did a special horizontal arrangement of the original Barcelona poles and added some drawings.

As the Barcelona version took shape, we were invited to propose an elaboration of the project to Documenta X. I wanted to move into a more graphic, sculptural direction that would key into the conceptual belief that the idea is the work and that it exists once it is put on paper. I had been thinking about this a lot when I heard that Bruce Nauman was showing works from the seventies that had never been realized before. I was familiar with this practice, and it seemed natural to take material from The Poetics' notebooks and have it made to specification. We used this as a starting point but also as an inversion of the conceptual training that had turned me away from painting. There was also an economic factor involved in working with hand-painted panels. The panels were references to the standard flat backdrops for performances or television scenery. I had looked into making large photographic or printed images, but it was cheaper to paint them by hand, and I liked the perversity of this as well as taking brush in hand again.

Since Mike and I live three thousand miles apart, we divided up the work and decided that some of the panels would be collaborative; in other words, we would visit each other and work together for some, while others would be individually authored. While I could go on about the sources of the images, the basic themes were ex-Catholicism, sex, drugs, and rock and roll. The results are highly coded on both the private and public

levels. For example, I took very small bits of stick figures, which I was really into twenty years before, and enlarged them from an eighth of an inch to four feet. This change of scale gave them an abstract, forensic feel, like a personal gesture that had exploded. I also made the notebook into a monolith, with camouflaged images of Brian Eno blended into the pattern.

The Pole Dance, which was a dance that we did in 1978, was projected onto the notebook. It was a dance that the choreographer Anita Pace had reconstructed from notes and memories; she did a fantastic job, which I shot as a classic, two-camera, black and white video documentary that lasted about thirty minutes.

So you get a general idea of how much detail went into the project. We experimented with layer upon layer of video projections onto paintings with sound coming out of some of them. For example, we made an installation of "battle" paintings with speakers embedded in their surfaces; these two faced each other with one, a green plaid canvas, playing a commissioned solo by Arto Lindsay called *Why I Love Guitar*, and the other, a glittering human heart, in which Mike does a solo called *Why I Love Drums*.

During the process of working on the project I became more and more interested in the music of the period, especially how vital and creative it was and how it helped blur the boundaries between sound and vision. As you mentioned, it was an expansive time and people were exploding all kinds of preconceptions. The conceptualist motto about form following content and the privileging of idea over craftsmanship changed the way we thought about what we could make. In retrospect, this was a kind of extreme idealism and a little in the clouds, but what do you expect? For me, the energy of that time can be summed up in the concept of crossover itself. The Poetics even produced a piece for the radio, which was profound for me, as it meant getting the work out there into cars and houses. In the seventies, artists were escaping the studio; they were interested in making art in more popular, public forms like music, performance, film, and video. The idea of crossover was and remains an important strategy for me…

As I look back on the last twenty years, there are certain histories that have been lost – a lot of performance, video, and computer art – and if the ways of working survive, there is very little committed to print. This hole was the impetus behind the historic side of *The Poetics Project*. I wanted to do some primary research into what artists of that time were thinking, so I made a list of my favorites and set out to interview them. Most were pleased to be involved, and it was a great personal pleasure to meet so many innovative artists. Mike was interested in involving critics as well and was going to do a series of West Coast interviews, which he still might do. I did the East Coast with the help of David West, a friend and fellow artist, and occasionally Linda Post. These interviews were an homage to these artists but also act as a foil to false assumptions that the project was self-promotion. Right now I'm working these interviews into a book and will release them on videotape later this year.

In the end, I learned quite a lot from the project and, as you mentioned, became reacquainted with painting, which I have

since continued to do seriously. But the real pleasure was to do the interviews and to work with Mike again. He has such an expansive view; it was a real journey. The reaction to the project, however, was really surprising. The mixture of information and noise did not make it an easy read (I remember that even in 1978 we would clear the room with our music), and one New York critic called The Poetics exhibition "the most irritating" of the season, which was a real honor for me.

EJ: *Fantastic Prayers*, which we talked about earlier in relation to your affinity for collaboration, has a long and rather complex history. It is one of your biggest and most complex projects to date and has been seen in various incarnations, the seeds of which can be found in many of your earliest videos. It started as a performance with the writer Constance DeJong and the composer Stephen Vitiello and blossomed into a CD-ROM and then one of the first artists' projects for the Dia Center's Web site. How did it all begin?

TO: The overall approach that DeJong, Vitiello, and I took for *Fantastic Prayers* was based on the idea of a landscape being distorted into a dreamlike flux between actual location and a narrative that had an almost physical presence. But first we should go back to the beginning as you suggested in your question, in other words, how did it all start? Sound experiments with them evolved into other projects, like the talking light bulbs in Münster.

As you know, Constance and I have been friends and collaborators for many years and we have written, videotaped, and performed numerous works together. I don't like to perform very much – I suffer from terrible stage fright – but I really enjoy putting together live and pre-recorded material, for example in my 1988–89 installation *Relatives*, which toured the U.S. and Europe with, basically, a television set and Constance. It was a very simple performance piece in terms of technology, but the idea was to present an electronic narrative in opposition to the very human act of storytelling: Constance and the TV together for one hour.

Several years later, the Dia Center invited us to do a performance and, as it happened, we had been working on a new improvisational piece. As *Relatives* became "locked" in time, we decided to develop a new body of material in several units of three to five minutes each and then shuffle them like cards: images of ghosts, insects, a figure falling down and getting up, and so on. The idea was to play them randomly like songs, and they had a very "can't read this" feel to them. We were trying to get away from the idea of a linear narrative, and it ended up being very experimental with some great moments. In the process we went through a lot of material, something like three different performances in three different places. One involved live video feeds and simultaneous broadcasts at R.P.I.

In 1994 we were invited to the Rushmore Theater Festival in upstate New York, and we produced a collaborative installation inside an old mansion, where we occupied the smoking room/library with projections and a text and sound piece that related to the early performance material, for example, ghosts projected onto the gingerbread ceiling. Constance also performed her "moon" text, which was projected onto a doll's head placed on a dusty book shelf. Outside, Stephen Vitiello placed speakers playing his music and bits of recorded texts in trees and shrubs all around the grounds. At the entrance to the grounds, in an old security/ticket booth, we put a large head with the projection of Tony Conrad's face. He was playing a director, spouting orders, which turned out to be really funny. At night, the insects were attracted to his mug, at least the light of the TV monitor, and they created nice little silhouettes. The big surprise of this installation, though, was Constance's and Stephen's sound work, which both of them had done before and are doing a lot more of now – really wonderful sound installations

So, *Fantastic Prayers* developed through these various incarnations and we began to think of it as a modular process. When we were invited to perform in the Dan Graham architectural pavilion on the roof of the Dia Center, we saw it as a fresh opportunity to regenerate and to bounce off some of Dan's ideas. This led to a sort of sci-fi/architectural/arcadian phantasmagoria that took place at sunset in Dan's half-mirrored structure overlooking the Chelsea skyline, west towards the Hudson River and New Jersey. Unfortunately, the performance was scheduled in May, and once the sun set, even though it was very beautiful, it became so cold that Stephen had trouble playing his guitar and Constance was shivering. This meant that the audience was really tested by our hypnotic ambient-performed installation, since they were frozen and ready to die by the end of it...

After this, Dia was very supportive of the whole project and realized that the work went beyond performance, so they helped us to design a very early Web site with texts and video clips. I'm pleased that the site is still on-line there, and I think that Dia wants to keep it in its original state until they can show the new version when the CD-ROM is finished.

At this point, however, *Fantastic Prayers* took a turn into the deep, dark digital world. Dia was interested in producing a record, but really more than a record, of our "event." We talked about videotaped documentation or a catalogue, but the CD-ROM seemed like a perfect vehicle for us and our material; it would satisfy many aspects of our collaboration and, of course, would allow us to continue experimenting and generating new material, which was a top priority. First, I wanted to thoroughly go over the technical end of the project, so it took several months of looking at what others had done with CD-ROMs and understanding the parameters of the form, which were, and still are, in constant flux. The rules include the fact that no two things can move at the same time, that no more than X amount of video is possible at that particular resolution, and so on.... so, given these strictures, it's not sure when we'll finish – maybe next month, maybe next year.

In reaching the final phase of *Fantastic Prayers*, which had little to do with the other phases in any overt way but everything to do with them in other ways, it became clear that the whole was a building process, that in the end it had begun to morph into something that took on a life of its own. The three of us – Constance, Stephen, and I – have too much respect for primary forms not to fully indulge in all the possibilities. And, early on,

Digital 3, 1997

we understood that computers – outside of live communication – are elegant archives that can exploit the natural drive to explore, to look around that corner or under that stone. This might infuriate some of our more theoretical computer friends because, at least now, artificial intelligence, interactivity, virtual reality, and the pipe dreams of the PR people at MIT are just not yet a reality. Some day, yes, but now all you get out of a computer is what you put into it. That's it. And, what you put into it is hard work, really hard. Putting in millions of hours for something that people will look at for a second! So, we also knew it had to be big; the word "big" meaning the sort of experience it would elicit, the time, the space or psychological distance that could be covered, the sound, the words, and the pictures, as well as the ways that all of them could be recombined had to be big. So we wanted to pack our archive as densely as possible and to use as many ways as possible to present data.

Even though I'm only one of the three in this (and can only speak for myself), I had the overall feeling that this CD-ROM is a battle between the forces of entropy and structure. That struggle infuses a compendium of each of our primary individual themes: sex, drugs, toxicity, creativity, color, dreams, spirits, sounds, decay, media, emotions, the novel, water, the I-Ching, music, cameras, Tracy Leipold, landscape, architecture, fashion, voices, things that stick in your throat, rock videos, rock stars, friends, graveyards, naked people, words, trash, VR nodes, and an old cup. Things break down into elements only to recombine into new narrative strands. Information, words, and images are cast off one reading in search of a new meaning while, ideally, the "players" guide this process and it builds within them, reflecting their personal pathway through the material. I've always felt that the work does not exit without the viewer, and here we have a very ephemeral bunch of 0s and 1s with no chance of coming to life without you. A giant house of cards.

Each screen was conceived as a different place with different laws and logic that operate within its parameters; we tried as best as we could to link the interactivity to the content of each. There is only so much you actually can do with existing technology, and that is always part of the equation. For example, the "Empathy Wheel" was the first and most simple click-response, which worked with the carnival graphics of colorful bands surrounding an image of Tracy. We wanted to fuse a game structure with that of a psychological test. During "play" a click on any band triggers a different emotional expression from her (there are roughly twenty). Once you decide to move on, the screen calculates your personal empathy level, from one through ten, by the nature of your playing.

Navigation was a big part of the creative process: jumping from place to place through various devices; for example, one clicks on an eye on the left and there are major screen jumps. We tried to use changing mouse icons and to design a sense of flow, of motion, into each screen.

I have always hated the look of computer-generated spaces, with their texture and slick surfaces as if trying to make something convincing – replication for replication's sake – but for no apparent reason. Most of the stuff I've seen would have been better if shot as live action, so that's what we did. We used a

continued on page 90

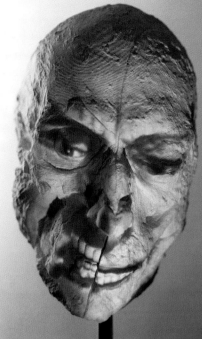

Kill or Be, 1997

Little Wonder, 1997, video still, in collaboration with David Bowie

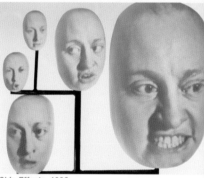

Side Effects, 1998

Escort, 1997

Actions Speak Louder Than Images (detail), 1997

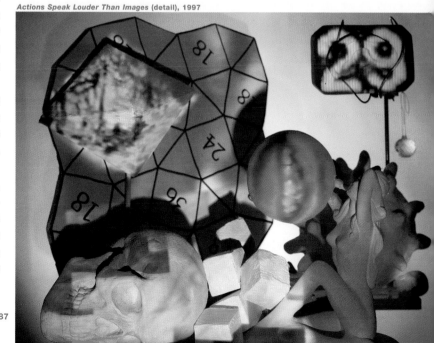

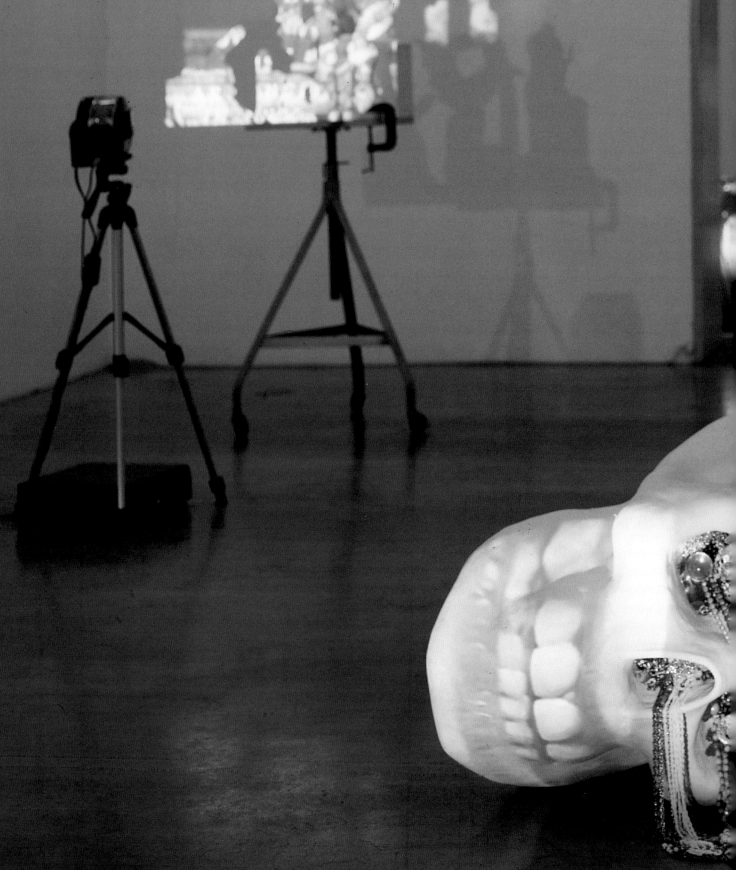

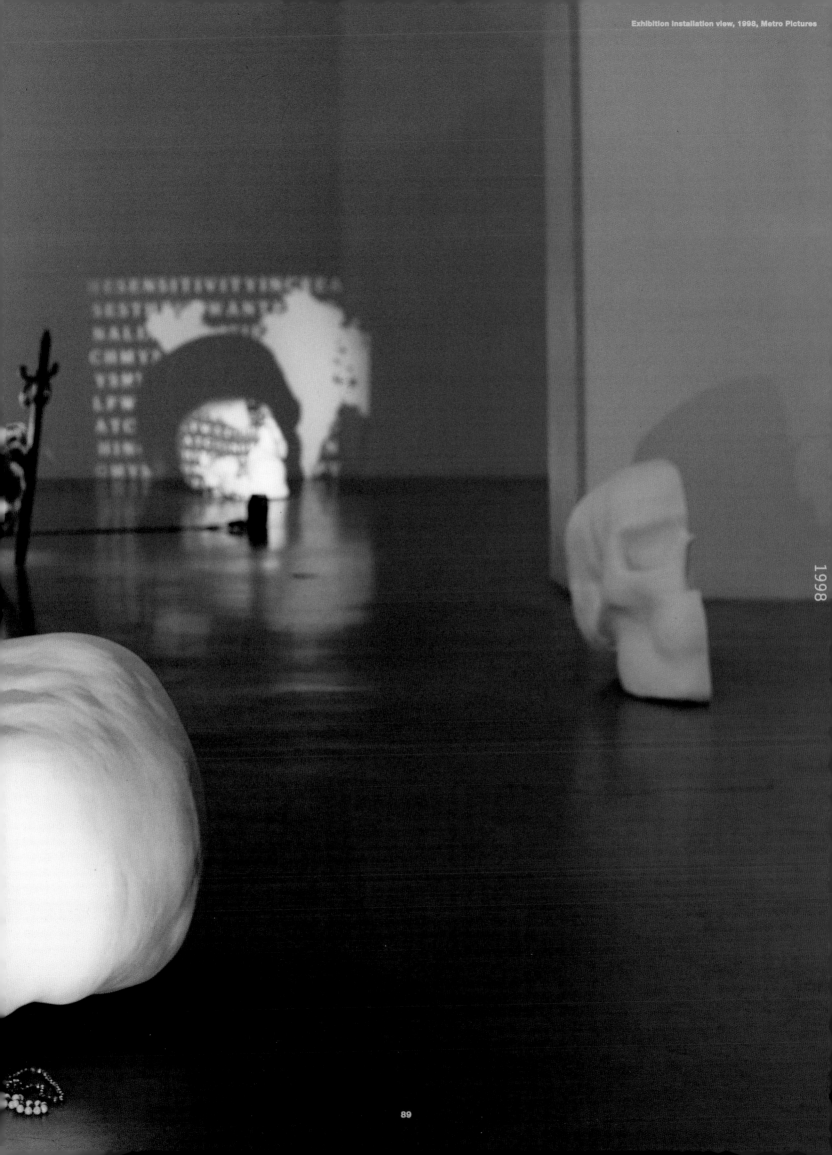

video and photographic base and let the computer do what it does best, which is to manipulate the material. In the "walls that speak" section, we built a classical 3-D room – a digital cliché – that was quite a challenge but inevitable in computer-land. I wanted to short-circuit the process by mapping photographic two-dimensional representation of three-dimensional space onto the "walls" of the computer, which is based in 3-D space; in other words, we took pictures of the peeling paint on the mint green interior walls of this weathered, old abandoned house from the fifties near Bard College and then mapped the photos onto the 3-D model of a room. The result contradicts a typical depiction of space and turns it into a composite space, which we found humorous. Someday, I'd love to see it built.

Inside this chamber, architecture is treated as if a recording medium – as if it could capture and fix everything that happened there. Domestic espionage. You can see into the walls as they melt into darkness and sound; you can see through all the cracks and pipes, and one gaping wall even leads to an aerial view of the suburbs, where Joe Gibbons orates about psychotropic drugs. Julia Scher buzzes as a flock of lips overdubs one of her amazing monologues. Mike Kelley appears pressed, muffled, and peering out of the wall and reads a poem that I wrote about a voyeur. A creaking door turns into a song written and performed by Stephen, Constance, and me.

Ludlow Street, where I used to live (as did many other artists), became another location because the street seemed the perfect device for connecting material, experiencing it. This was just what we wanted for such a loosely associated and discordant group of ideas. As players move down the street by pushing the mouse, they discover that the graffiti is really the title of DeJong's novel *I.T.I.L.O.E.* and they can read all the hundred or so pages by clicking on each of them. A pile of trash flows into an endless stack of photos of trash troops. One can go up to the roof and see a panorama – night or day. Vitiello's sounds and song fragments cascade out of nowhere or from a car radio. At the end of the block, there is a phone able to predict the future (a keypad can be used to cast the numbers of the I-Ching). Constance went to great lengths to translate the I-Ching, so it's really happening, it's really predicting the player's future.

The "jacket" screen was for the most part designed by Constance, and it is an idea she's been working on for some time but was never able to resolve – either printed text or spoken word – so the open, associative structure of the computer really worked for her. Nonlinear language is an idea that has been thrown around for some time, but as Constance has said, "You can't be truly nonlinear in a linear form, such as a book or videotape." So, this screen was an opportunity to move in that direction. With art-making, it often works that way: themes, obsessions float and recur for years and, with a little luck, they all come together. The jacket is an abstraction of a garment that is actually reconstructed by the player to reveal its origins in a narrative form: the design, buttons, thread, dye, and so on spin a tale in wild and intricate detail. Constance worked up some storyboards that were very loose and colorful but at the same time very detailed. During all the years that I've known Constance, I had never seen her draw anything, and it was a

window into a whole new side of her creativity. The drawings were so good that they ended up as the basis for a number of the subsections. Even though we worked with the design firm ReVerb in Los Angeles, and I shot some still-photo animation and video (the filmmaker Mark LaPore also donated a few images from India), it is the text that drives this screen, with the player taking on the challenge of decoding the object.

The jacket design was also a good example of how the three of us often switched rolls completely. Like Constance, Stephen had a lot of ideas for the visuals (he is very attuned the visuals as he has created so many soundtracks and worked on countless videos). Also, all three of us are very interested in sound, and Constance and Stephen are now working on a sound installation. But in *Fantastic Prayers*, Stephen is largely responsible for the sound tracks, which are a unifying factor throughout. His style of guitar-effects music is both sweet and gothic, and it keeps things floating from one section to another, meshing with the images and language in a style uniquely his.

One screen is a close-up exploration – one might say a forensic reading – of the chemical traces found in human hair, which looks really crazy – like a psychedelic landscape – when magnified a thousand times. We were attracted to it because any toxins or drugs introduced into the body leave a trace/record in hair as it grows. This chronological structure was attractive because it's like an organic archive of narrative conjecture flowing through the body. We arrived at a microscopic graphic format and injected various contemplations on some of our favorite subjects. (Kristin Lucas appears as a casualty of acid – great performance.)

The "Natatorium" screen is based on a 1930s-looking shell of a structure that once housed some sort of swimming pool and auditorium (but now occasionally acts as shelter to the homeless, to drug addicts, or teenagers up to no good) near the East River in New York City. It's a wonderful structure and very New York in that it is covered with layers of beautiful graffiti that almost visually obliterate the structure itself: language breaking it down, dissolving it into its component building blocks. The tags become transformative, turning the building into language and language into color like the essence of an entropic struggle. Working with this idea of transformation, we created a kinetic VR node through which the player can peel off layers of rot, insects, money, worms, children's drawings, video images, and architectural details. Our main design collaborator, Stephen Dean, worked closely with us to invent a mosaic of cascading images in a programming system that is really unique. At one point here, the player can zoom into the pixels until they become large blocks of color, each with its own number. The colors can be played like a musical instrument using the mouse like a sampler to make your own music; it's very computer, very abstract. Negotiating the technology can work for or against you, and Dean was great at turning things around for the better . . .

Another one of Constance's long-term obsessions is a "place where lost things go." It's a humorous place that we have all imagined one time or another, but here there are also somber overtones that reflect the stupid and mystical fact of losing an object. In the end, it becomes a kind of metaphor for mortality:

Poetry, 1998

Fear, 1998

Composite Still Life, 1999 *Flame, 1998*

1998-99

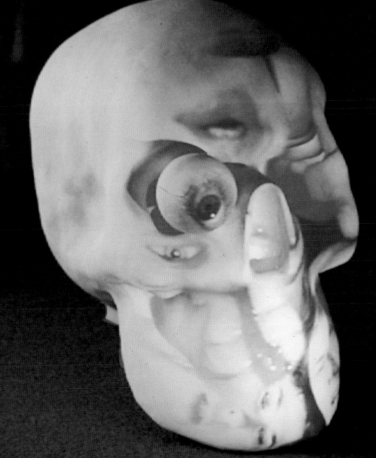

Ghost Ball, 1998

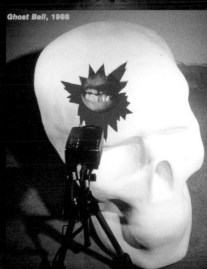

that dilemma of having something (or someone) vanish, like magic. It takes the form of a large pile of junk that keeps getting bigger and unfolding into sounds and visions. We were looking for that fragile bond we have with our things and how it can be stretched thin, then broken like in a Salvation Army thrift store where the dust is thick with sickly sweet memories, disposable love stories, and free-form melancholia. As the player digs into it with the mouse, he/she can animate lost objects with the whole process being one of a tentative reattachment – however fleeting – of meaning, of context, of flesh and blood, before finally letting go. In following the archival feel to this we embedded a subscreen into this one that was of approximately seventy photographs taken of objects from the Chevalier Jackson Collection of Objects Swallowed or Inhaled, which we discovered in Philadelphia's Mütter Museum. These were combined with corresponding medical texts and poetic commentary made by Constance. (The organization Arranged Introductions was instrumental in gaining access and permission to photograph this arcane collection.)

The "Graveyard" screen is our phantasmagoric media deconstruction. It was shot over two years and "bookends" the project for me; it was one of the first things we started with for the project, later adding more complicated material. We always had this crazy idea of relating ghosts to media, and in the performance we had planned, there were these elliptical death scenes (sort of James Brown up and down) that never made it into the final version. So in the CD-ROM, we continued developing the death/media relationship and the latter's ability to pre-form fundamental reanimation and provoke the uncanny. The inverse also might be considered: media as a negative drain on the life force, with the contract between it and the viewer put in question. I included shots of people passively watching a movie screen, which I used in *System for Dramatic Feedback*. So things have moved in and out of this project, and it has been densely creative and inclusive; the three of us used our personal archives and spun off lots of material that either did not fit or were turned into other forms, such as drawings and photographs. In this screen, things came together: past, present, and cicadas – that large, sluggish insect that appears around every fifteen years and overruns the Northeast, eating, flying, mating and, above all, making that very loud, high-pitched drone twenty-four hours a day. Linda Post and I became fascinated by them for their Biblical connections. So, as the player moves through this graveyard screen, he/she is faced with a cicada on a gravestone and gets to choose whether to kill it or let it live.

Constance and I share a great respect for some gothic novels, such as *Frankenstein* and, particularly, Bram Stoker's *Dracula*, which we had read together and analyzed in awe. Some years later Joe Gibbons and I had shot extensive video footage in a cemetery near Franklin Park in Boston, where Joe had been kicked out several times. As it turns out, the security guards had complained about all the amateur rock video people who had tried to film there, disturbing the mourners. I found this – kids feeding their rock star fantasies and death fascination in this graveyard – inspirational and the scenario so indicative of media culture, with the camera as the perfect metaphor for the whole system. The apparatus's aperture seems to me the dividing point between two states, but what these states are exactly remains unclear. In retrospect, my work with the skull, the still life, and the camera obscura seems to have come out of the screen.

For the aerial views of sites around Williams College and North Adams, Massachusetts, Michael Govan provided the smooth piloting. I love the feeling of flying, like the aviator in those military computer games, so we made a simulation with real footage, and the player can fly around a composite graveyard inside the computer. To reinforce a sense of a rock video shoot gone wrong, we used a cinematic grammar based on pans and zooms but with some special effects, too. There were some excellent cameos in this section by the likes of Kim Gordon, who hoots and screams; David West, who flies; Catherine Dill, who reads the book of the dead; David Bowie, who plays the mad director morphing in and out of the flowers on a tomb; Jim Shaw, Diana Thater, Kelley Mason, Niagara, and the Paris catacombs make brief appearances. The list can go on.... as I'd love to continue this never-ending story, but, sadly, there must be an end to this conversation.

Elizabeth Janus is a critic living in Geneva, Switzerland. Recent publications include "Un séjour romain" in the exhibition catalogue *Francesca Woodman* (Paris: Fondation Cartier pour l'art contemporain, 1998) and *Veronica's Revenge: Contemporary Perspectives on Photography* (Zurich: Scalo, 1998). At present, she is preparing an essay on South African artist Moshekwa Lange for a catalogue on the artist to be published by the Centre d'art contemporain, Geneva, and The Renaissance Society, Chicago (December, 1999), and is collaborating on an artist's book with Juan Muñoz.

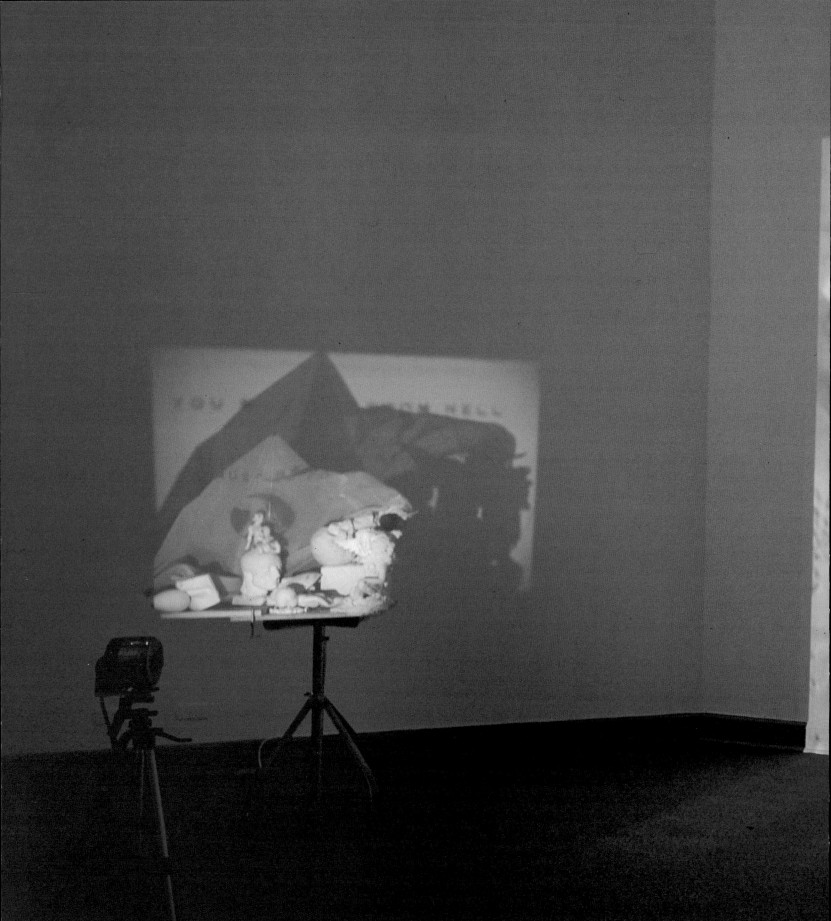

oursler's ether

by laura heon

For the better part of his career, Tony Oursler has plumbed the depths of psychic fallout from overexposure to television. He has presented characters infected by the visual media, using video as a microscope to magnify their neuroses and psychoses. His "video effigies" elicit laughter, empathy, and anxiety in part because they seem trapped in the medium of video (as well as in a water-filled jar or under a chair, mattress, or sofa). Oursler limits the existence of these lost video creatures to the small shaft of light between a projector and a head-like orb. As the proverbial "primitive" has been said to fear, the camera has stolen their souls and detains them in this cone of ether. It is this space, this cone of light and the drama that unfolds within it, that concerns Oursler in *Optics*. In this work he examines the fulcrum on which his previous body of work has balanced.

Oursler's abiding interest in the seeming dark powers of contemporary visual media (television, video, and film) led him to undertake a search for their origins: the first time someone's image traveled through a lens and emerged metamorphosed at the other end. The hunt, which resulted in *Optics*, took him through the earliest days of movies, the oddball optical contraptions of the Victorian era, an endless number of books entitled *Optics* written in the nineteenth, eighteenth, even as far back as the thirteenth century, and finally to the camera obscura, first used thousands of years earlier. The standard histories of the camera obscura are usually accompanied by illustrations of an artist (a peer of Brunelleschi, perhaps) using the device to make perspective drawings: a Renaissance man pursuing logical, scientific ends. The history that appealed to Oursler, however, begins in the Middle Ages and is shot through with unreason and magic. At that time and for centuries afterward, the camera obscura was used by scientists/black magicians. These proto-video artists, Oursler's artistic forebears, invited viewers into a darkened room (camera obscura) to face a blank wall. Pageants of various sorts staged outside the room were transmitted through a small hole in a wall and viewed as a projected image on the opposite wall by the audience gathered inside, who may

have responded to these moving projections as we do to Oursler's work today – with nervous laughter and giddy fear.

Given his interest in the insidious side of contemporary media, Oursler was struck by illustrations of medieval camera obscuras, which were often populated by devils frolicking in the (invisible) space of the transmission of light – seen by no one but sensed by all. (Some devil brethren appear in *Optics*.) If early viewers were uncertain about the mechanics of the camera obscura, they were sure of its metaphysics: something satanic happened in the journey from object to image. At last we find the reason for the television-based multiple personality disorder depicted in *Judy*, *MMPI (Red)*, and *Six*; for our unease around the characters Oursler has caged in video; and for the reticence of the camera-shy anthropological subject: dark powers (devils, psychosis, perhaps the Lacanian Real) lurk in the light.

In the dark gallery, a small clear glass devil runs for cover into a bright light bulb placed on the floor, as a mouse runs to darkness. Three other devils accompany the fugitive: one devil's disembodied head glows emerald green from staring transfixedly into a green light on the floor; another snuggles against a phallic red light on a long metal stem; still another, the tiniest, fluoresces a toxic chartreuse in the presence of a large black light. Like addicts, each takes a desperate, intense pleasure in its light. The glass devils in this dark room are out of their element, compromised, and anxiously desire to return to light. These creatures, like those in the camera obscura illustrations, live in the ether, which was once believed to be the invisible medium through which light waves travel.

On one side of a freestanding wall in the center of the gallery, Oursler projects a video of never-ending lens flare, which seems to transmit the viewer through an infinitely long lens. This video, *Flares*, was generated with help from the Kleiser-Walczak Construction Company. On the opposite side, a video of the classic battle between good and evil unfolds. Two actors (one male, one female) dress each other up as a devil and an angel and stage a fight: the devil prods the angel with a plas-

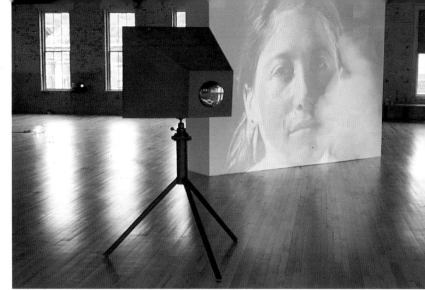

Optics: Camera Obscura; Devil and Angel, 1999, Mass MoCA

tic pitchfork, the angel punches and kicks. Then the actors trade costumes (halo for horns, tinsel wings for pitchfork, white gown for red body suit) and fight once again. Neither wins either match. Through coupling these videos back to back, Oursler places the battle in the same space as the ever-receding light. The angel and devil wage war over the souls of those traveling through the lens.

There are three large, sculptural rainbows in the installation: one sloppily hand-painted in true rainbow colors that comes in from the window; an inverted one in sickly browns, reds, and yellows that hangs from the ceiling, and a transparent one that rests on the floor near a talking light. Traditionally viewed as a portal to other realities ("over the rainbow," "under the rainbow," "at the end of the rainbow"), a rainbow is created when moisture in the air acts as a lens and reveals light's constituent frequencies. A rainbow is the original "virtual reality" because it exists only in effect, rather than as matter or form. The virtual space of the rainbow, ancient ancestor of contemporary visual media such as television, marks the beginning of the codification of virtual space (and the pot of gold at the end of Oursler's search).

In a corner, a video of a naked figure (the artist) slithering around a circuitous path is projected on a small sheet of frosted Plexiglas mounted on a stand in a corner. The projector is placed behind the translucent Plexiglas screen, giving the figure an ethereal quality like those in *Lach von #12* (1994), in which puffy pink "clouds" were used as a screen. The wiggling figure travels a complicated circuit comprised of a brain and optic nerve, becoming longer and thinner in some areas, shorter and fatter in others, refracting in a prism, swimming like a fish in a bowl. At points, the figure turns into lightning, a rainbow, a death's head. Repeatedly subjected to these optic phenomena, the figure is transformed by each.

A talking light near the transparent rainbow pulses out a litany of optic aberrations. The measured, uninflected voice reads:

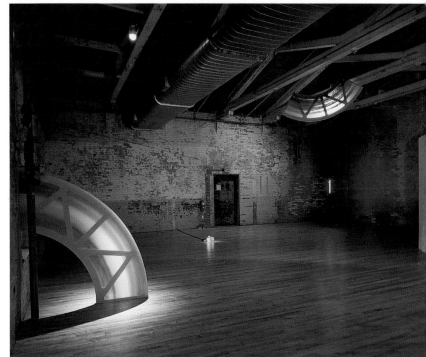

Optics: Rainbow, 1999, Mass MoCA

1999

Optics: Lens Flare Projection, 1999, Mass MoCA

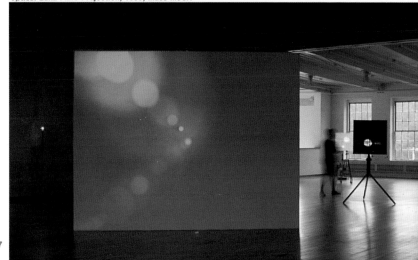

Blind spot. A nearly circular area at the base of the retina where the optic nerve enters the eyeball. This area is not sensitive to light.

Camera. A device for fashioning an image out of light. The eye has many similarities to the camera. Both have lenses for bending light rays to project an inverted image onto a light-sensitive surface at the back. Unlike the camera, the visual receptive pigments of the eye continually refresh themselves. Otherwise a newborn infant would open its eyes, look around at the world, and never see again. Its retina would be bleached forever.

Camera, lenses, flare, camera obscura, blind spot, floaters, flashes. These are straightforward technical terms and definitions – you wouldn't blink if you read them in a textbook. But here, their inherent strangeness surfaces – blindness at the center of the eye? an image made of light? The talking light, which represents sound as light, further complicates Oursler's dark musings.

A small camera obscura or "shadow box" is aligned between the green light devil and the ethereal video. The large trapezoidal box is open on the wide end and closed by a rough lens at the narrow one. Regardless of the angle from which one views the convex lens, the green light from the devil pollutes it. Visitors who have accepted the theory Oursler proposes in *Optics* – that the visual media can produce pernicious effects – tend to steer clear of the shadow box. Perhaps they recognize that this simple avatar – an ancestor, like the rainbow, of television, film, and video – is the germ from which the epidemic grew.

In *Optics*, Oursler ruminates on the transmission of light through a lens, the betwixt-and-betweenness of media, the invisible transmutation of the visible, the collusion between occult and ocular; the inverted polarity of light and dark. The uncanny qualities he reveals throughout the installation bear out the suspicion with which he has viewed visual media throughout his career. In his characteristically quirky and provocative fashion, Oursler exposes us to the dark side of light.

Laura Heon is associate curator at the Massachusetts Museum of Contemporary Art (MASS MoCA).

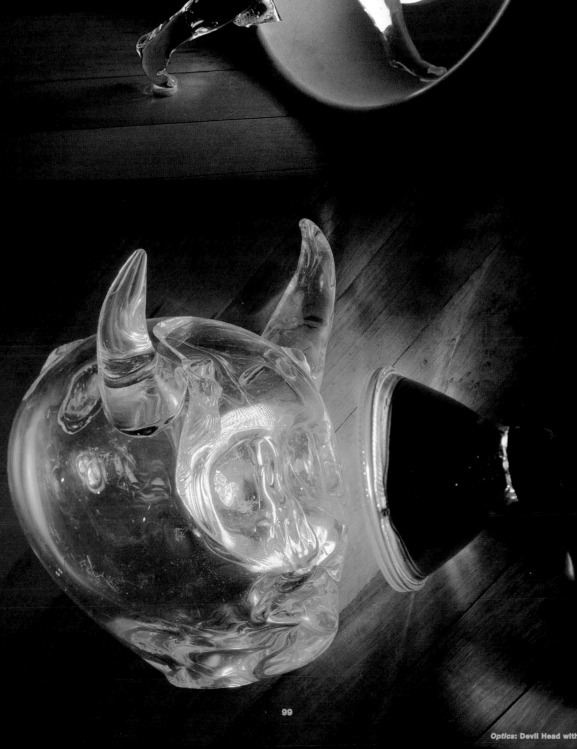

1999

Optics: Devil Head with Green Light, 1999, Mass MoCA

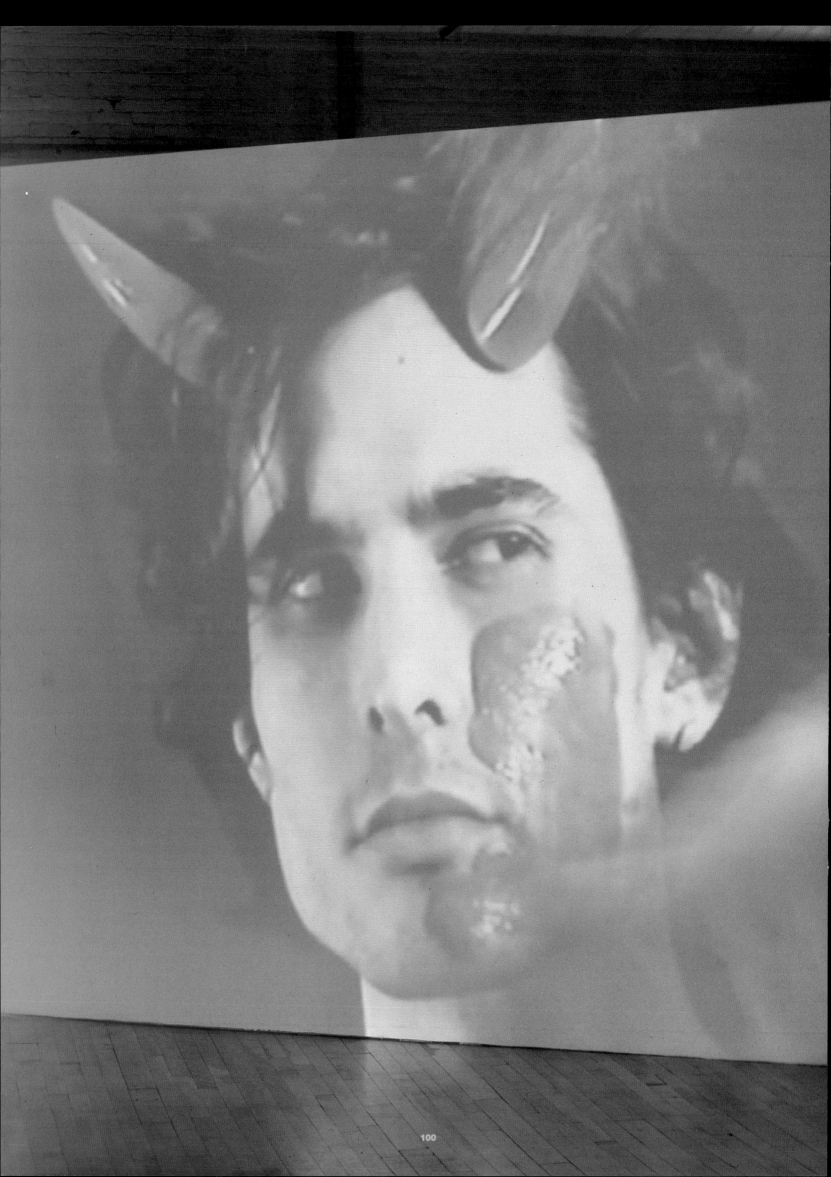

1999

I hate the dark.
I love the light.
by tony oursler

I hate the dark.

I love the light.

Iris is thought to be derived from the Greek word for *speaker* or *messenger*.

5th century b.c. Chinese philosopher Mo Ti, in the first description of the **camera obscura**, refers to the pinhole as "collection place" and "locked treasure room."

Diamonds and other clear crystals have three important characteristics that come together and foreshadow future technologies:
1. transparency of optical quality, allowing one to peer into, as in a crystal ball, or through the stone
2. refraction of light into its spectral colors
3. possession of mystical or occult powers

Plato's Cave depicts the dilemma of the uneducated in a graphic tableau of light and shadow. The shackled masses are kept in shadow, unable to move their heads. All they can see is the wall of the cave in front of them. As a result of being locked into physical sense perception, they are doomed to view only shadows of "truth" on the wall of the cave. In Plato's metaphor, an unseen fire behind the shackled illuminates a marionette or puppet show taking place above and behind their heads; the puppets' machinations represent the interactions of true contemplation, visible to the masses only as indecipherable shadows projected to the cold stone before them.

Homer equates the rainbow/Iris with a **serpent**, a sentiment shared in African mythology, in which the colors materialize as a giant consuming snake attacking the unsuspecting. In the tribal myths of South America we can find the rainbow personified in evil figures, and in Eastern Europe the colored light sometimes sucks up water and children.

The prophet **Zoroaster** of Persia describes the first character similar to the Christian Devil. He teaches that Ahura Mazda, the god of light, is in battle with the evil Angra Mainyu. The first dualist, Zoroaster believes the world is divided between dark and light.

The Dual Horus-Seth god, Egypt

Red
Seth, the Egyptian god most associated with evil, is depicted in many guises: a black pig; a tall, double-headed figure with a snout; and a serpent. Sometimes he is black, a positive color for the Egyptians, symbolic of the deep tones of fertile river deposits; at other times he is red, a negative color reflected by the parched sands that encroach upon the crops. Jeffrey Burton Russell suggests that "it is possible that the redness of Seth helped make red the second most common color, after black, of the Christian Devil."

Black

Darkness becomes a palpable mass that occupies the room completely. It expands to fill every void within the chamber, including our eyes. Perhaps there is something there that can see us and take advantage of our blinded, confused position. Gone is the steady stream of images absorbed into the eyes. All stimulation is halted as blood, nerve, retina, self-animate – sparks fly, points of false light deceive us. In the dark, the eye or brain or chemicals or electricity makes things up. Sensory deprivation is not lack of information, colors, and shapes. No, it is fear of constructing the void. Fear of the dark.

"Get behind me Satan! You are an obstacle in my path...." (Matt. 16:23)

Rainbow:
The Devil's Arc
Iris
Arco Iris
God's Sword
A person who crosses or passes directly below will change sex.
One who points at it will be struck by lightning.

Teufelsregenbogen, the dim outer rainbow, is an unsuccessful attempt by Satan to compete with the glorious original.

First reference to the **persistence of vision**: "This [perception of motion] is to be explained in the following way: that when the first image passes off and the second is afterwards produced in another position, the former is seen to have changed its gesture." – Titus Lucretius Carus (98–55 b.c.)

The One = Perfection = Infinite Good
Unformed Matter = Total Imperfection = Infinite Evil

Symyaz leads the **fallen angels**. According to Enoch, they came to earth of their own free will at Mount Hermon, descending like stars. This description gives rise to the name Lucifer, "giver of light."

And now there is no longer any difficulty in understanding the **images in mirrors** and in all smooth and bright surfaces. The fires from within and from without communicate about the smooth surface, and from one image which is variously refracted. All which phenomena necessarily arise by reason of the fire or the light about the eye combining with the fire or ray of light about the smooth bright surfaces. Or if the mirror be turned vertically, the face appears upside down and the upper part of the rays are driven downwards, and the lower upwards. – From *Timaeus*, by Plato (427–347 b.c.). Translation by B. Jowett in the *Dialogues of Plato*, Oxford, 1875.

Aristotle (384–322 b.c.) writes *De Meteorologica*. His treatise devotes a substantial amount of space to a penetrating discussion on the causes of the rainbow, luminous halos, northern lights. This section may in fact be taken as the first truly systematic theory of the rainbow that has come down to us. He also writes on sound:
Why is it that the voice which is air that has taken a certain form and is carried along often looses its form by dissolution, but an **echo** which is caused by such air striking on something hard does not become dissolved and we hear it distinctly? Is it because in an echo refraction takes place and not dispersion? This being so the whole continues to exist and there are two parts of it of similar form; for refraction takes place at the same angle. So the voice of the echo is similar to the original voice.

During an eclipse Aristotle notices many images of a crescent sun on the ground below a tree. He later discovers that whatever the shape of the aperture, jagged or smooth, the images projected are the same. The riddle is known as **Aristotle's Problem.**

Around 300 b.c. **Euclid** publishes *Optics*, in which he isolates the concept of a beam of light, suggests the eye sends out visual rays to the object that the viewer wishes to see.

Archimedes (287?–212 b.c.) is said to have used a large magnifying lens or burning glass, which focused the sun's rays, to set fire to Roman ships off Syracuse.

Day and Night, Day and Night, Day and Night, Day and Night. Over and over again the same things happen. Storm comes and then sunshine. Colors appear in the sky, always in the same order – red, orange, yellow, green, blue, indigo, violet. You think the same thoughts. You feel the same feelings. You breathe in and out. Your heart beats and beats and beats. A voice comes out of your mouth and soon it returns, repeating in your ears. In a pool your reflection floats and you are happy.

Balinese shadow puppet

"Your own hands shaped me, modeled me; and would you now have second thoughts and destroy me? You modeled me, remember; as clay is modeled, and would you reduce me now to dust?" (Job 10:8–9)

The gemstone **diamond** was often associated with lightning and was sometimes believed to owe its origin to the thunderbolt. It was also believed that the electronic current that created the stone could dissolve it.

"I have seen **Satan** fall like lightning from heaven." (Luke 10:18–20)

Green
In the Book of Revelations it is stated, "There is a need for shrewdness here: if anyone is clever enough he may interpret the number of the beast: it is the number of a man, the number is 666." One theory of the number's puzzling origin has anti-Roman groups giving letters numerical significance so that coded messages could be passed among themselves. By obscure calculation the number 666 has the letter value of Nero, who ruled a.d. 54–68. Nero is known to have enjoyed peering through a rudimentary lens crafted of the gemstone emerald, which has the property of enlargement. This is one of the first records of the use of a lens. As no records exist past the bare facts, one can only imagine the joy the emperor must have felt.

Aperture
IN: The gates of hell are often depicted as the gaping mouth of the Devil, while at other times Satan gives birth through the rectum. These entities, Satan's children, are born of a negative aperture, from an evil supernatural chamber. They are reflections of the Dark Light, disguised as human beings delivered to our world to operate as corrupting agents: OUT.

"The association of farting and shitting with the **Antichrist** was part of a conscious program of insult by inversion of values, meant to unmask the ultimate human evil found in the Antichrist." – Bernard McGinn

Ibn al-Haytham (a.k.a. **Alhazen**), a tenth-century Arabian scholar, publishes *Optics*, which is the basis of Europe's knowledge on the subject until the sixteenth century. In it he describes the camera obscura. He also expands on the optical understanding of the Greeks, explaining that light spreads out in all directions from an object. In addition he describes the linearity of light through the use of three candles and one pin hole, proving that we see objects by viewing light reflected from them.

Shen Kua (1031–1095), Chinese astronomer, mathematician, and poet, expresses the first moral equivalent of the inherent qualities of the camera obscura. He makes an analogy between the camera obscura's image inversion and the nature of man's vision, which can be so polluted as to see right as wrong.

Christians link the **colors of the rainbow** to the seven sacraments.

The Comic Devil appears in popular medieval dramas. His role is slapstick – screaming oaths, making obscene gestures, and executing pratfalls. Like Hell, the character was an inversion of norms of the day.

Robert Grosseteste (c. 1175–1253) translates the works of Alhazen to Latin.

Alhazen's ideas of the formation of the halo

c. 1200
Alhazen, who was no fool, wrote his *Treatise on Aspects*: the wise naturalist who would learn about the rainbow, must consult this book and must also possess notions of geometry to understand the demonstrations in this treatise. He will then be able to find the causes and the potency of glasses which possess marvelous qualities: the smallest things, the most minute lettering, tiny grains of sand, are seen so big and thick that they can be exactly distinguished and even counted from afar, which seems incredible to one who has not seen them or does not know the causes thereof.

Others burn and consume things placed before them if the rays of the sun which strike them are cunningly made to converge....

Others cause different images to appear straight, oblique or reversed. So that mirrors according to how they are arranged, can show two objects instead of three, eight instead of four. – Jean de Meun, *Roman de la Rose*

"**Vision** is of three kinds: direct in those who are perfect, refracted in those who are imperfect, and reflected in evildoers and those who ignore God's commandments." – Roger Bacon (1214–1292)

French astronomer **Guillaume de Saint-Cloud** suggests in an almanac of 1290 that viewers of an eclipse use a hole in their roof and a board as projection screen to avoid blindness from staring directly at the sun.

It should be noted that a colorless lunar rainbow is widely considered to be an ill **omen**.

In the thirteenth century, **Arnaud de Villeneuve**, showman and magician, utilized the camera obscura to stage

something between shadow play and cinema: players performed warlike or murderous episodes outside in the bright sunlight, while inside the audience was shocked and delighted by sound effects linked to the dramatic gestures of the projected images. The fact that the audience would stay inside and watch such a mediated event when they could have gone outside and viewed the event directly points to a victory of the virtual image over reality. The disembodiment of the moving image and its removal from the recognizable physical laws that bind the body of the viewer imbue the image with a magical quality at once distant and intimate. Thus, a new space is created, one of activated viewing, which will later incorporate all forms of cultural production – a space between darkness and light.

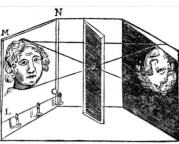

Giovanni Battista della Porta, 1558

Albrecht Dürer (1471–1528) illustrated two drawing aids: one involving a grid through which to view images, and another using a ground glass pane to trace images from life.

Buddhists associate the colors of the rainbow with the seven regions of the earth and the seven planets.

Formula for a Homunculus

Place human semen in a glass vial and nourish with blood for forty days and forty nights, keeping it at the temperature of a horse's belly: and from it will be born a genius, a nymph, or a giant Theophrastus Bombastus von Hohenheim, a.k.a. Paracelsus.

Anonymous engraving,
The Soul of Man, 1629

1558 Giovanni Battista della Porta publishes details of construction and use of the **camera obscura** in the widely distributed and popular *Magiae naturalis*:

First of all you must close the windows in the room, you will make a round hole the size of one's little finger and opposite you will stretch pieces of white sheets or white cloths or paper; and the result will be that all things which outside are illuminated by the sun you will see inside, you will see those walking in the streets with their heads downwards, as if at the antipodes, and the things on the right will appear on the left and all things turned over and the further they are from the hole the larger they will appear.

I will not conceal at last a thing that is full of wonder and mirth, because I am faln upon this discourse, that by night an image may seem to hang in the chamber. In a tempestuous night anything may be represented hanging in the middle of the chamber, that will terrify beholders. Fit the image before the hole that you desire to make seem hanging in the air in another chamber, that is dark; let there be many torches lighted around about. In the middle of the dark chamber place a white sheet, or some solid thing that may receive the image sent in; for the spectators will not see the sheet, will see the image hanging in the middle of the air, very clear, not without fear or terror, especially if the artificer be ingenious you may see hunting, battles of enemies and other delusions, and animals that are really so, or made by art of wood or some other matter. You must frame the little children in them, as we used to bring them in when comedies are acted; and you must counterfeit stags, boars, rhinoceros. . . .

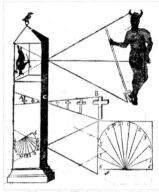

Athanasius Kircher's parastatic machine, engraving for
Ars magna lucis et umbrae, 1656

Later he discovers that by adding a lens to the enlarged hole images can be sharpened.

1604 The astronomer **Johannes Kepler** wrote *Ad Vitellionem paralipomena*, in which light and the physiology of the eye are explored in depth. He coins the term *camera obscura*, which had been known variously as *conclave obscurum*, *cubiculum tenebricosum*, and *camera clausa*. By using this device he is able to measure the diameters of the sun and moon. He also demonstrates how the focal distance of a lens can be reduced by interposing a negative concave lens; this may be the first description of a telephoto lens. As imperial mathematician, Kepler used a portable tent camera obscura to survey Upper Austria.

1610 Achilles Landenbucher, a watchmaker, devises musical instruments that play themselves.

"For since God has given each of us a light to distinguish truth from falsehood, I should not have thought myself obliged to rest content with the opinions of others for a single moment if I had not intended in due course to examine them using my judgment; and I could not have avoided having scruples about following these opinions, if I had not hoped to take every opportunity to discover better ones, in case there were any." – From *Discourse on the Method of Rightly Conducting One's Reason and Seeking the Truth in the Sciences*, by **René Descartes**, first published anonymously in 1637.

Giovanni da Fontana, 1620

"I will suppose therefore that not God, who is supremely good and the source of truth, but rather some malicious demon of the utmost power and cunning, has employed all his energies in order to deceive me." – *From Meditations on First Philosophy, 1638–1640*, by René Descartes, 1641.

"All Knowledge is light and all proceeds from the First, Infinite Light Who is God." – **Athanasius Kircher** (1601–1680)

1646 Kircher, a German who was a professor of philosophy, mathematics, and oriental language at a Jesuit college in Rome, publishes *Ars magna lucis et umbrae*. It includes the earliest known illustrations of lantern slides and the first descriptions of lantern shows and other devices such as dioptrics, lenses of pantoscopes, and telescopes, in "which little known powers of light and shadow are put to divers uses." Two lenses can be put together to create a microscope, "which will amplify a fly into a camel."

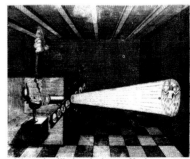

Athanasius Kircher, *La Lampe Magique ou Thaumaturge*, engraving for *Ars magna lucis et umbrae*, 1656

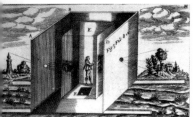

Athanasius Kircher's double camera obscura, engraving for *Ars lucis et umbrae*, 1656

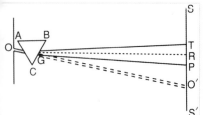

Newton's measurement of refractions of light passing through a camera obscura in conjunction with a prism

Hauksbee's Influence Machine

Slide from Robertson's Fantasmagoria

Slide from Robertson's Fantasmagoria

Kircher also describes a portable camera obscura with two apertures and an inner cube. The outer box has a hole on one side facing another hole on the opposite side. Inside is another box or frame covered with translucent paper. The draughtsman within is able to see an image on two sides of the little paper-walled room.

Kircher describes persistence of vision, likening the change of color in an after-image to the glow of a phosphorous stone when placed in darkness after exposure to light.

1647 Johannes Hevelius, an astronomer, designs a lathe that can produce large-scale telescope lenses.

1666 Isaac Newton studies the Phenomena of Colors, which is to become the modern physical theory of color. To begin, he creates a camera obscura with a triangular glass prism at its "entrance," which he ground himself, focusing and refracting the sun's rays through the dark room onto the opposite wall. There it is "a very pleasing divertissement [diversion] to view the vivid colors" of the spectrum. These experiments culminate in his letter of 6 February 1672 to the Royal Society of London that outlines his discovery of the properties of light rays. Newton also notes that the relative color or perceived color of objects is determined by the quality of the light striking the object. For example, an apple tends to reflect red in a full spectrum of light. As Newton points out, it is useless to think of an apple as red, for "**any body may be made to appear any color**" by controlling the reflected light. Newton is also the first person in history to unlock the riddle of the rainbow when he applies his understanding of refraction to the water droplets in the air.

1675 Jean Picard, the French astronomer, is walking home late one night from the Paris Observatory, swinging his barometer by his side. To his great surprise, the glass tube emanates a faint glow; the more he shakes it the more it glows: "the glow of life."

1706 Influence Machine. Francis Hauksbee, an English student of Isaac Newton, invents a machine that produces "the glow of life" at will. It consists of a hand-cranked device that spins a glass vacuum globe, half full of air. The mysterious "luminosity" can be produced by touching the surface of the glass as it spins; also produced is a crackling sound that reminds the inventor of lightning.

The Devil's Chord (a tritone)

Etienne de Silhouette (1709–1767), French controller general of finances, cuts out profiles of his contemporaries in black paper.

1717 Richard Bradly describes the kaleidoscope in a work on garden design.

1720 Louis-Bertrand Castel invents the *clavecin oculaire* or optical harpsichord. The keys trigger not only sound but also a corresponding color produced by transparent colored gels.

1725–27 James Graham establishes the Temple of Health in London. He invites childless couples to indulge in sexual intercourse in his celestial or magneticoelectro bed within a therapeutic electric field created by a Hauksbee machine.

1738 Jacques de Vaucanson, inventor of the automated loom, amazes the world by exhibiting in Paris a number of automata including a life-size Flute Player and the celebrated Duck, which is reported to flutter its wings, swim in water, eat, drink, and, finally, pass the food as amorphous matter.

1749 Horace Walpole, a young British socialite, begins to convert his home, Strawberry Hill, into "a little Gothic castle." The interior is to become a repository of everything antique; when he can't find an object he desires, he employs artisans to build a replica for him. His random collection of oddities from throughout the ages, such as a Roman tomb with the bones of a child within, are aesthetically arranged. The towers and stained glass are not in themselves designed to evoke fear; the setting is meant to stimulate visitors to feel a bygone era when our predecessors believed dwellings to be haunted. This influential building is viewed as the origin of a resurgence of gothic and the camp-pop cultural interpretation of the past that is so prevalent today in theme parks, architecture, and media.

The spectrum and depth of one's emotions are a preoccupation of the time, as represented in the introspective "theater of the mind." Any emotion can generate pleasure, regardless of the circumstances; real or fictional, unpleasant or pleasant, an emotion can be indulged, gauged, and amplified to this end. False feelings are thought to be more pleasurable.

1763 Edward Gaspard Robertson, showman-scientist-occultist, is born in Liège. In his memoirs Robertson writes of his fascination with "Father Kircher" and of the early motivations that he shared. "Who has not believed in the Devil and were-wolves in his early years? I admit frankly that I believed in the Devil, in raising the dead, in enchantments.... since the Devil refused to communicate to me the science of creating prodigies, I would apply myself to creating Devils, and I would have only to wave my wand, to create all the infernal cortege to be seen in the light. My habitation became true Pandemonium."

By the 1790s he shifts his exploration from the occult to the science of optics and, finally, to a new theatrical form. In 1794 Robertson founds the Fantasmagoria, an influential sound and light show in Paris, which makes use of his own graphic designs and innovations in the magic lantern projection system. He combines performers, props, and sound effects produced by the Musical Glass (and a robotic trumpet player) and projects moving images on clouds of smoke and layers of gauze curtains. In the area of slide projection, he introduces the idea of painting images on an opaque black background rather than on clear glass – so the images seem to float free in the air. His theater, a "vast abandoned chapel" dressed up with elaborate "Gothic" decor, is the first permanent auditorium

Staging Robertson's Fantasmagoria

for projected audio-visual shows (he performs the Fantasmagoria for six years). So convincing are his illusions that "gentlemen drew their swords, ladies fainted." He insists that his aim is not to deceive the public but to arm them against irrational superstition. His themes are culled from popular lore, historic and religious: the Apparition of the Bleeding Nun, Chinese Tamtam called Gongon in Sweden, the Death of Lord Littleton, and Preparation for the Sabbath.

1766 Jean Jacques Rousseau coins the word *melodrama* to describe a drama in which words and music, instead of proceeding together, are heard in succession, and in which spoken phrases are to some degree announced and prepared for by musical phrases.

1773 Jean Pierre and Henri-Louis Droz produce The Scrivener, a robotic writing figure who dips his pen into an inkwell and writes a limited number of words.

1784 Friedrich Anton Mesmer, an Austrian physician, is legally forbidden to practice in France. His treatments involve groups of patients conducting the current known as animal magnetism through chambers, huge vats, or metaphorical "batteries" of mysterious solutions. The treatments, accompanied by shouts, hysterical laughter, and music, end in mattress-lined rooms for the patients' decompression.

Robertson's re-design of Archimedes' legendary Burning Glass for the French government

1800 Humphry Davy, English electro-chemist, is the first to observe the light produced by the discharge of electric current between two carbon electrodes. The arc light is produced.

1802 Thomas Holcroft's play *A Tale of Mystery: A Melodrama* is innovative in its use of music and calls for intensifying dramatic moments by the sonic expression of "discontent and alarm," "chattering contention," and "pain and disorder." Over the next forty years, stage music evolves into a modular system of repeatable phrases known as melos, each identified with a different emotion.

1814–26 Joseph Nicéphore Niépce achieves his first photographic images with a camera obscura.

1817 What is the normal state of a room? One could say that a dark room is a more natural and normative state than a lighted room. As with the cave before it, the room is enclosed and inherently cut off from natural light. Windows can be employed to let light and air into a room, but daylight is limited by the cycles of the sun. At night artificial light is needed to illuminate the chamber. The open fire gave way to more controlled forms of light: oil lamps, candles, and finally, in cities, systematically supplied gas.

1825 Peter Mark Roget of thesaurus fame demonstrates the **persistence of vision** with his Thaumatrope.

1831 Joseph Henry's single-wire telegraph is introduced.

1832 Charles Wheatstone invents a nonphotographic "stereoscopic viewing device."

1833–38 Michael Faraday investigates electrical discharges of gases using vacuum tubes in which a current is passed from a negative electrode to a positive electrode, producing a glow on the inner surface of the opposite end of the tube.

1834 William George Horner patents an image-animation device, the daedelum, "Wheel of the Devil." Later, around 1864, French inventor Pierre Desvignes refines the device for the home market under the name **zoetrope**, "Wheel of Life." • Simon Von Stampfer invents the stroboscope, a device using variable-speed, extremely bright flashing light that creates the optical effect of capturing motion in a series of frozen images.

Contemporary cartoon, satirizing a Mesmer session, shows the tub dispensing fluid through its movable iron rods and ropes

1841 Frederick De Moleyn first uses vacuum for electric light bulbs.

1843 Rogues' Gallery: The first index of photographed criminals is organized by the police of Brussels. • Fox Talbot makes first instantaneous photographs using electric spark illumination.

1850s In a lawsuit against Thomas Edison, Heinrich Gobel, an American of German descent, is ruled to have made "a truly serviceable, practical incandescent lamp and exhibited it publicly twenty or thirty years before Edison."

1858 Heinrich Geissler, a German glass blower and maker of scientific instruments, created the Geissler tube. A vacuum is created in a glass container sealed with electrodes at either end. Electrons moving through the tube are visible as patterns of light, varying according to the shape of the tube or the type of gas introduced into the vacuum. This invention will lead to the discovery of cathode rays, a basic principle of video technology.

1859 Establishing an important principle for the future of electronics, the German mathematician and physicist Julius Plücker discovers that cathode rays (electrons) are deflected by a **magnetic field**. • Alexandre Edmond Becquerel, a member of the noted family of French physicists, uses a Geissler discharge tube filled with fluorescent material to create the first fluorescent lamp.

1860 Oliver Wendell Holmes invents popular stereoscope viewer.

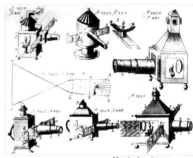

Magic Lantern slide

1860–80 Photographic lightning is believed to be a flash of lightning that creates the image of a person on an ordinary windowpane or mirror. In U.S. folklore the legend encompasses the possibility that sick, dying, or dead persons leave an image of themselves on a glass surface in the building of their confinement. The subjects are criminals, victims, and sometimes Jesus Christ. Folklorist Barbara Allen suggests that popular misunderstanding of current technology such as the photographic plate spawned such lore, and with the introduction of flexible film, the glass plate legends declined.

1864 Lewis Morris Rutherford pioneers astrophotography. • Pigeons are used to carry micro-photographed messages across enemy line.

Sincere Acting

"This woman's nature was one in which all . . . experience immediately passed into drama, and she acted her own emotions. . . . It would not be true to say that she felt less because of this double consciousness. " – George Eliot, describing Princess Halm-Eberstien in *Daniel Deronda* (1868)

Magic Lanterns

Pepper's Ghost, a mirror illusion performed extensively in dramatic sketches in the late 1800s

Etienne-Jules Marey, photographic gun, 1884

Electricity and health: Electrification from *L'electricité*, 1882

The Final Camera Obscura: The Corpse

1870 Dr. Vernois of the Society of Legal Medicine of Paris publishes his theory of the optigramme. He believes that at the point of death, the retina freezes the last frame of one's life and retains the image until decomposition of the body. The forensic implications of the theory are explored by surgically removing the retinas of murder victims and examining them under a microscope.

1872 Joseph May, a worker at Telegraph Construction and Maintenance Co., is testing transatlantic transmissions using rods made of selenium as resistors. He finds the resistance to be inexplicably variable; his lab desk is near a window, and he notices that when a ray of sunlight strikes the test rods, current flows freely through it, while in the dark the electricity crawls. The company's head electrician, Willoughby Smith, later takes credit for the discovery. Recognizing the implications of the phenomenon, he follows up with heavy experimentation and soon proposes "visual telegraphy." He states at the time, "Selenium's sensibility to light is extraordinary . . . a mere Lucifer match being sufficient to effect its conductive powers."

1878 Eadweard Muybridge publishes *The Horse in Motion*. • Dennis Redmond develops "electric telescope" to produce moving images.

1879 General Electric introduces the first Edison carbon filament electric light bulb.

1881 Rudge and Friese-Greene use a lantern with a scissors shutter to animate consecutive images of a man removing his own head.

Artificial lighting during theatrical performances causes audience discomfort; they are subjected to extremes of temperature (the ceiling goes from 60 to 100 degrees) and suffer headaches due to the fact that gaslight consumes large amounts of oxygen while its exhaust includes ammonia, carbon dioxide, and sulfur. In Berlin the effects of **gaslight** on luxurious public decor and architecture are noted: "The gas flames began their destructive work . . . blackening the ceilings . . . most surfaces turned yellow . . . and the oil paintings almost disappeared or were darkened by smoke."

1884 Etienne-Jules Marey develops the chronophotography device, which looks very much like a machine gun. He successfully exposes a number of photographic images in quick succession, thus capturing exact details of motions that had never been seen before. One of his first motion studies is of a flying bird, which he then presents on an electronic zoetrope. Marey, a scientist, is interested in using his devices only for speeding things up or down to study locomotion. He shies away from the replication of real time, stating that the absurdity of such an undertaking "would be attended by all the uncertainties that embarrass the observation of the actual movement."

1886–89 German physicist Heinrich R. Hertz produces radio waves.

1887 "Look," said the lady, "the gas flames are upside down."

"You are mistaken my dear," replied her husband. "They are electric lamps!"

"That's nice," said the lady, "but what would happen if they were to break? Would it still give out light? Would it leak out into the auditorium? Wouldn't that be dangerous for the audience?"

"My dear wife," said her husband, "one can breathe electricity without the least danger. And in any case, it would rise and collect under the ceiling at once, so we would have nothing to fear."

1888 On 27 February Muybridge meets Edison and suggests the combination of their respective inventions – the zoöpraxiscope and the phonograph. • Eastman markets the Kodak, a roll-film camera capable of taking 100 separate pictures without reloading. Eastman provides developing and printing facilities: "You press the button, we do the rest." Amateur photographers come into being. • Frederick Eugene Ives files patent for taking color photographs.

1889 A. Pumphery (U.K.) invents and markets the cycloidotrope or Invisible Drawing Master, a machine that will "trace an infinite variety of geometric designs" upon smoked or darkened glass slides for the magic lantern. By turning a hand crank, one produces a rudimentary animation of white or tinted lines on the screen. • First commercial transparent roll film makes possible the development of the movie camera.

1890 German physicist **Karl Ferdinand Braun** invents the Braun tube, an adaptation of a Lenard cathode ray tube, that is the forerunner of the TV picture tube. • Hertz develops electromagnetic radiation.

1892 Arsene D'Arsonval studies the psychological effect of electrical current on humans.

1893 Thomas Alva Edison patents the kinetoscope.

Red Shift

The systematic increase of the wavelength of all light received from a celestial object is observed in all segments of the spectrum to shift toward the higher or red end. This is mostly caused by the Doppler effect on the light of the heavenly body as it travels across vast distances of space.

Inside InsideOut Outside

1895

1. German physicist Wilhelm Conrad Röntgen discovers **x-rays**; slide makers publish long lists from which to choose interesting and macabre examples ranging from coins in a purse to a bullet lodged in a cranium.

2. George Méliès works as a magician/artist at the Robert-Houdin Theater, which regularly combines lantern shows with performances. On 4 April Méliès shows his first film at the theater, along with Edison's kinetoscope films. Also on the bill are boxing kangaroos, serpentine dancers, seascapes, and white silhouettes on black. He founds first pro-

Méliès as Satan in *The Devil and the Statue*, 1902

Cycloidotrope, 1889

duction company, Star Film, which produces 500 films from 1896 to 1912; fewer than 90 survive. Méliès himself plays the Devil in a number of his own films.

3. On 28 December, in front of the Grand Café in Paris, thirty people watch Auguste and Louis Lumière's *Workers Leaving the Lumière Factory* as the **Lumières** and Edison demonstrate motion picture cameras and projectors.

1897 Albert Allis Hopkins publishes the book *Magic, Stage Illusions and Scientific Diversions, Including Trick Photography*, which describes the techniques of photography on a black ground, spirit photography, and duplex photography.

Scene under incandescent lights from *La Lumière Electrique*, 1885

Electricity + Soviet Power = Communism – Lenin

1900 Max Planck introduces the **quantum theory** in physics. • First mass-marketed camera, the **Brownie**, introduced.

1902 Otto von Bronk applies for German patent on color television.

1904 Alfred Korn announces facsimile telegraphy.

1909 "*Phantom Rides*," films shot from the front of a boat or train, are distributed. Audiences find the simulated motion intriguing and disorienting. • GE introduces the Mazda trademark on Edison light bulbs.

1910 Portable (home) high-frequency electrotherapy devices are marketed as health aids. These machines send electrical charges through shaped vacuum tubes filled with various gases to send rays into the body. The tubes are held against the skin or eyes or inserted into the nose, mouth, ear, urethra, vagina, or anus. The violet or ultraviolet ray machines are said to cure everything from pain to cancer. The following is a chart of the possible discharges at various vacuums:

1. Normal red vacuum level
2. Slightly higher violet vacuum level
3. Higher yet white vacuum level (note phosphorescence of glass)
4. Highest Crookes vacuum level (note yellow-green phosphorescence of glass from cathode ray/x-ray formed inside tube)

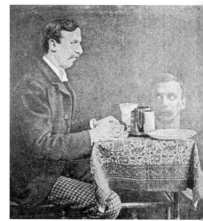

A spirit picture

1915 What is that sound? Where is that voice coming from? I don't see anybody, yet I clearly hear a voice speaking to me. It is not inside my head. Could it be God or the Devil? No, it is from inside the machine. Ray Kellogg invents the electric moving-coil speaker.

A case of paranoia. Freud analyzes a young woman who is convinced that someone is following, watching, and photographing her. She has detected this surveillance by hearing clicking or knocking sounds that she believes to be the shutter of the camera taking her picture. Freud analyzes the aural hallucinations as originating within the woman's body, and the clicks to be an aural displacement of the throb of her excited clitoris.

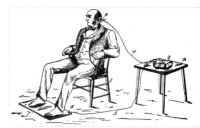

Electric Extraction of Poisons, U. S. Patent Office Application filed 5 October 1896

1920 Albert Abrams, M.D., invents a "radionics" system, which uses the crystals of dried blood from a patient to perform as do the crystal detectors of homemade radio to transmit the patient's disease.

1920–21 Ernst Belin works on and introduces wireless transmission of photographs.

1923 Vladimir Zworykin applies for patents for a television picture tube. • First **radio** network established by AT&T.

John Baird sells his soap business, moves for health reasons from London to the seaside town of Hastings. There he shares a flat with his boyhood friend Guy "Mephy" Robertson, nicknamed for his seeming resemblance to Mephistopheles. In this pastoral setting he decides to try to construct a television. The world's first working television was to "grow to fill my bedroom," which he shared with Mephy: "It became a nightmare cobweb of . . . junk. . . . at last to my great joy I was able to show the shadow of a little cross transmitted over a few feet." Some of the objects used in the invention: cardboard cross, wires, old hat box, electric batteries, bicycle lamp lenses, used tea chest, sealing wax, glue, scissors, lamp bulbs, darning needles, neon lamp, Nipkow disk, wireless valves, transformers, selenium cells, electric motors.

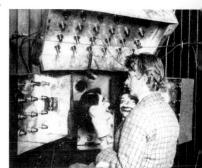

Baird and dummies in his laboratory, 1929

1925 Dinshah P. Ghadiali is jailed for fraud. He is founder of a nationwide cult in the United States that uses his Spectrochrome. His machine, based on a theatrical spotlight, generates and focuses colored light to heal people.

1926 USA Radio Act declares public ownership of the airwaves.

Freud, rejecting concepts of good and evil, looks upon the Devil as a symbol of the dark, repressed abyss of the unconscious: "The Devil is clearly nothing other than the personification of repressed, unconscious drives." The historical association of the Devil with anal imagery leads Freud to locate him in repressed anal eroticism. **Jung**, on the other hand, interprets religion as a necessary expression of the collective unconscious, and God and the Devil as essential archetypes of that system. Jung thinks of the Devil as a union of mythical and psychological repression, which he sometimes likens to The Shadow. For the individual, **The Shadow** is a highly personalized, unintegrated collection of repressed elements. The Shadow can manifest collectively in groups or in society as a whole, unleashing mass phenomena such as racism, rioting, and war with great destructive force.

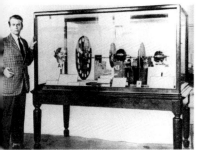

Baird's favorite television model was "Stookie Bill," a ventriloquist's dummy. In October 1925 Baird wrote, "The dummio's head formed itself on the screen with what appeared to me almost unbelievable clarity. I had got it."

Purple

Television is conceived with the advent of photoconductivity and the further refinement of the photoelectric cell. The notion of translating or coding the bright and dark areas of images into a corresponding electrical signal and decoding it back into an image at another location is within reach. Baird, unable to build a photocell that works, is aware that the light sensitivity of the human eye resides in the purple fluid, called visual purple, found in the retina. He decides to experiment with a real human eye. He goes to Charing Cross Ophthalmic Hospital, is taken for a doctor, receives a fresh eye wrapped in cotton wool, and returns to his lab in the attic at 22 Frith Street. There he dissects it with a razor; unable to put it to use, he throws it into a local canal.

1927 General Electric invents the modern flashbulb. • Bell Laboratories performs the first mechanical television transmission in the United States. • Warner Bros., faced with bankruptcy, launches sound film *(The Jazz Singer)*.
1934 Philo T. Farnsworth publicly demonstrates electronic television. • Electron microscope developed in Germany.
1937 Chester Carlson invents xerography.
1941 FCC authorizes commercial TV in the United States.
1945 Arthur C. Clark proposes a geosynchronous satellite.
1946 CBS demonstrates color TV to journalists and the FCC in the Tappan Zee Inn at Nyack-on-the-Hudson, New York.

Whiteside Parsons, a devotee of Aleister Crowley's magick and a brilliant scientist at the Jet Propulsion Laboratory in Pasadena, attempts to create a homunculus, literally an artificially conceived person occupied by a preterhuman spirit. Among the oldest of alchemical legends, Crowley's *Moonchild* suggests that a homunculus could be created when both parents were Crowleyan initiates who performed the required sex magick rituals. The embryo created by their congress would act as a "butterfly net" that would capture the appropriate spirit. The resultant child would be human in the commonplace biological sense, but for all pragmatic occult purposes would function as a homunculus. After the appropriate chants, intonations, and gestures, Parsons and Marjorie Cameron commence sex magick congress in the presence of L. Ron Hubbard, who describes the activity on the astral plane.

Tragically, on 20 June 1952 Parsons is blown apart by an explosion in his garage. Bloody body parts are visible in the rubble. Today Parsons is credited with aiding in the creation of solid rocket fuel, which is commonly used in space exploration. A crater on the moon is named after him, honoring his achievements in this field. – Compiled from *Anger: The Unauthorized Biography of Kenneth Anger,* by Bill Landis (New York: Harper Collins, 1995).

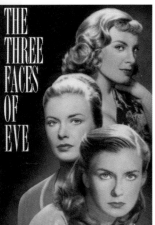

The Three Faces of Eve, 1957

1947 Walter Brattain and John Bardeen of Bell Laboratories invent the transistor. • Dennis Gabor describes principles of holography.
1948 Ampex Corporation markets first commercial **videotape recorder**.
1950 First U.S. **cable television** system appears.
1953 The film *Meet Mr. Lucifer* features a moralizing tale of television as "an instrument of the devil, a mechanical device to make the human race utterly miserable."
1957 A conversation between Jerry Lee Lewis and Sam Phillips, owner of Sun Records:
SP: You can save souls!
JLL: No! No! No! No!
SP: Yes!
JLL: How can the Devil save souls? What are you talkin' about? I have the devil in me! If I didn't, I'd be Christian!
SP: Well you may have him –
JLL: JESUS! Heal this man! He cast the Devil out, the Devil says, "Where can I go?" He says, "Can I go into this swine?" He says, "Yeah, go into him. Didn't he go into him?"

Release of **The Three Faces of Eve**, the first movie about multiple personality disorder, based on the best-selling book of the same name. • Sputnik, first satellite, launched.

The Exorcist,
robotic figure of actress, 1973

1958 Color is synthesized from a monochrome television set in the first "flicker color" broadcast. • *Kukla, Fran and Ollie* begins **color television** broadcast. • Pope Pius XII declares Saint Clare of Assisi the patron saint of television.
1960 First ruby laser built by Theodore Maiman. • First successful hologram produced.
1961 First manned space flight.
1965 Early Bird (Intelsat I), first telecommunications satellite launched; live video feeds from all over the world begin.
1967 Sony introduces the Portapak, first portable video recording system.
1969 First manned landing on the moon. • Glenn McKay creates psychedelic light shows for rock bands which combine the live manipulation of pigmented liquids and film projection systems.
1973 *The Exorcist* is one of the top-grossing films of the year. It is said to have been based on the true story of the demonic possession of a fourteen-year-old boy. Set in the Georgetown district of Washington, D.C., the film uses graphic violent scenes including special effects to depict the exorcism of a young girl. The impact on audiences is profoundly terrifying, and there are reports of fainting. More serious are accounts of cinematic neuroses, as previously unidentified psychiatric patients claim to be possessed. Classical symptoms and disabilities are observed in audiences after viewing the movie. Psychiatrist Bozzuto suggests that the loss of impulse control depicted in some scenes may threaten people with similar problems by exceeding their "stimulus barrier."

The Exorcist,
inside of robotic head, 1973

1975 It is now estimated that by the time a person reaches eighteen years of age, he or she has, on average, attended school for 10,800 hours and watched television for 20,000 hours.

1977 Rumors surface that accuse **McDonald's** fast-food restaurant of donating a percentage of its profits to the Church of Satan. The corporate logo of golden arches is said to be a symbol of the gates of hell. People are said to have seen and heard Ray Kroc, company founder, admit to the truth of these charges on a popular TV program, although no factual record is ever found. • SMTE (Society of Motion Picture and Television Engineers) recommends the use of the color bar for registration of color on TV. • **Apple** introduces home computer; the company logo depicts a rainbow-colored apple with one bite taken out.

1980 Publication of *Michelle Remembers*, in which Michelle Smith and her psychiatrist, and later husband, tell of her escape from a cult and of the extreme satanic ritual abuse she suffered at their hands. This book sparks a flood of similar accounts, which increases over the next decade. A template narrative of ritual abuse is repeated under hypnosis to psychiatrists from coast to coast. The narrative involves these repeated elements: satanic rites, rape, kidnapping, and the forcing of the victim to kill an infant. Law enforcement finds no evidence to support the claims. • Sony demonstrates first consumer camcorder.

1980–85 Scitex, Hell, and Crosfield introduce **computer-imaging** systems.

1981 MTV begins broadcasting.

1982 The film *Poltergeist* features a television set as a portal from which evil spirits are able to enter a suburban home and destroy the family.

1988 Red-eye reduction in cameras.

1989 Parents Music Resource Center (PMRC) is set up by the wife of future Vice President Al Gore to lobby the U.S. government for the censoring of the music industry. At congressional hearings she states that heavy metal music is "dangerous to the children of America." The music industry agrees to self-regulation and adopts a sticker system to warn of offensive content.

1990 Judas Priest, a heavy metal band, is cleared of charges that their music contains subliminal messages inserted through the technique of backward masking (messages recorded in reverse are embedded in songs). Allegedly, these messages have provoked the tragic suicide of two young fans. • Ritual abuse causes a total reassessment of psychiatric technique and casts great doubt on the field of dissociative identity disorders.

1991 Procter & Gamble announces that it will change its logo. The graphic man-in-the-moon with thirteen stars is to be redesigned in response to years of protest that the logo was a satanic symbol. Since the early 1980s the image has been said to involve the Antichrist: when looked at from certain angles it looks like a 666; the man-in-the-moon's hair forms the devil's horns; his beard when viewed in a mirror reveals 666; the stars when connected by three curved lines form 666. The following is a recording of a conversation from the **Procter & Gamble** product information phone line in 1989:

Customer: What about the logo, I'm worried about it....

Procter & Gamble: Oh, that's just a cute little logo.

C: Where did it come from?

P&G: Over one hundred years ago it was used on the docks to identify our products, it was stamped on the crates,....

C: Was there.... is there anything.... ?

P&G: No, there's nothing satanic or evil about it, it's just, like, a cute little symbol, like a smiley face or something, it's just a symbol....

1992–94 Black metal rock groups in Norway, aligned with Finland's pagan past and Satan worship, incite the burning of twenty churches, and rival band members commit murder and suicide.

CU-SeeMe, a live video streaming program for the Internet, is developed at Cornell University. The program allows anyone to broadcast in cyberspace.

1997 Six hundred Japanese children and a few adults are rushed to emergency rooms after watching the television program *Pocket Monster (Pokémon)*. As the red eyes of the cartoon monster flashed, some viewers fell into convulsions. One person in 200 suffers from epilepsy, and of those, 5 percent have photic seizures, which may be provoked by frequencies of 5 to 30 flashes per second. Other triggers may be: TV and computer screens, video games, faulty screens and lights that flicker, sun shining through a row of trees viewed from a passing car, looking out of a train window, sunshine on water, stroboscopic lights, geometric shapes or patterns.

1999 Live slow motion. Lene Vestergaard Hau slows down a light pulse from 300 million meters per second to 17 meters per second by passing it through a cloud of laser-tuned sodium atoms chilled to less than 50 nanokelvins. Optical properties of materials can be altered with this process, she states; "It's really opened up a lot of new exciting things that you can start doing."

Apple logo

Pokémon, 1997

Installations and Sculpture

Dimensions include equipment.

1 **Son of Oil,** 1982 (refabricated 1999)
 acrylic, canvas, paper, wood, cardboard, string, VCR, videotape, television set
 Variable dimensions
 Courtesy the artist and Metro Pictures

2 **L7-L5,** 1984 (refabricated 1999)
 glass, wood, water, plexiglass, cardboard, electric motor, paper, plasticene, foam core, four television sets, four VCRs, four videotapes
 variable dimensions in built room
 Courtesy the artist and Metro Pictures

3 **Diamond: The Eight Lights,** 1985 (refabricated 1999)
 wood, plexiglass mirror, fabric, two television sets, VCR, videotape
 variable dimensions
 Courtesy the artist and Metro Pictures

4 **Molecular Mutation (from Spillchamber II),** 1987–89
 (refabricated 1999)
 plastic spheres, paint, two television sets, VCR, videotape, sound system
 performers include Mark Wilson and Takashi Kimi
 variable dimensions
 Courtesy the artist and Metro Pictures

5 **Kepone Drum,** 1989
 painted glass, painted steel drum, television set, VCR, videotape
 23 x 35 x 32 in.
 Courtesy the artist and Metro Pictures

6 **The Watching,** 1992
 mixed media installation with video projection
 Bucket of Blood: metal tub, cloth, wig, colored water
 Candle Dress: cloth, red candle, wood stand
 Reflecting Faces: two painted televisions
 Sex Plotter: cloth, hair, LCD video projector, VCR, videotape, tripod
 Effigy Eye: cloth, mechanical eye, LCD video projector, VCR, videotape
 Model Release Forms: two cloth banners
 F/X Plotter: cloth, fiberglass, LCD video projector, VCR, videotape, speakers
 Instant Dummies: three glass capsules, cloth, wig, dildo
 Chain of Figures: cloth
 Bleeding Figures: cloth
 Variable dimensions
 Courtesy the artist and Metro Pictures

7 **Getaway #2,** 1994
 mattress, cloth, LCD video projector, VCR, videotape
 performer: Tracy Leipold
 16 x 120 x 72 in.
 Whitney Museum of American Art, New York; Purchase with funds from the Contemporary Painting and Sculpture Committee, 95.22a-h

8 **Judy,** 1994
 cloth, metal, wood, plastic flowers, used furniture, closed circuit surveillance system, audio intercom, four LCD video projectors, four VCRs, four videotapes, three tripods
 performers: Catherine Dill and Tracy Leipold
 variable dimensions
 Courtesy the artist and Metro Pictures

9 **Keep Going,** 1995
 cloth, stand, LCD video projector, VCR, tripod, videotape
 performer: Tony Conrad
 78 x 20 x 35 in.
 Williams College Museum of Art, Kathryn Hurd Fund, 99.4

10 **Insomnia,** 1996
 six pillows, cloth, LCD video projector, VCR, videotape, tripod
 performer: Tracy Leipold
 34 x 25 x 36 in.
 Collection of the Robert J. Shiffler Foundation; Collection and Archive, Greenville, Ohio

11 **Let's Switch,** 1996
 wood, cloth, LCD video projector, VCR, videotape, tripod
 performer: Tracy Leipold
 70 x 20 x 36 in.
 Collection of The Broad Art Foundation, Santa Monica

12 **MMPI (Red),** 1996
 cloth, metal chair, LCD video projector, VCR, videotape
 performer: Tony Oursler
 27 x 37 x 51 in.
 Collection of Laura-Lee W. Woods

13 **Six,** 1996
 acrylic on fiberglass, six LCD video projectors, six VCRs, six videotapes, two tripods
 each sphere 18 in. in diameter; overall dimensions variable
 The Museum of Modern Art, New York, Margot Gottlieb Bequest (by exchange), 1996 (Williams College venue only)

14 **Underwater (Blue/Green),** 1996
 ceramic, plexiglass, wood, water, LCD video projector, VCR, videotape, tripod
 performer: Tony Oursler
 52 x 18 x 51 in.
 Collection of The Broad Art Foundation, Santa Monica

15 **Aperture,** 1998
 plaster and hydrocal on metal, Formica, wood, cloth, LCD video projector, VCR, videotape, tripod
 64 x 35 x 95 in., plus equipment
 Courtesy the artist and Metro Pictures

16 **Side Effects,** 1998
 painted plastic, stand, LCD video projector, VCR, videotape, tripod
 performer: Tracy Leipold
 70 x 24 x 72 in.
 Courtesy the artist and Metro Pictures

17 **Talking Light,** 1999
 light, wire, speakers, amplifier, sound organ, CD player, CD
 performer: Tony Oursler
 variable dimensions
 Courtesy the artist and Metro Pictures

18 **Composite Still Life,** 1999
 painted fiberglass, books, LCD video projector, VCR, videotape
 performers: Louise Bourke, Joe Gibbons, Zoe Pettijohn, Tony Oursler
 28 x 21 x 75 in.
 Courtesy the artist and Metro Pictures

19 **Fear Flower,** 1999
cloth, stand, two LCD video projectors, two VCRs, two videotapes, tripod
performer: Tracy Leipold
variable dimensions
Courtesy the artist and Metro Pictures

20 **Molecule Spectre,** 1999
acrylic on plastic and wood, stand, LCD video projector, VCR, videotape, tripod
performers: Tracy Leipold and Tony Oursler
68 x 18 x 57 in.
Courtesy the artist and Metro Pictures

21 **Optics,** 1999
mixed media installation with video projection
Rainbow, Inverted Rainbow, Clear Rainbow: acrylic on plexiglass, wood
Small Green Devil Head with Black Light: glass, steel, black light
Devil Head with Green Light: glass, light
Lens Flare Projection: video projector, VCR, videotape
Devil and Angel: video projector, VCR, videotape
Red Devil: glass, steel, light
Camera Obscura: glass, steel, wood
Optical Timeline: LCD video projector, tripod, videotape, glass, metal
White Devil: glass, floodlight
Crystal Light: light bulb, wires, sound system, controller, CD player
variable dimensions
Courtesy the artist and Metro Pictures

Drawings, Paintings, Props

22 **I'll Get You,** 1970
pencil and ink on paper
10.5 x 8 in.
Courtesy the artist and Metro Pictures

23 **Crab,** 1972
colored pencil on paper
11 x 14 in.
Collection of Mr. and Mrs. Frederick Rudolph

24 **Untitled,** 1972–73
watch, comb, collage, found objects, acrylic on canvas
16 x 16 in.
Courtesy the artist and Metro Pictures

25 **Order Obsession,** 1976
acrylic on canvas
10 x 9.5 in.
Private Collection

26 **Study for The Life of Phillis,** 1977
acrylic on board
11.5 x 10 in.
Courtesy the artist and Metro Pictures

27 **One Fly Can Cause More Trouble,** 1978
ink on paper
12 x 9 in.
Courtesy the artist and Metro Pictures

28 **Pillowcase,** 1978
acrylic on fabric
16 x 27 x 4 in.
Courtesy the artist and Metro Pictures

29 **Study for Pillowcase,** 1978
ink on paper
11 x 9 in.
Courtesy the artist and Metro Pictures

30 **Rousseau, Marx, Jung (Dream Paintings),** 1979
acrylic on board with collage
three paintings, each 17.5 x 14 in.
Courtesy the artist and Metro Pictures

31 **Studies for Eyes,** 1979
acrylic on paper
four sheets, each 9 x 12 in.
Courtesy the artist and Metro Pictures

32 **The Wheel,** parts of interactive installation, 1979
acrylic on cardboard
9 "plates," each approx. 10 in. diameter
Courtesy the artist and Metro Pictures

33 **White House,** prop from **Son of Oil,** 1979
acrylic on cardboard
3.5 x 8 x 3 in.
Courtesy the artist and Metro Pictures

34 **Candle,** 1981
electric light, acrylic on cardboard
16 x 5 x 5 in.
Courtesy the artist and Metro Pictures

35 **Gray and Pink Worms,** props from **Grand Mal,** 1981
acrylic on paper
ten worms, each 3 x .5 in., mounted on foam core
Courtesy the artist and Metro Pictures

36 **Permanent Vacation I,** 1982
acrylic on canvas
24.5 x 30.5 in.
Courtesy the artist and Metro Pictures

37 **Permanent Vacation II,** 1982
acrylic on canvas
24.5 x 30.5 in.
Courtesy the artist and Metro Pictures

38 **Modernist Head (Alien),** prop from **Spinout,** 1983
acrylic on cardboard
11 x 3 x 3 in.
Courtesy the artist and Metro Pictures

39 **Female Figure,** prop from **EVOL,** 1984
acrylic on cardboard
9 x 2 x 5 in.
Courtesy the artist and Metro Pictures

40 **Leaves,** props from **EVOL,** 1984
acrylic on cardboard with string
six, each 10 x 4 in.
Courtesy the artist and Metro Pictures

41 **The Lovers,** prop from **EVOL,** 1984
acrylic on copper, plastic
10 x 7 x 4 in.
Courtesy the artist and Metro Pictures

42 **Black Light Props** from **Spheres of Influence,** 1985
acrylic on cloth, clay, plastic
7 x 14 x 11 in.
Courtesy the artist and Metro Pictures

43 **Chair and Television,** props from **Spheres of Influence,** 1985
acrylic on cardboard
two, each 5 x 2 x 2 in.
Courtesy the artist and Metro Pictures

44 **Clay Head,** prop from **Spheres of Influence,** 1985
clay, acrylic, human hair
3 x 2 x 2 in.
Courtesy the artist and Metro Pictures

45 **Organic Brain Damage,** 1985
acrylic on canvas
9 x 11 in.
Courtesy the artist and Metro Pictures

46 **Slimed Man and Woman,** props from **Spheres of Influence,** 1985
acrylic on cardboard
two, each 12 x 4 x 3 in.
Courtesy the artist and Metro Pictures

47 **Studio Camera,** prop from **Spheres of Influence,** 1985
acrylic on cardboard
10 x 4 in.
Courtesy the artist and Metro Pictures

48 **Venus of Willendorf,** prop from **Spheres of Influence,** 1985
acrylic on papier mâché
6 x 3 x 2 in.
Courtesy the artist and Metro Pictures

49 **Green Letters,** 1987
acrylic on cardboard
variable dimensions
Courtesy the artist and Metro Pictures

50 **Reaching Hands,** 1987
acrylic on cardboard
two, each 12 x 3 in.
Courtesy the artist and Metro Pictures

51 **Reagan Piñata,** 1987
acrylic on cardboard
15 x 8 x 5 in.
Courtesy the artist and Metro Pictures

52 **Roses,** 1987
acrylic on plexiglass
eight, each approx. 5 in. diameter
Courtesy the artist and Metro Pictures

53 **Telephone Wire,** 1987
acrylic on cardboard
23 x 2 in.
Courtesy the artist and Metro Pictures

54 **Wait/Go,** 1987
cardboard, wood, acetate, electric light
16 x 18.5 x 2.5 in.
Courtesy the artist and Metro Pictures

55 **Joy Ride™ Storyboard,** 1988
watercolor and pencil on paper
11 x 14 in.
Courtesy the artist and Metro Pictures

56 **Tylenol,** 1988
acrylic on paper
11 x 14 in.
Courtesy the artist and Metro Pictures

57 **Early American House,** 1989
glass, wood, VCR, videotape, television, paint
65 x 13 x 12 in. (with equipment)
Courtesy the artist and Metro Pictures

58 **Pill,** 1989
acrylic on foam core
15 x 15 x 5 in.
Courtesy the artist and Metro Pictures

59 **Study for Krypt,** 1989
acrylic on glass mirror
10 x 11.5 in.
Courtesy the artist and Metro Pictures

60 **System for Trapping a Psychic,** 1989
acrylic on paper
14 x 17 in.
Courtesy the artist and Metro Pictures

61 **Things I Did In Other People's Dreams,** 1000
acrylic on paper
14 x 17 in.
Courtesy the artist and Metro Pictures

62 **De-Icer,** 1990
watercolor and pencil on paper
14 x 11 in.
Courtesy the artist and Metro Pictures

63 **Winston,** 1990
watercolor on paper
17 x 14 in.
Courtesy the artist and Metro Pictures

64 **Three Cameras,** 1990–91
wax, collage, wood
three, each 5 x 12 x 3 in.
Courtesy the artist and Metro Pictures

65 **3-Methylfentoanyl,** 1991
acrylic and stencil on paper
19 x 24 in.
Courtesy the artist and Metro Pictures

66 **Dog's Head,** prop from **Air,** 1991
acrylic on cardboard with cloth
12 x 20 x 5 in.
Courtesy the artist and Metro Pictures

67 **Heroin,** 1991
acrylic and stencil on paper
19 x 24 in.
Courtesy the artist and Metro Pictures

68 **Poetic (Coda) #41 (Iggy Pop),** 1997
acrylic and watercolor on paper
20 x 26 in.
Courtesy the artist and Metro Pictures

69 **Poetic (Coda) #2 (Crazy Head),** 1997
mixed media on paper
26 x 20 in.
Courtesy the artist and Metro Pictures

Single-Channel Video
All videotapes courtesy the artist and Electronic Arts Intermix.

70 **Diamond (Head),** 1979
13:52 min., b&w, sound

71 **Good Things and Bad Things,** 1979
11:51 min., b&w and color, sound

72 **Life,** 1979
9:17 min., b&w, sound

73 **The Loner,** 1980
29:56 min., color, sound

74 **The Weak Bullet,** 1980
12:41 min., color, sound

75 **Grand Mal,** 1981
22:36 min., color, sound

76 **Spinout,** 1983
16:02 min., color, sound

77 **EVOL,** 1984
28:58 min., color, sound

78 **Sucker,** 1987
5:33 min., color, sound

79 **Joy Ride™** (in collaboration with Constance DeJong), 1988
14:23 min., color, sound

80 **ONOUROWN** (in collaboration with Joe Gibbons), 1990
45:40, color, sound

81 **Tunic (Song for Karen)** (in collaboration with Sonic Youth), 1990
6:17 min., color, sound

82 **Toxic Detox** (in collaboration with Joe Gibbons), 1992
32 min., color, sound

83 **Little Wonder** (in collaboration with David Bowie), 1997
4 min., color, sound

84 **Off,** 1998
60 min., color, sound

CD-ROM

85 **Fantastic Prayers,** 1999
Constance DeJong, Tony Oursler, Stephen Vitiello
Published and produced by Dia Center for the Arts
Courtesy Dia Center for the Arts and the artists

exhibition history

compiled by ian berry and alanna gedgaudas

Tony Oursler (b. 1957) received a B.F.A. from the California Institute of the Arts in Valencia in 1979. For the past twenty years he has lived and worked in New York.

Solo Exhibitions

1981 University Art Museum, University of California, Berkeley
Video Viewpoints: Tony Oursler – The More You Take from It the Bigger It Gets, Museum of Modern Art, New York
School of the Art Institute of Chicago, Chicago

1982 *Complete Works*, The Kitchen, New York
Walker Art Center, Minneapolis
Boston Film/Video Foundation, Boston
A Scene, P.S. 1, New York
Soho TV, M/T Channel 10, New York

1983 La Mamelle, San Francisco
Son of Oil, A Space, Toronto, Canada
The Tony Oursler Show, Los Angeles Contemporary Exhibitions – Panic House, Los Angeles
My Sets, Media Study, Buffalo

1984 Anthology Film Archives, New York
MO David Gallery, New York
L7-L5, The Kitchen, New York

1985 Espace Lyonnais d'art contemporain, Lyons, France
The American Center, Paris, France
Schule für Gestaltung, Basel, Switzerland
Sphères d'influence, Musée National d'Art Moderne, Centre Georges Pompidou, Paris, France

1986 Boston Film/Video Foundation, Boston
Nova Scotia College of Art and Design, Halifax, Nova Scotia

1988 *Tony Oursler's Works*, Le Lieu, Quebec City, Canada
Diane Brown Gallery, New York
Western Front Video, Vancouver, Canada
Los Angeles Center for Photographic Studies/EZTV, Los Angeles (with Constance DeJong)

1989 *Drawings, Objects, Videotapes*, Delta Gallery, Düsseldorf Museum, Düsseldorf, Germany
Folkwang Museum, Essen, Germany
Collective for Living Cinema, New York
Museum für Gegenwartskunst, Basel, Switzerland
Bobo Gallery, San Francisco

1990 Hallwalls Center for Contemporary Art, Buffalo
Video-Sculpture, Diane Brown Gallery, New York
The Kitchen, New York (with Joe Gibbons)

1991 *Poison Candy, Dummies, Designer Drugs*, Diane Brown Gallery, New York
Dummies, Hex Signs, Watercolors, The Living Room, San Francisco
University Museum, The Pacific Film Archive, University of California, Berkeley
The Cinémathèque, San Francisco

1992 *F/X Plotter, 2-Way Hex*, Het Kijkhuis, The Hague, Netherlands
The Space, Boston
The Knitting Factory, New York

1993 *White Trash and Phobic*, Centre d'art contemporain, Geneva, Switzerland; traveled to Kunstwerke, Berlin, Germany
Andrea Rosen Gallery, New York, curated by Lois Plehn
The Living Room, San Francisco
Dummies, Dolls, and Poison Candy, IKON Gallery, Birmingham, and
 Cigarettes, Flowers, and Video Tapes, Bluecoat Gallery, Liverpool, England (two-site exhibition)

1994 Lisson Gallery, London, England
Jean Bernier Gallery, Athens, Greece
Dummies, Flowers, Alters, Clouds, and Organs, Metro Pictures, New York

Street artist, 1980, New York

Stories about Cars, 1982, performance by Tony Oursler

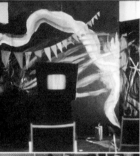

Son of Oil, 1982, installation, Toronto

Spinout, 1983, production photo

EVOL, 1984, Buffalo

Constellation Intermission, 1987

Tony Oursler, Constance DeJong on set of Joy Ride, 1988

Tony Oursler – Recent Video Works, The Contemporary Museum, Honolulu
System for Dramatic Feedback, Portikus, Frankfurt, Germany; traveled to Centre d'art contemporain, Geneva, Switzerland; Les Musées de la Ville de Strasbourg, Strasbourg, France; Stedelijk Van Abbemuseum, Eindhoven, Netherlands

1995 *Rum*, Malmö, Sweden
Galerie Ghislaine Hussenot, Paris, France
Soledad Lorenzo, Madrid, Spain
Hysterical, Atle gerhardsen, Oslo, Norway

1996 Lisson Gallery, London, England
Metro Pictures, New York
Museum of Contemporary Art, San Diego
My Drawings 1976–1996, Kasseler Kunstverein, Kassel, Germany
Jean Bernier Gallery, Athens, Greece

1997 *Judy*, Institute of Contemporary Art, Philadelphia
Colours, Heads, and Organs, Margo Leavin Gallery, Los Angeles
Tony Oursler: Video Sculpture, Aspen Art Museum, Aspen
Gallery Paule Anglim, San Francisco
Galerie Biedermann, Munich, Germany
capcMusée, Musée d'art contemporain de Bordeaux, Bordeaux, France; traveled to Salade Exposiciones Rekalde, Bilbao, Spain
Gallery Koyanagi, Tokyo, Japan
Spinout, The Video Room, White Columns, New York

1998 1000eventi, Milan, Italy
Soledad Lorenzo, Madrid, Spain
Directions – Tony Oursler: Video Dolls with Tracy Leipold, Hirshhorn Museum and Sculpture Garden, Washington, D.C.
Videotapes, Dummies, Drawings, Photographs, Viruses, Heads, Eyes, and CD-ROM, Kunstverein Hannover, Hanover, Germany; traveled to Konsthalle, Sweden; Tel Aviv Museum of Art, Tel Aviv, Israel
Metro Pictures, New York

1999 *Introjection: Tony Oursler mid-career survey 1976–1999*, Williams College Museum of Art, Williamstown, Mass., and Massachusetts Museum of Contemporary Art, North Adams, Mass.; traveled to Contemporary Arts Museum, Houston; Museum of Contemporary Art, Los Angeles; Des Moines Art Center, Des Moines
Center for Contemporary Art, Ujazdowski Castle, Warsaw, Poland
Provinciaal Centrum Voor Beeldende Kunsten – Begijnhof, Hasselt, Belgium

Performances and Projects

1982 *Stories about Cars*, Minneapolis College of Art and Design, Minneapolis

1983 *X Catholic*, performance with Mike Kelley, Beyond Baroque, Los Angeles

1989 *Relatives*, video/performance with Constance DeJong, The Kitchen, NewYork; traveled to Rockland Center for the Arts, West Nyack, N.Y.; Seattle Art Museum, Seattle; Mikery Theatre, Amsterdam, Netherlands; ECG-TV Studios, Frankfurt, Germany

1992 *Station Project*, light box installation with James Casebere, commissioned by Kunstichting Kanaal, Kortrijk Railway Station, Kortrijk, Belgium

1994- *Fantastic Prayers*, Web site project, performance, and CD-ROM with
2000 Constance DeJong and Stephen Vitiello, commissioned by the Dia Center for the Arts, New York; also presented with performance at The Rushmore Festival, Woodbury, N.Y.

1996 Performance with Constance DeJong, Philadelphia Museum of Art, Philadelphia

1997 *Pink*, performance with Constance DeJong and Stephen Vitiello, in conjunction with the 1997 *Whitney Biennial*, The Performing Garage, New York
The Poetics Project: 1977–1997 (Barcelona version), with Mike Kelly, Museu d'Art Contemporani, Barcelona, Spain; Lehman Maupin Gallery, New York; Patrick Painter, Santa Monica
The Poetics Project: 1977–1997 (*Documenta* version), with Mike Kelly, Documenta X, Kassel, Germany; Watarium, Tokyo, Japan; Metro Pictures, New York

Video

1976 *Joe, Joe's Transsexual Brother and Joe's Woman*, 25 min., b&w, sound

1977 *The Life of Phyllis*, 55 min., b&w, sound

1977–79 *Early Shorts: I'm Pretty Nice, Get out of That Tree, Crazy Head*, 20 min., b&w, sound

1979 *Tony Oursler: Selected Works*, 34:20 min., b&w and color, sound
 Life, 9:17 min., b&w, sound
 Good Things and Bad Things, 11:51 min., b&w and color, sound
 Diamond (Head), 13:52 min., b&w, sound

1980 *The Rosey Finger of Dawn*, 10 min., color, sound
 The Loner, 29:56 min., color, sound
 The Weak Bullet, 12:41 min., color, sound

1981 *Grand Mal*, 22:36 min., color, sound

1982 *Son of Oil*, 16:08 min., color, sound

1983 *Spinout*, 16:02 min., color, sound
 Theme Song from Sci Fi, 5 min., color, sound
 Rome Hilton, 2 min., color, sound
 My Class, 12 min., color, sound

1984 *EVOL*, 28:58 min., color, sound

1985 *Diamond: The Eight Lights (Sphères d'influence)*, 53:47 min., color, sound

1987 *Sucker*, 5:33 min., color, sound

1988 *Joy Ride™* (in collaboration with Constance DeJong), 14:23, color, sound

1990 *ONOUROWN* (in collaboration with Joe Gibbons), 45:40 min., color, sound
 Tunic (Song for Karen) (in collaboration with Sonic Youth), 6:17 min., color, sound

1991 *Kepone*, 11:05 min., color, sound

1992 *Toxic Detox* (in collaboration with Joe Gibbons), 32 min., color, sound
 Triptych, 12 min., color, sound
 Model Release (in collaboration with Constance DeJong), 3:24 min.
 Par-Schizoid Position (in collaboration with Kim Gordon), 2:53 min.
 Test (in collaboration with Karen Finley), 5:23 min.

1976–97 *The Poetics' Re-enactment Rock Videos* (featuring Robert Appleton), 20 min., color, sound
 The Pole Dance (in collaboration with Mike Kelley and Anita Pace), 31 min., b&w, sound

1993–97 *Air*, 30 min., color, sound

1997 *Little Wonder* (in collaboration with David Bowie), 4 min., color, sound

1997–99 *Synesthesia: Interviews about Rock and Art*, 10 hours, color, sound

1998 *Off*, 60 min., color, sound

Audio

1985 *Sphères d'Influence*, soundtrack for installation (music by Edward Primrose), Centre Georges Pompidou, Paris

1997 *The Poetics: Remixes of Recordings: 1977–83*, Compound Annex Records, Los Angeles
 (all music by The Poetics; tape mixes by Mike Kelley and Tony Oursler)
 The Poetics: Critical Inquiry in Green, Compound Annex Records, Los Angeles
 (all music by The Poetics; tape mixes by Mike Kelley and Tony Oursler)

Selected Group Exhibitions

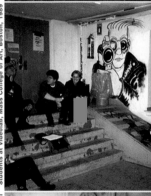

1978 *15 Artists: Videotapes*, Los Angeles Institute of Contemporary Art, Los Angeles

1979 *10 Artists: Videotapes*, Los Angeles Institute of Contemporary Art, Los Angeles
 The New West, The Kitchen, New York

1980 *Tony Oursler and Van Waterford*, Los Angeles Contemporary Exhibitions, Los Angeles
 Second Generation Video, Studio Gallery, Berlin, Germany
 New Video, Everson Museum, Syracuse, N.Y.
 New Narrative Video from California, Anthology Film Archives, New York
 California Video, Long Beach Museum of Art, Long Beach, Calif.; traveled to *XI Biennale de Paris*, Musée d'Art Moderne
 de la Ville de Paris, Paris; Mandeville Art Gallery, University of California, San Diego; Meadows Mall, Las Vegas; P.S. 1,
 New York; Northwest Film Studies Center, Portland, Ore.; Rocky Mountain Film Center and the Boulder Public Library,
 Boulder, Colo.; Utah Media Center, Salt Lake City; Washington Project for the Arts, Washington, D.C.
 By-Products, Los Angeles Contemporary Exhibitions, Los Angeles

Photo captions (right margin, vertical):

Oursler/Kelley on set of Tony Conrad's Army Movie

Video Sculpture Retrospective, 1963–1989, Germany

Students at Videolab, Mass College of Art, Boston, 1989

ONOUROWN, 1990, production still

Jamaica Plains studio, Boston, 1991

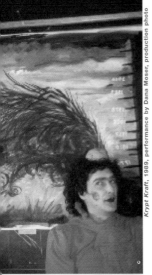

1981 San Francisco Video Festival, San Francisco
Videos–Slides–Songs, Hallwalls Contemporary Arts Center, Buffalo
Not Just for Laughs, New Museum of Contemporary Art, New York
Kobe Video Festival, Kobe, Japan
Los Angeles Film Exhibition, Los Angeles
Love Is Blind, Castelli Graphics, New York
Funny Video, P.S. 1, New York
Beware of the Dog! Mudd Club, New York

1982 *Not Just for Laughs: The Art of Subversion*, New Museum of Contemporary Art, New York
The San Francisco International Video Festival: 1981 Traveling Show, Walker Art Center, Minneapolis
International Film Festival, Seville, Spain
Return/Jump, The Kitchen, New York
Twilight, 80 Langton Street, San Francisco
Video Video, Toronto, Canada
London Video Arts, London, England
Donnell Film Library, New York
New TV New York, Long Beach Museum, Long Beach, Calif.
4th Biennale of Sydney, Sydney, Australia
New Images, Museum of Modern Art, New York
Record Covers for Show, White Columns, New York
Interiors, Façades, Landscapes, Artists' Space, New York
NYC Art Video 2, Global Village, New York
Running Commentary, SUSHI Performance and Visual Arts, University of San Diego, San Diego
University of Wisconsin, Milwaukee
Hallwalls Contemporary Arts Center, Buffalo

1983 *Funny/Strange*, Institute of Contemporary Art, Boston; traveled to York University, Toronto, Canada
Twenty Contemporary American Video Tapes, Museum of Modern Art, New York; traveled to Kitakyushu Municipal
 Art Museum, Kitakyushu, Japan; Hara Museum of Contemporary Art, Tokyo, Japan; Fukui Prefectural Museum of Art,
 Fukui, Japan
Headhunters, VIDEOLACE, Los Angeles
Art Video Retrospectives et Perspectives, Palais des Beaux-Arts, Charleroi, Belgium
Video/TV: Humor/Comedy, Media Study, Buffalo
Nova Scotia College of Art and Design, Halifax
Cegep de Levis-Lauzon, Quebec, Canada
Off Center Centre, Calgary, Canada
IV Festival International d'Art Video, Locarno, Switzerland
World Wide Video Festival, Het Kijkhuis, The Hague, Netherlands
The Second Link: Viewpoints on Video in the Eighties, Walter Phillips Gallery, Banff, Canada; traveled to Long Beach Art
 Museum, Long Beach, Calif.; Museum of Modern Art, New York; Stedelijk Van Abbemuseum, Amsterdam, Netherlands;
 Institute of Contemporary Arts, London, England
A Space, Toronto, Canada

1984 *The Luminous Image*, Stedelijk Van Abbemuseum, Eindhoven, Netherlands
New Acquisitions, Museum of Modern Art, New York
Signal Approach, The Funnel, Toronto, Canada
Content: A Contemporary Focus, 1974–1984, Hirshhorn Museum and Sculpture Garden, Washington, D.C.

1985 *Fiction: James Casebere, Ericka Beckman, Tony Oursler*, Diane Brown Gallery, New York
Out of the Ooo Cloud: Artists Salute the Return of Halley's Comet, Edith C. Blum Art Institute, Bard College,
 Annandale-on-Hudson, N.Y.
Black and White, Los Angeles Institute of Contemporary Art, Los Angeles
Video: A Retrospective, Long Beach Museum of Art, Long Beach, Calif.

1986 *Resistance or Submission: Snatches of a Christian Conversation*, Walter Phillips Gallery, Banff, Canada; traveled to
 London Regional Art Gallery, London, Canada; Musée du Quebec, Canada; Mendel Art Gallery, Saskatoon, Canada
World Wide Video Festival, Haags Gemeentemuseum, The Hague, Netherlands
The Maelstrom, Palais des Beaux-Arts, Brussels, Belgium
Off Off Festival, Museum van Hedendaagse Kunst, Ghent, Belgium

1987 *L'époque, la mode, la morale, la passion: Aspects de l'art d'aujourd'hui, 1977–1987*, Musée National d'Art Moderne,
 Centre Georges Pompidou, Paris, France
Aspects of Media: Video, Department of Video/Art Advisory Service of Museum of Modern Art, New York,
 for Johnson & Johnson
Japan 1987 Television and Video Festival, Spiral, Tokyo, Japan
Documenta 8, Museum Fridericianum, Kassel, Germany
Schema, Baskerville + Watson Gallery, New York

1988 *The Binational: American Art of the Late 80s, German Art of the Late 80s*, Institute of Contemporary Art and Museum
 of Fine Arts, Boston; traveled to Städtische Kunsthalle, Düsseldorf, Germany; Kunsthalle Bremen, Bremen, Germany;
 Württembergischer Kunstverein, Stuttgart, Germany
Film and Video Arts: 17 Years, Museum of Modern Art, New York
World Wide Video Festival, The Hague, Netherlands
Twilight, Festival Belluard 88 Bolwerk, Fribourg, Switzerland
2nd Videonale, Bonn, Germany
New York Dagen, Kunstiching, Rotterdam, Netherlands
Videografia, Barcelona, Spain
Varitish, Korea

NY Musikk, Oslo, Norway
The Body: Locomotion/Transport, Boston Foundation for Video and Film, Boston
Festival International du Nouveau Cinéma et de la vidéo, Montreal, Canada
Replacement (with Constance DeJong), LACE, Los Angeles
Infermental 7, Hallwalls Contemporary Arts Center, Buffalo
Telling Tales, Artists' Space, New York
Serious Fun Festival, Alice Tully Hall, Lincoln Center, New York

1989 *1989 Biennial Exhibition*, Whitney Museum of American Art, New York
 Video Skulptur Retrospectiv and Aktuell: 1963–1989, Kölnischer Kunstverein, Cologne, Germany; traveled to
 Kunsthaus, Zurich,Switzerland; Kongresshalle, Berlin, Germany
 XII Salso Film and Television Festival, Salsomaggiore Terme, Italy
 Masterpieces, Stadtgarten, Cologne, Germany
 Nepotism, Hallwalls Contemporary Arts Center, Buffalo
 Video and Language, Museum of Modern Art, New York
 Sanity Is Madness, The Artists Foundation Gallery, Boston
 World Wide Video Festival, The Hague, Netherlands

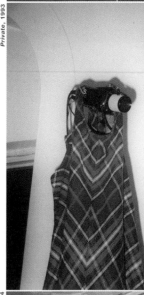

1990 *The Technological Muse*, Katonah Museum of Art, Katonah, N.Y.
 Tendance Multiples, *Video des Années 80*, Musée National d'Art Moderne, Centre Georges Pompidou, Paris, France
 Video/Objects/Installations/Photography, Howard Yezerski Gallery, Boston
 Video Transforms Television: Communicating Unease, New Langton Arts, San Francisco

1991 *New York Times Festival*, Museum van Hedendaagse Kunst, Ghent, Belgium
 Triune, Video Positive Festival, Liverpool, England; traveled to Birmingham, England

1992 *Documenta 9*, Museum Fridericianum, Kassel, Germany
 Ways to See: New Art from Massachusetts, Institute of Contemporary Art, Boston

1993 *Love Again*, Kunstraum Elbschloss, Hamburg, Germany
 3rd International Biennale in Nagoya-Artec '93, Nagoya City Art Museum, Nagoya, Japan
 Private, Gallery F-15, Moss, Norway
 The Figure as Fiction: The Figure in Visual Art and Literature, Contemporary Arts Center, Cincinnati

1994 *The Lach von #12*, Fort Asperen, Amsterdam, Netherlands
 Galleria Galliani, Genoa, Italy
 The Figure, The Lobby Gallery, Deutsche Bank, New York
 Tony Oursler and Jon Kessler, Salzburger Kunstverein, Salzburg, Austria
 Metro Pictures, New York
 A Sculpture Show, Marian Goodman Gallery, New York
 Tony Oursler and Jim Shaw, Laura Carpenter Fine Art, Santa Fe
 Home Video Redefined: Media, Sculpture and Domesticity, North Miami Center of Contemporary Art, Miami
 Light, ARTprop, New York
 Medienbiennale 94, Minima Media, Leipzig, Germany
 Beeld, Museum van Hedendaagse, Ghent, Belgium
 Heart of Darkness, Rijksmuseum Kroller-Muller Museum, Otterlo, Netherlands

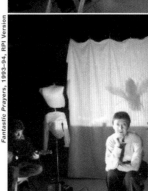

1995 *ARS 95 Helsinki*, Museum of Contemporary Art, Helsinki
 The Message Is the Medium: Issues of Representation in Modern Technologies, Castle Gallery, College of New
 Rochelle, New Rochelle, N.Y.
 Zeichen & Wunder: Niko Pirosmani (1862-1981), Kunsthaus Zürich, Zurich, Switzerland; traveled to Centro Galego de
 Arte Contemporanea, Santiago de Compostela, Spain
 Entre'Acte 1, Stedelijk Van Abbemuseum, Eindhoven, Netherlands
 Fetishism: Visualizing Power and Desire, Brighton Museum and Art Gallery, Brighton, England; traveled to City Art
 Gallery and Museum, Nottingham Castle, England; Sainsbury Centre for Visual Arts, University of East Anglia,
 Norwich, England
 Le Printemps de Cahors, La Compagnie des Arts, Cahors, France
 Inside Out: Psychological Self-Portraiture, Aldrich Museum of Contemporary Art, Ridgefield, Conn.
 Trust, Tramway, Glasgow, Scotland
 Oh Boy, It's a Girl: Feminismen in der Kunst, Kunstverein München, Munich, Germany;
 traveled to Kunstraum, Vienna, Austria
 Mendelson Gallery, Pittsburgh
 Video Spaces: Eight Installations, Museum of Modern Art, New York
 Metro Pictures, New York
 Man and Machine: Technology Art, Dong-Ah Gallery, Seoul, South Korea
 Configura 2 – Dialog der Kulturen – Erfurt 1995, Erfurt, Germany
 Immagini in Prospettiva, Galleria Zerynthia, Rome, Italy
 L'Effet Cinéma, Musée d'Art Contemporain de Montréal, Montreal, Canada
 1995 Carnegie International, Carnegie Museum of Art, Pittsburgh
 3ème Biennale de Lyon, Musée d'art contemporain, Lyons, France
 Passions Privées, Musée d'Art Moderne de la Ville de Paris, Paris, France
 Whitney Museum of American Art at Champion, Stamford, Conn.

1996 *Sampler 2: More Videos from Southern California*, David Zwirner, New York
 Empty Dress, The Rubelle & Norman Schafler Gallery, Pratt Institute, Brooklyn
 Altered and Irrational, Whitney Museum of American Art, New York
 Sex & Crime: On Human Relationships, Sprengel Musem, Hanover, Germany
 Kingdom of Flora, Shoshana Wayne Gallery, Santa Monica
 Human Technology, Revolution, Ferndale, Mich.

Linda Post — David West
ursler — Alan Vega
Interview team for the Poetics Project, 1997

Drawing project with Cooper and Peter Rey, 1998

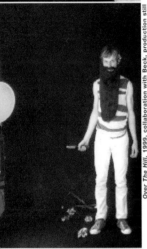

Over The Hill, 1999, collaboration with Beck, production still

Performer Tracy Leipold, 1999

Christine Van Assche and Zoe Pettijohn

Blue Dilemma (Baird's) (detail), 1999

Young Americans: New American Art in the Saatchi Collection, Saatchi Gallery, London, England
Lisson Gallery, London, England
Tomorrow, Rockland Center for the Arts, West Nyack, New York
Cincinnati Art Musuem, Cincinnati
New York "Unplugged II," Gallery Cotthem, Knokke-le-Zoute, Belgium
Phantasmagoria, Museum of Contemporary Art, Sydney, Australia
Metro Pictures, New York
Radical Images: 2nd Austrian Triennial on Photography 1996, Neue Galerie am Landesmuseum Joanneum, and Camera
 Austria in the Kunsthalle Szombathely, Graz, Austria
Scream and Scream Again, Museum of Modern Art, Oxford, England; Douglas Hyde Gallery, Trinity College, and Irish
 Museum of Modern Art, Dublin, Ireland
10th Biennale of Sydney: Jurassic Technologies Revenant, Sydney, Australia
Matthew Barney, Tony Oursler, Jeff Wall, Sammlung Goetz, Munich, Germany
Being and Time: The Emergence of Video Projection, Albright Knox Art Gallery, Buffalo; traveled to Contemporary
 Arts Museum, Houston; Cranbrook Arts Museum, Bloomfield Hills, Mich.; Site Santa Fe, Santa Fe;
 Portland Art Museum, Portland, Ore.
New Persona/New Universe, Biennale di Firenze, Florence, Italy
The Red Gate, Museum van Hedendaagse Kunst, Ghent, Belgium
The Scream, Nordic Arts Centre, Helsinki, Finland; Arken, Museum of Modern Art, Ishøj, Denmark
Face Value: American Portraits, Parrish Art Museum, Southampton, N.Y.; traveled to Wexner Center for the Arts,
 Columbus; Tampa Art Museum, Tampa
Intermission, Basilico Fine Arts, New York
ID: An International Survey on the Notion of Identity in Contemporary Art, Stedelijk Van Abbemuseum, Eindhoven,
Netherlands

1997 *Anatomy of Space/Time*, Kobe Fashion Museum, Kobe, Japan
 Musée National d'Art Moderne, Centre Georges Pompidou, Paris, France
 The Digital Video Wall, Rockefeller Center, New York
 The Whitney Biennial, Whitney Museum of American Art, New York
 Gothic, Institute of Contemporary Art, Boston
 in VISION, Center for Curatorial Studies, Bard College, Annandale-on-Hudson, N.Y.
 Now on View, Metro Pictures, New York
 Skulptur Projekte, Westphalian Museum of Art and Cultural History, Münster, Germany
 Documenta X (collaboration with Mike Kelley), Museum Fridericianum, Kassel, Germany
 Angel, Angel, Kunsthalle Wien, Vienna; Galerie Rudolfinum, Prague, Czech Republic
 Identité, Institut d'Art Contemporain, Geneva, Switzerland
 Barbara Krakow Gallery, Boston
 The Body, Art Gallery of New South Wales, Sydney, Australia
 Blurring the Boundaries: Installation Art 1969–1996, Museum of Contemporary Art, San Diego; traveled to
 Worcester Museum of Art, Worcester, Mass.
 Installations/Projects, P.S. 1, New York
 World Wide Video Festival, Stedelijk Van Abbemuseum, Eindhoven, Netherlands
 Chuck Close and Tony Oursler, Galerie Franck + Schulte, Berlin, Germany
 Zones of Disturbance, Steirischer Herbst 97, Graz, Austria
 Der Menschliche Faktor – Das Individuum im Spiegel zeitgenössischer Kunst, Hypobank International S.A., Luxembourg
 The Eli Broad Family Foundation, Santa Monica

1998 Gian Enzo Sperone, Milan, Italy
 Presumed Innocence, Anderson Gallery, Virginia Commonwealth University, Richmond
 The Secret Life of Clothes, The Nishinippon, Fukuoka, Japan
 Mysterious Voyages, Contemporary Museum, Baltimore
 Exterminating Angel, Galerie Ghislaine Hussenot, Paris, France
 Spectacular Optical, Thread Waxing Space, New York
 Video: Tony Oursler, Bruce Nauman, Sam Taylor-Wood, San Francisco Museum of Modern Art, San Francisco
 Pop Surrealism, Aldrich Museum of Contemporary Art, Ridgefield, Conn.
 Avatar, De Oude Kerk, Amsterdam, Netherlands
 Bathroom, Thomas Healy, New York
 "mächtig gewaltig: Internationale Videokunst," ACC Galerie Weimar, Burgplatz, Germany
 Connections and Contradictions: Modern and Contemporary Art from Atlanta Collections, Michael C. Carlos Museum,
 Emory University, Atlanta
 From Figure to Floor: Sculpture in the Twentieth Century, Milwaukee Art Museum, Milwaukee
 Sao Paulo Biennale XXIV, Sao Paulo, Brazil
 Emotion, Deichtorhallen, Hamburg, Germany
 I Love New York, Museum Ludwig, Cologne, Germany
 Bowie, Rupert Goldsworthy Gallery, New York
 Escences de L'Imaginari: Festival Internacional de Teatre Visuali de Titelles de Barcelona. XXV aniversari,
 Institut del Teatre, Barcelona, Spain

1999 *Drawn by...* , Metro Pictures, New York
 Salome: Images of Women in Contemporary Art, Castle Gallery, New Rochelle, N.Y.
 Collectors Collect Contemporary: 1990-1999, Institute of Contemporary Art, Boston
 Heaven, Kunsthalle Düsseldorf, Düsseldorf, Germany
 Double Lives, Institut de Cultura de Barcelona, Barcelona, Spain
 The American Century, Art and Culture 1900–2000, Part II, 1950–2000, Whitney Museum of American Art, New York
 Report Now! Museet for Samtidskunst, Oslo, Norway
 Life Cycles, Gallery for Contemporary Art, Leipzig, Germany

bibliography

compiled by ian berry and alanna gedgaudas

Writings by the Artist

"Legend: One Inch, One Mile."
 With Constance DeJong, *Topstories*, 1986

"Phototrophic." *Forehead No. 2*.
 Venice, Calif.: Beyond Baroque Foundation, 1987. Reprinted in
 Illuminating Video: An Essential Guide to Video Art, edited by
 Doug Hall and Sally Jo Fifer. New York: Aperture Foundation, 1990.

"Psychomemetiscape: A Conversation between Tony Oursler and Philip Dick."
 In *American Art of the Late 80s: The Binational*. Boston:
 Institute of Contemporary Art, Museum of Fine Arts;
 Düsseldorf: Städtische Kunsthalle, 1988, 149–52.

"Vampire."
 Communications Video, November 1988, 48.

"Triune: A Work in Progress."
 Visions, Summer 1991, 5.

"Dummies, Flowers, and Alters."
 Grand Street: Games 52 (1995).

"The Warped Vision of Bruce Nauman."
 Paper Magazine, May 1995.

"Why I Like Flowers."
 Paletten, March 1995, 30–33.

"Hot.list."
 Artforum, March 1999, 2.

Monographs and Solo Exhibition Catalogues

Centre Georges Pompidou. *Sphères d'influence*.
 Paris: Centre Georges Pompidou, 1985.

Folkwang Museum. *Tony Oursler*.
 Essen: Folkwang Museum, 1989.

Centre d'art contemporain, ed. *Tony Oursler: White Trash and Phobic*.
 With introduction by Elizabeth Janus. Geneva: Centre d'art
 contemporain, 1993.

IKON Gallery and Bluecoat Gallery. *Dummies, Dolls and Poison Candy*.
 Birmingham: IKON Gallery; Liverpool: Bluecoat Gallery, 1993.
 (unlimited edition photocopy).

Galeria Soledad Lorenzo. *Tony Oursler: Obra Reciente*,
 with essay by Octavio Zaya. Madrid: Galeria Soledad Lorenzo, 1995.

Malsch, Friedemann, ed. *Tony Oursler: Dummies, Clouds, Organs, Flowers,
Watercolors, Videotapes, Alters, Performances and Dolls*.
 Frankfurt: Portikus; Strasbourg: Les Musées de la Ville de Strasbourg;
 Geneva: Centre d'art contemporain; Eindhoven: Stedelijk Van
 Abbemuseum, 1995.

Museum of Contemporary Art, San Diego. *Tony Oursler: A Written Conversation
between Tony Oursler and Christiane Meyer-Stoll and Tony Oursler and Jim Lewis*.
 San Diego: Museum of Contemporary Art, 1996.

Balkenhol, Bernhard, Tony Oursler, and Kasseler Kunstverein, eds. *Tony Oursler –
My Drawings*.
 Cologne: Oktagon Verlag, 1997.

capcMusée d'art contemporain. *Tony Oursler*.
 With essays by Jean-Marc Avrilla and Elizabeth Janus. Bordeaux:
 capcMusée d'art contemporain, 1997.

Galeria Soledad Lorenzo. *Tony Oursler*.
 With essay by Santiago B. Olmo. Madrid: Galeria Soledad Lorenzo, 1998.

Lodi, Simona, ed. *Tony Oursler*.
 Milan: Edizioni Charta, 1998.

Schneider, Eckhard, ed. *Tony Oursler: Videotapes, Dummies, Drawings,
Photographs, Viruses, Light, Heads, Eyes, and CD-ROM*.
 Hanover: Kunstverein Hannover, 1998.

Williams College Museum of Art. *Introjection: Tony Oursler mid-career survey
1976–1999*.
 Williamstown, Mass.: Williams College Museum of Art, 1999.

Selected Group Exhibition Catalogues and Books

Stedelijk Museum. *The Luminous Image*.
 With essay by Constance DeJong. Amsterdam: The Museum, 1984.

Ackerman, Philip, Douglas F. Maxwell, and Marc J. Strauss. *Inside Out:
Psychological Self-Portraiture*.
 Ridgefield, Conn.: Aldrich Museum of Contemporary Art, 1995.

Asselin, Olivier. *L'Effet Cinéma*.
 Montreal: Musée d'art contemporain de Montréal, 1995.

Kunsthaus Zürich. *Zeichen & Wunder*.
 Edited by Bice Curiger. Küsnacht: Cantz Verlag, 1995.

London, Barbara. *Video Spaces: Eight Installations*.
 New York: Museum of Modern Art, 1995.

Museum of Contemporary Art, Helsinki. *ARS 95 Helsinki*.
 Helsinki: Museum of Contemporary Art, 1995.

Parrish Art Museum. *Face Value: American Portraits*.
 With essay by Donna De Salvo. Southampton, N.Y.: Flammarion, 1995.

Whitney Museum of American Art at Champion. *Playtime: Artists and Toys*.
 New York: Whitney Museum of American Art, 1995.

Arken Museum of Modern Art. *The Scream*.
 Ishøj, Denmark: Arken Museum of Modern Art, 1996.

Art Gallery of New South Wales. *Jurassic Technologies Revenant*.
 Sydney: Art Gallery of New South Wales, 1996.

Benning, Sadie, Chrissie Iles, and Museum of Modern Art, Oxford. *Scream and
Scream Again: Film in Art*.
 Oxford: Museum of Modern Art, 1996.

Callas, Peter, David Watson, and Museum of Contemporary Art, Sydney.
Phantasmagoria: Pre-Cinema to Virtuality.
 Sydney: Museum of Contemporary Art, 1996.

Deitch, Jeffrey. *Young Americans: New American Art in the Saatchi Collection*.
 London: Saatchi Gallery, 1996.

Ehmke, Ronald, ed., with Elizabeth Licata. *Consider the Alternatives: 20 Years of
Contemporary Art at Hallwalls*.
 Buffalo: Hallwalls Contemporary Art Center, 1996.

Lovejoy, Margot. *Postmodern Currents: Art and Artists in the Age of Electronic Media.*
 Englewood Cliffs, N.J.: Prentice Hall, 1996.

Lyttelton, Celia, and Waldemar Januszczak. *The Now Art Book.*
 Kyoto-Shi: Korinsha Press & Co., Ltd., 1996.

Matthew Barney, Tony Oursler, Jeff Wall.
 Munich: Sammlung Goetz, 1996.

Mayer, Marc, curator, and Karen Lee Spaulding, ed. *Being and Time: The Emergence of Video Projection.*
 Buffalo: Buffalo Fine Arts Academy, 1996.

Museum van Hedendaagse Kunst, Ghent. *De Rode Poort.*
 Ghent: Museum van Hedendaagse Kunst, 1996.

Neue Galerie am Landesmuseum Joanneum. *Radical Images.*
 Graz: Edition Camera Austria; Neue Galerie am Landesmuseum Joanneum, 1996.

Sprengel Museum and Vito Acconci. *Sex & Crime: On Human Relationships.*
 With essays by Fritz Haarmann and Ulrich Krempel. Hanover: Sprengel Museum, 1996.

Stedelijk Van Abbemuseum. *ID – An International Survey on the Notion of Identity in Contemporary Art.*
 Eindhoven: Stedelijk Van Abbemuseum, 1996.

Bond, Anthony, ed. *The Body.*
 Melbourne: Bookman Schwartz; Sydney: Art Gallery of New South Wales, 1997.

Chevrier, Jean-Francois and Catherine David. *Politics, Poetics: Documenta – The Book.*
 Ostfildern-Ruit: Cantz, 1997.

Eiblmayr, Silvia, ed. *Zones of Disturbance.*
 With essays by Rosi Braidotti, Ekaterina Dyogot, Silvia Eiblmayr, John Roberts, Brian Massumi, and Marc Ries. Graz: Steirischer Herbst, 1997.

Kunsthalle, Wien. *Angel, Angel.*
 New York: Springer, 1997.

Marcoci, Roxana, Diana Murphy, and Eve Sinaiko. *New Art.*
 New York: Abrams, 1997.

Aldrich Museum of Contemporary Art. *Pop Surrealism.*
 With essays by Richard Klein, Dominique Nahas, and Ingrid Schaffner. Ridgefield, Conn.: Aldrich Museum of Contemporary Art, 1998.

Collings, Matthew. *It Hurts: New York Art from Warhol to Now.*
 London: 21 Publishing, 1998.

Crutchfield, Jean, curator. *Presumed Innocence.*
 With essays by Kathryn Hixon and Robert Hobbs. Richmond: Anderson Gallery, Virginia Commonwealth University, 1998.

Felix, Zdenek. *Emotion: Young British and American Art from the Goetz Collection.*
 Ostfildern-Ruit: Cantz Verlag; New York: Distributed Art Publishers, 1998.

Noever, Peter, ed. *Art in the Center: Two Discussions on Documenta X.*
 Ostfildern-Ruit: Cantz; New York: Distributed Art Publishers, 1998.

Price, Dick. *The New Neurotic Realism.*
 London: The Saatchi Gallery, 1998.

Tippett, Michael. *The Midsummer Marriage.*
 Program for a performance. Munich: National Theater, 1998.

Wadley, Nick. *The Secret Life of Clothes.*
 Fukuoka, Japan: Nishinippon, 1998.

The Art Society, Kunsthalle Düsseldorf. *Transition: Düsseldorf 1999.*
 Düsseldorf: The Stadtmuseum, 1999.

Grosenick, Uta, and Burkhard Riemschneider, eds. *Art at the Turn of the Millennium.*
 New York: Taschen, 1999.

Selected Articles and Reviews

Adams, Brook. "Report from New York."
 Art in America, June 1997, 35–41.

Ames, Kenneth L., et al. "Tony Oursler."
 Katalog, autumn 1996, 50.

Angus, Denis. "Tony Oursler: tout le répertoire des émotions."
 Omnibus 21 (1997): 5–7.

Ardenne, Paul. "Tony Oursler's Cruel Theater."
 Art Press, November 1997, 19–24.

Artner, Alan G. "Matter over Mind."
 Chicago Tribune, 28 June 1992.

Atkins, Robert. "The San Francisco International Video Festival."
 Artforum, April 1983, 78–79.

Baer-Bogenschütz, Dorothee. "Beobachter der Beobachter."
 Frankfurter Rundschau, 22 September 1994.

Baker, Kenneth. "Talking Heads Can Speak to Us."
 San Francisco Chronicle, 18 September 1997, sec. E, pp. 1, 5.

———. "Tony Oursler: Paula Anglim."
 Artnews, December 1997, 168.

Banigan, John J. and Phil Richards. "How to Abandon Ship."
 FAT, no. 2 (winter 1995/96): 34–35.

Batchelor, David. "Tony Oursler – Lisson Gallery."
 Artforum, summer 1996, 118.

Berke, Lisa. "Short Bytes: Kingdom of Flora."
 Los Angeles Jewish Times, 15 March 1996.

Berlinsky, John. "The Light Fantastic."
 Metro, October 1988.

Bonetti, David. "Video Effigies Dispense Empty Wisdom, Sorrow."
 San Francisco Examiner, 24 September 1997, sec. 9.

Bratschi, Isabelle. "Tony Oursler Parvient à Faire Parler d'Etranges Poupées."
 Le Courrier, 3 February 1995.

Bumpus, Judith. "Video's Puppet Master."
 Contemporary Visual Arts, no. 15 (1997): 38–43.

Camhi, Leslie. "A Sharpies' Crisis."
 The Village Voice, 7 May 1996, 79–80.

Carr, C. "Constance DeJong and Tony Oursler: Relatives, The Kitchen."
Artforum, May 1989, 157.

Christakos, John. "Punkers Pack a Punch on Art Scene."
Daily Yomiuri, 13 January 1998, 10.

Click, Carrie. "Look into Tony Oursler's Interactive World."
Aspen Times, 23 August 1997, sec. B, p. 3.

Colman, David. "The Art Screen Scene."
Artforum, September 1995, 9-10.

Cooke, Lynne. "Tony Oursler: ALTERS."
Parkett 47 (1996): 38–41.

Cornwell, Regina. "Great Videos, Shame about the Show."
Art Monthly, September 1992, 22.

Cotter, Holland. "Optic Nerve."
Art in America, June 1996, 92–95.

Danto, Arthur C. "Art: TV and Video."
The Nation, 11 September 1995, 248–53.

Decter, Joshua. "Tony Oursler, Diane Brown Gallery."
Arts Magazine, October 1990, 65.

———. "Tony Oursler, Metro Pictures."
Artforum, February 1995, 89.

DiPietro, Monty. "Never Mind the Academics."
Asahi Evening News, 4 December 1998, 11.

Dorment, Richard. "Portraits for the Age of Anxiety."
Daily Telegraph (London), 3 March 1994.

Druey, Monique-Priscille. "L'Americain Oursler Hurle à Genève."
Tribune des Arts, March 1995, 15.

Duehr, Gary. "'Gothic' is Spooky: ICA Exhibit Touches on Terror and Taboo."
The TAB, May 1997, 6–12.

Duncan, Michael. "Tony Oursler at Metro Pictures."
Art in America, January 1995, 105.

Edelman, Robert G. "Tony Oursler."
Art Press 199 (February 1995): vi–vii.

Fargier, Jean Paul. "Installation à Beaubourg."
Le Journal Cahiers du Cinéma, February 1986, xii.

———. "Tony Oursler."
Le Monde, March 1995, 19–20.

Frank, Peter. "Art Picks of the Week: Tony Oursler, Lutz Bacher."
LA Weekly, 11-17 April 1997, 144.

Galloway, David. "Digital Bauhaus."
Art in America, June 1998, 44–47.

Geerling, Let. "De lach van de gehangene."
Metropolis M, no. 4 (1994): 34–39.

Gilbert, Andrea. "Tony Oursler."
Arti, Athens 33 (March/April 1997): 178–82.

Glueck, Grace. "Turn On, Tune In and Drop By: Video Art's Come a Long Way."
New York Observer, 24 July 1995, 20.

Goldberg, Vicki. "Photos That Lie – and Tell the Truth."
New York Times, 16 March 1997.

Gordon, Kim. "American Prayers."
Artforum International, April 1985, 73–77.

Grundberg, Andy. "Review/Photography, Tony Oursler, Diane Brown Gallery."
New York Times, 8 June 1990, sec. C, p. 21.

Hagen, Charles. "Video Art: The Fabulous Chameleon."
Artnews, summer 1989, 118–23.

———. "Back in Fashion, Video Installations."
New York Times, 11 July 1995, sec. C, pp. 13, 15.

Halle, Howard. "The Vision Thing."
Time Out New York, 1-8 May 1996, 22.

———. "Portraits of the Whitney Biennial."
Time Out New York, 20-27 March 1997, 10–16.

Heartney, Eleanor. "Video in Sity."
Art in America, October 1995, 94–99.

Heiser, Jorg. "Den Plot ernst nehmen – Tony Oursler's Installation 'System for Dramatic Feedback.'"
Texte Zur Kunst 10 (October 1994): 191–94.

Herbert, Martin. "Project Yourself onto This."
Dazed & Confused, April 1996, 102–4.

Herzog, Samuel. "Schaschlik aus Half Brain und Dirty Harry."
Basler Zeitung, 11 June 1998, 39.

Hoberman, J. "The Weak Bullet; The Loner; Grand Mal."
The Village Voice, 23 March 1982.

Hohmeyer, Jürgen. "Die Fernbedienung der Kunstgeschichte."
Der Spiegel (1988): 52.

———. "Apokalypse im Koffer."
Der Spiegel 51 (1996): 194–97.

Howlett, Margaret. "Sound and Light."
Scholastic Art 27 (March 1997): 10–11.

Hummer, Tracey. "Tony Oursler."
Sculpture, September 1996, 63–64.

Iso, Claudine. "Tony Oursler at Margo Levin."
Art Issues 48 (summer 1997): 48.

James, Caryn. "Critics Notebook, Avant-Garde Films in a Struggle to Stay Avant."
New York Times, 29 June 1989.

———. "Art Flickers from Video Screens."
New York Times, 26 July 1996, sec. C, pp. 1, 4.

Jana, Reena. "Grace Note."
Artforum, April 1998, 18.

Janus, Elizabeth. "Sue Williams, Renee Green, Tony Oursler."
Furor (Voltaire) 26 (September 1994).

Januszczak, Waldemar. "Heart of the Matter."
New York Times, 27 February 1994, 16.

Johnson, Ken. "Tony Oursler and Mike Kelley."
New York Times, 19 June 1998, sec. E, p. 39.

Joselit, David. "Mind over Matter: Tony Oursler and Ericka Beckman Master the Politics of Art."
The Boston Phoenix, 7 September 1990.

Kandel, Susan. "'Kingdom of Flora' Blooms Again."
Los Angeles Times, 22 February 1996, sec. F, pp. 3, 12.

———. "Facing an Encounter with a Surrealist Edge."
Los Angeles Times, 7 March 1997, sec. F, p. 20.

———. "'Poetics Project' Relives Group's Heady Days."
Los Angeles Times, 12 December 1997, sec. F, p. 28.

Kaoru, Yanase. "Tony Oursler."
BT 48 (June 1996): 53–59.

Kent, Sarah. "Dummy Copy."
Time Out (London), 16 February 1994.

Kimmelman, Michael. "Narratives Snagged on the Cutting Edge."
New York Times, 21 March 1997, sec. C, pp. 1, 26.

———. "Few Paintings or Sculptures, but an Ambitious Concept."
New York Times, 23 June 1997, sec. C, pp. 9–10.

Kohen, Helen L. "Home Video Never Looked Like This."
Miami Herald, 27 February 1994, 41.

Labat, Tony. "Tony Oursler."
Shift 12 (1991): 33–36.

Lalanne, Dorothee. "Tony Oursler: Dernier Soir."
Cinema, 10 February 1986.

Landi, Ann. "The Vision."
Artnews, special issue, fall 1996, 18–23.

Lange, Regina. "Media Power, Video-arbeiten von Tony Oursler."
Apex-Heft 7 (1989): 97–100.

"The News Hour with Jim Lehrer,"
Channel 13/WNET New York, 23 May 1997

Levin, Kim. "Trans-Europe Express."
The Village Voice, 27 September 1994.

Lewis, Jim. "Doll Parts."
Spin, November 1995, 28.

Lewis, Jo Ann. "At the Hirshhorn, Dolls with Attitude."
Washington Post, 5 July 1998, sec. G, pp. 1, 8, 9.

Leydier, Richard. "Exterminating Angel."
Art Press, May 1998, 76–77.

Licata, Elizabeth. "Living with Art,"
Artnews, December 1995, 87–90.

Lloyd,Ann Wilson."A Multiplex of a Museum Turns on the Lights."
New York Times, 23 May 1999, 31–32.

Lunghi, Enrico. "Arret sur images: Luxembourg 1996."
Cafe Crème 17 (1996): 65.

Mackey, Heather. "Something Fishy Going On."
After Dark, February 1991.

MacMillan, Ian. "Expressway to Your Skull."
Modern-Painters, spring 1998, 77–79.

Maillet, Florence. "Oursler ça se Projette."
Beaux Arts, December 1997, 38.

Maloney, Martin. "Young Americans: Parts I and II."
Flash Art, May/June 1996, 108–9.

Maurer, Simon. "Der Videokünstler Tony Oursler im Centre d'Art Contemporain Genève."
Tages Anzeiger (Zürich), 9 March 1995.

McCormick, Carlo. "True Terror."
Paper, November 1994, 31.

Meigh-Andrews, Chris. "Tony Oursler."
Art Monthly, November 1993, 25.

Miller, John. "Tony Oursler, Diane Brown Gallery."
Artforum, October 1990, 164.

Morgan, Stuart. "The Human Zoo: Stuart Morgan on Documenta X."
Frieze, September/October 1997, 70–77.

Morrissey, Simon. "Tony Oursler."
Creative Camera, April/May 1996, 35.

Movin, Lars. "Images from a Psychotic Doll's House."
Katalog, summer 1998, 52–56.

Muchnic, Suzanne. "LACE Exhibits Video Art Puppetry."
Los Angeles Times, 26 January 1980, sec. 11, p. 2.

Neri, Louise, Tracy Leipold, and Tony Oursler. "Oursler/Leipold/Neri: A Conversation in the Green Room."
Parkett 47(1996): 21–27.

Nobis, Beatrix. "Der Multiple Dr. Caligari."
Süddeutsche Zeitung, 5 June 1998, 14.

Norklin, Kathi. "The Compulsion to Curate."
Woodstock Times, 8 May 1997, 14.

Ollman, Leah. "Art That Talks Back: The Shrink Is In."
Los Angeles Times, 30 June 1996, 55–56.

Pesch, Martin. "Tony Ourslers Videoskulpturen in Frankfurt: Mehr als Medien-Feedback."
Frankfurt Neue Presse (Die Tageszeitung), 30 September 1994.

Pieters, Din. "Het geheim achter het lachen."
NRC Handelsblad, 6 October 1994.

Price, Mark S. "Tony Oursler: Video Dolls with Tracy Leipold."
Sculpture, December 1998, pp. 57–58.

Protzman, Ferdinand. "Aroma One's Own."
Washington Post, 21 December 1996, sec. B, p. 2.

Puvogel, Renate. "Tony Oursler – System for Dramatic Feedback."
Kunstforum International, November 1994, 403–4.

Ramirez, Yasmin."Tony Oursler at Diane Brown Gallery."
Art in America, May 1992, 137.

Read, Brock. "WCMA: Oursler Retrospective."
Williams Record (Williamstown, Mass.), 20 April 1999.

Rice, Robin. "It's Alive: Three Shows Animate the Galleries of the ICA."
Philadelphia City Paper, 14 February 1997, 30.

Richard, Frances. "Like Water."
Parkett 47 (1996), 46–49.

Ritchie, Matthew. "Video Spaces: Eight Installations, MOMA."
Zingmagazine, autumn 1995.

———. "Tony Oursler: Technology As an Instinct Amplifier."
Flash Art, January/February 1996, 76–79.

———. "The Edge of Vision."
FAT no. 2 (winter 1997): 8–10.

Russell, John. "Portraits That Beckon to the Cross-Examiner."
New York Times, 11 August 1995, sec. C, p. 30.

Sage, Elspeth. "The Joy of Collaboration: An Interview with Constance DeJong and Tony Oursler."
Video Guide 9 (1988): 3–4.

Sandqvist, Gertrud. "Privat." Translated by Michael Garner.
Parkett 37 (1993): 152–54.

Sarrazin, Stephen. "Tony Oursler en de nieuwe gedaante van de videokunst."
Metropolis M, no. 6 (1993): 30–33.

Sausset, Damien. "L'entrepot de l'etrange."
L'Oeil, November 1997, 23.

Schjeldahl, Peter. "Get out of Here."
The Village Voice, 29 November 1994, 97.

———. "Museumification 1997: The Whitney Biennial As Pleasure Machine."
The Village Voice, 1 April 1997, 80–81.

Schmitz, Rudolf. "Frankfurt: Tony Oursler im Portikus."
Kunstbulletin, October 1994, 38–39.

Schulman, Ken. "A Touch of Class."
Artnews, May 1997, 87.

Schwarze, Dirk. "Die Klagende Puppe im Koffer."
Donnerstag, 28 November 1996, 26.

———. "Oursler: Wie Übungen im Atelier."
Montag, 25 December 1996, 19.

Schwendener, Martha. "Tony Oursler: Dummies, Flowers, Alters, Clouds, and Organs."
Art Papers, January/February 1995, 59.

———. "Mike Kelley/Tony Oursler: The Poetics Project, 1977–1997."
Time Out New York, 25 June – 2 July 1998, 58.

Sciaccaluga, Maurizio. "Tony Oursler."
Tema Celeste (Milan), March/April 1998, 75.

Searle, Adrian. "Nowhere to Run."
Frieze 34 (1997): 42–47.

Shamash, Diane. "At the Close of the Century: Documenta X."
Documents 10 (fall 1997): 57–60.

———. "A History Lesson."
Art in America, October 1998, 112–15.

Smith, Roberta. "Tony Oursler."
New York Times, 25 November 1994, sec. C, p. 24.

———. "A Neo-Surrealist Show with a Revisionist Agenda."
New York Times, 12 January 1996, sec. C, p. 23.

———. "The Horror: Updating the Heart of Darkness."
New York Times, 1 June 1997, sec. C, p. 33.

———. "Art Center Has Room for the Big and the New."
New York Times, 2 June 1999, sec. C, p. 1.

Sonna, Birgit. "Köpfe, Puppen, Videospiele."
Münchner Kultur, 12 September 1997, 16.

Sozanski, Edward J. "ICA Exhibits Range from Video to Tree Trunks."
Philadelphia Enquirer, 21 February 1997, 36.

Spiegel, Andreas. "Jon Kessler/Tony Oursler."
Arti 22 (November/December 1994): 208–11.

Stafford, Amy. "Tony Oursler: Video Drone."
Surface 11 (1997): 94–95.

Taubin, Amy. "Choices."
The Village Voice, 20 June 1990, 99.

———. "The Big Sleep."
The Village Voice, 3 August 1993, 48.

Temin, Christine. "At ICA, Art That Goes Bump in the Night."
Boston Globe, 25 April 1997, sec. D, pp. 1, 11.

———. "Oursler's Video Take on Life."
Boston Globe, 16 July 1999, sec. C, p. 1.

Tiberio, Margaret. "Method to This Media: An Interview with Tony Oursler."
Visions, A publication for the Media Arts by the Boston Film/Video Foundation, summer 1989, 3.

Tomii, Reiko. "New York."
Bijutsu Shinbun 767 (1 June 1996).

Valentin, Beate. "Es Fehlt an Gemeinsamen Inhalten."
Handelsblatt, 20 September 1997, 4.

Van Assche, Christine. "Six Questions to Tony Oursler."
Parachute 84 (1996): 6–10.

Van Derjagt, Marijn. "Reis van onder-naar bovenlichaam."
De Groene Amsterdammer, 15 June 1994, 28.

Van-Proyen, Mark. "Some Call It Video."
Artweek, 1 November 1986, 9.

Vogel, Carol. "Inside Art."
New York Times, 10 March 1995, sec. C, p. 3.

Volk, Gregory. "Tony Oursler, Metro Pictures."
Artnews, February 1995, 127.

Von Ziegesar, Peter. "A Pilgrim's Progress: Gallery Rounds."
http://www.artnet.com, 1997.

Ward, Sarah. "Tony Oursler at Metro Pictures,"
Art in Context, http://www.artincontext.org/reviews//1996/oursler.htm, 17 May 1996.

Welchman, John C. "Tony Oursler: Angels of the Techno-Grotesque."
Art + Text, May 1995, 25–27.

Wooster, Ann-Sargent. "Tony Oursler at MO David."
Art in America, December 1985, 134.

Zeichner, Arlene. "Critique of Pure Reason."
The Village Voice, 3 April 1984, 62.

Zimmer, William. "No Simple Innocence, Childhood Now Invoked Has More in Tow."
New York Times, 21 January 1996, sec. C, p. 16.

Museum Staff

Diane Agee, registrar
John R. Anderson, security officer
Ian Berry, assistant curator
Kenneth Blanchard, security monitor
Melissa Cirone, development associate
Marion M. Goethals, associate director
Ann Greenwood, members program coordinator
J. Patrick Holden, preparator
Stefanie Spray Jandl, Mellon curatorial associate
Kay M. Kamiyama, public relations coordinator
Robert T. Kove, security monitor
Silvio J. Lamarre, security monitor
Dorothy H. Lewis, budget assistant
Christine F. Maher, museum shop manager
Sheila Mason, museum secretary
Nancy Mowll Mathews, Eugénie Prendergast curator
Hideyo Okamura, chief preparator
Vivian L. Patterson, associate curator, collections management
Judith M. Raab, director of membership and events
Barbara Robertson, director of education
Deborah M. Rothschild, curator of exhibitions
Edith V. Schwartz, Prendergast office assistant
Linda Shearer, director
Gregory J. Smith, art handler
William A. Steuer, security officer
Sue Superneau, security officer
Rachel U. Tassone, catalogue assistant
Amy Tatro, assistant to the director
Theodore Wrona, security supervisor

Visiting Committee

Herbert Adler
Sigmund R. Balka
Lucinda Barnes
Nancy K. Breslin
Charles M. Collins
Michael A. Dively
Michael S. Engl, vice chair
Romeyn Everdell
Michael B. Keating
Thomas Krens
John R. Lane
Susan W. Paine
Randall R. Perkins
Harvey R. Plonsker
Earl A. Powell III
Jock Reynolds
Sally W. Robinson
Dorothy D. Rudolph
Margaret Stone, chair
Catherine C. Vare
Stuart B. Young

Members Emeriti

S. Lane Faison Jr.
Whitney S. Stoddard

Advisory Members

Sigmund R. Balka, chair, Fellows Program
Thomas J. Branchick, director, Williamstown Art Conservation Center
Michael Conforti, director, Clark Art Institute
Charles W. Haxthausen, director, Graduate Program in Art History, Williams College
John H. Skavlem, associate director, development, Williams College
Robert L. Volz, custodian, Chapin Library of Rare Books, Williams College

Members Ex Officio

Keith C. Finan, associate provost, Williams College
Marion M. Goethals, associate director, Williams College Museum of Art
Guy M. Hedreen, chair, art department, Williams College
Harry C. Payne, president, Williams College
Linda B. Shearer, director, Williams College Museum of Art

Untitled, MPD, 1998.

Book designed by Pascale Willi, xheight inc., New York

Edited by Brenda Niemand

Introjection installation photography by Arthur Evans.
Other photography by Boshra Al-Saadi, Tony Huang,
Bill Orcut, Tony Oursler, and Katrin Schilling.

Body text set in Egyptienne and Helvetica 55

Printed at Studley Press, Dalton, Massachusetts,
on Centura dull